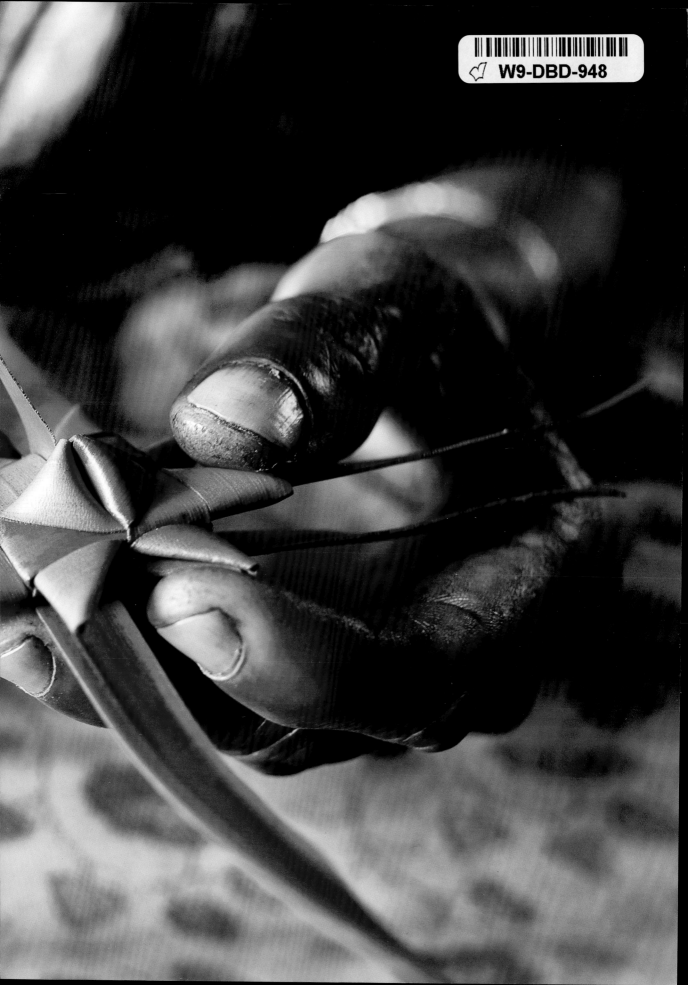

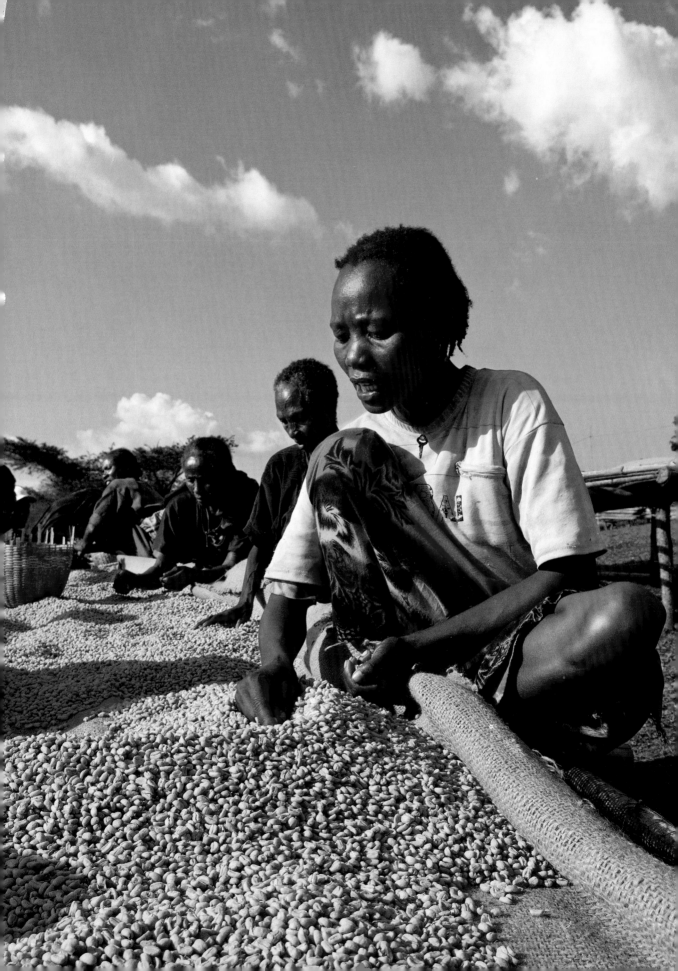

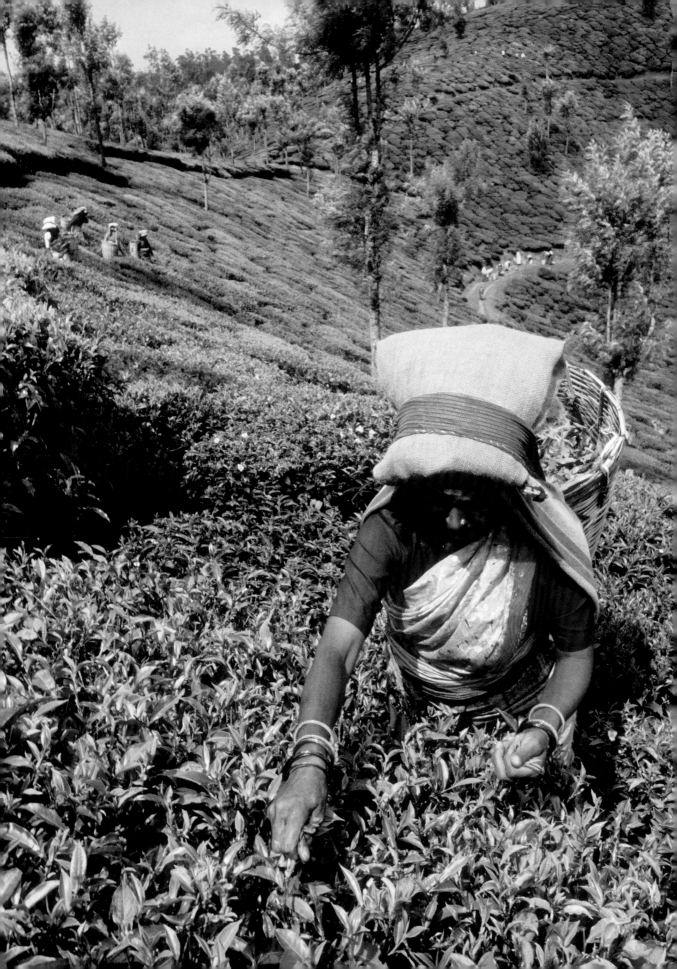

fair trade

a human journey

Goose Lane Editions acknowledges the financial support of the Canada Council for the Arts, the Government of Canada through the Canada Book Fund (CBF), and the government of New Brunswick through the Department of Wellness, Culture, and Sport.

10 9 8 7 6 5 4 3 2 1

Goose Lane Editions
500 Beaverbrook Court, Suite 330
Fredericton, New Brunswick
CANADA E3B 5X4
www.gooselane.com

Graphic design: Josée Amyotte

Endsheets: A palm leaf Christmas star cleverly fashioned by Anita Joychar, an artisan at Keya Palm Handicrafts in Bangladesh.
Page 1: Itanish Wolde and her co-workers at the Negele Gorbitu fair Trade coffee cooperative in Ethiopia sing to keep their spirits up during the long and tedious manual selection process.
Page 2: Harvesting in the Dunsandle tea garden in India's Nilgiri Hills
Page 6: Anita, an artisan with Hajiganj Handicrafts, near Saidpur, Bangladesh

Library and Archives Canada Cataloguing in Publication

St-Pierre, Éric, 1971-
 Fair trade: a human journey / Éric St-Pierre; translated from the French by Barbara Sandilands.

Translation of: Le tour du monde équitable.
ISBN 978-0-86492-673-9

1. Commerce — Moral and ethical aspects — Pictorial works.
2. Price maintenance. I. Sandilands, Barbara II. Title.

HF1379.S2413 2012 382'.1 C2011-907809-0

éric st-pierre

fair trade
a human journey

Text Collaboration: Emerson da Silva
and Mathieu Lamarre

Translated from the French
by Barbara Sandilands

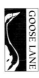

contents

The experience of small-scale indigenous coffee producers in the southern part of the Mexican state of Oaxaca laid the groundwork for the fair trade certified labelling initiative. Sent there to offer assistance by a Mexican Catholic bishop concerned about the poverty and famine rife among the native Zapotec and Mixe people, I came to know and experience their daily reality by picking coffee alongside them.

In 1981, 150 coffee producers gathered in an old church in the heart of the mountains to "take stock" of their communities – lack of roads, houses with no running water, dependency on small local 'barons', who exploited them, keeping them under a yoke that hindered any kind of progress. As a way of changing things, they decided to establish a peasant farmers' organization, the Unión de Comunidades Indígenas de la Región del Istmo – the Union of Indigenous Communities in the Isthmus Region, or UCIRI. In spite of their limited means, and by learning from experience, they got themselves organized. Little by little, they learned to communicate and negotiate directly with the roasting companies. At the same time, in 1985, 17 indigenous communities made the switch to organic agriculture.

Three years later, I visited the Netherlands with a group of small-scale producers with the aim of letting various organizations know that they wanted to do business differently, rather than just receive charitable assistance. These farmers, sitting at the bottom of the scale, knew too well that they could never improve their lot

Fair Trade – A Constant Learning Process

by taking a "western-style" economic approach. In their view, there could be no true development without real cultural change, and perhaps even a paradigm shift; they had to come up with a new way of doing business. In 1988, fair trade certification, with a distinctive label, came to pass, taking advantage of existing "worldshops" networks already in place in several countries.

This was clearly a challenge to the predominant economic model – a model not based on social or scientific ideas but rather on an almost blind faith in the sacrosanct 'laws' of the market and that sometimes seems to be a product of wishful thinking.

Today, neoliberalism and its Holy Trinity – deregulation, innovation and globalization – are facing a crisis, and we are finding out that the trendy notion of 'sustainable development' is, for all practical purposes, an oxymoron. The time is perhaps ripe to rethink our ways of doing things and fight the spread of individualism and consumerism, even if it is not always easy to go against the current.

Fair trade proposes an alternative based on ideas of social justice, product quality and respect for the environment. It is fuelled by a more direct relationship between producers and consumers, who can finally exercise their decision-making power based on a clear understanding of the true costs of production and the real dangers of social and environmental exploitation. Its aim is to encourage involvement and solidarity.

In the mountains of the Mexican isthmus, we have learned a great deal from our efforts.

With the benefit of their experience or perhaps as a direct result of it, peasants are putting forward the concept of 'decent poverty' as a modest but attainable goal. Poverty already possesses its own wisdom, a creativity that enables it to fight death with love and life – and this is not just romantic view. At the same time, along with poverty comes perseverance, from which we can learn a great deal. This is the kind of education that, with the advent of fair trade, has gradually led to societal, cultural and political self-determination. It is hoped that economic self-determination will be next. For this to happen, indigenous coffee producers know they have to get ready for a long and bitter struggle. By not settling for just a market niche, they naturally have to be prepared to confront the established system.

Images that manage to portray the harsh lives of small farmers, right down to their souls, as well as their resilience and their concern about producing quality foods for themselves and others are just as important as long discussions as to how changes can be brought about in a world that is crying out for them. They act like a cure for powerlessness, discouragement and mediocrity and they underline the invincible hope so evident in the landscapes and, of course, the faces of people – men or women, children or the elderly – who aspire to a life with dignity. This book is a sign of hope that another world is possible.

Dʳ Francisco Van der Hoff Boersma
UCIRI Member, Oaxaca, Mexico an co-founder of the
Netherlands' Max Havelaar label

In front of me, in a framed photograph, Rosanalia may well be trying to hide her mouth with her hand, but her eyes are laughing. In her smile is the dignity of the peasants of the Mexican Isthmus, who are courageously fighting the oppression of an economic system in which they are treated like slaves.

Éric St-Pierre took this magnificent photograph during our first visit to the communities of the Unión de Comunidades Indígenas de la Región del Istmo (UCIRI) in 1996. Each time I look at it, it reminds me of the reasons why fair trade exists. It shows me the importance of putting words into action. I can hear Luc de Larochellière singing "J'suis né du bon bord, du bord de l'Amérique, de l'Amérique du Nord" – I was born on the right side, the side of America, of North America. I could have been the beautiful Rosanalia. And then what would I have expected from all those people in the Western world who live in luxury? Charity? No – justice.

After a decade of rapid expansion, the movement is now at a crossroads. Two solutions present themselves: encouraging the fair trade market to grow in volume under current criteria, or perhaps under even more open criteria (notably by admitting plantations into sectors reserved for cooperatives) or nurturing its growth in social and environmental terms, thus turning it into an engine for the development of a truly fair global trading system.

As the stories and images in this book show, there is no simple response. The discussion is a lively one, in both North and South. It's a big challenge to preserve the fundamental values that gave rise to fair trade while making sure that a growing number of small producers, artisans and workers reap its benefits. Each strategy has its advantages and risks. The word 'fair' doesn't resonate in the same way for everyone. This pluralist movement is like a big mosaic; each person contributes the colour and shape that corresponds to his or her own life experience. This is also the beauty of this book, which introduces us to men and women from every continent who,

Foreword

Unidos for Fairer Trade

without knowing each other, are part of the same movement.

Their story reminds us that, despite fair trade's amazing growth, we are only witnessing the first flutterings of the wings of a still fragile butterfly. Fair trade accounts for but a tiny fraction of international trade. Fairness in trade is still the exception. Yet for several decades we have been watching the deterioration of ecosystems and the gap between rich and poor grow ever wider thanks to the bulldozer that is globalized exploitation. It's time not just to hope for fairer trade, but to take action, individually and collectively.

While it is true that buying fair trade products helps make a difference in the lives of thousands of people, this should not blind us to the importance of changing, for the majority of the world's inhabitants and for future generations, the rules of a world trading system that is currently unfair. This change cannot happen without all citizens, whatever our rank in society. We have to convince decision-makers everywhere that fair trade is not just a choice between two products; it has to be a mandatory criterion in every transaction. We will all be winners as a result of this change.

To my friend Éric, I say thank you for having taken this journey around the world so that we can better understand the lives of women and men involved in fair trade. Thank you for lending us your brilliant photographer's eye – an eye that shows us that what is there is also here, and that the other is also us.

Laure Waridel

Sociologist, author and pioneer in fair trade and responsible consumption in Quebec.

▽ Rosanalia Teran Guzmán, from the village of Guadalupe in the state of Oaxaca, Mexico.

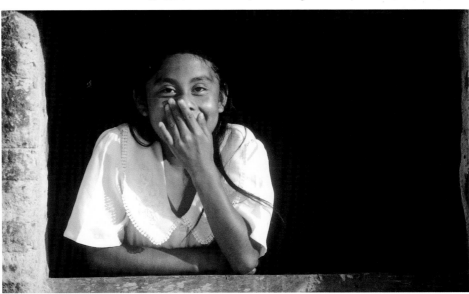

© Adela Guzmán López, a member of UCIRI, in Mexico.

"The equitable, though it is better than one kind of justice, yet is just...(it) is just, but not legally just, but a correction of legal justice." The fact that three centuries before Christ Aristotle was already thinking about 'equity' and 'fairness' is a testimony to the timeless legitimacy of these concepts for those with an unquenchable thirst for justice. More than 60 years ago, Christian movements in the United States, the Netherlands, England and France laid the groundwork for what would become today's global 'fair trade' network. From the first 'Worldshops' to the advent of product certification at the end of the 1980s, the fair trade market has taken giant steps to reach its current sales levels of nearly five billion dollars. In 2001, four major fair trade organizations defined the movement as follows:

> Fair trade is a trading partnership, based on dialogue, transparency, and respect, that seeks greater equity in international trade. It contributes to sustainable development by offering better trading conditions to, and securing the rights of, marginalized producers and workers – especially in the South. Fair trade organizations (backed by consumers) are engaged actively in supporting producers, raising awareness, and in campaigning for changes in the rules and practice of conventional international trade.

Not everyone agrees with this definition, which is constantly being rewritten by the movement itself. This movement is not only growing rapidly in economic terms but is also attracting new adherents every day – producers in the South, consumers in the North, industrialists, shopkeepers, students, academics and other national and international decision-makers.

For almost 15 years, as a photojournalist, I've experienced fair trade mainly in the field, among

introduction

families at the grassroots of the system – a fair trade world tour that began in 1996 with Laure Waridel and members of the Unión de Comunidades Indígenas de la Región del Istmo (UCIRI) in Mexico. In the company of Felix, Adela and the extraordinary Francisco Van der Hoff, we worked, discussed, observed and learned. I returned four times in ten years to visit the members of UCIRI. The children have become adults and some have left their villages for urban centres, the capital or even – illegally – for the United States. In its 25 years of history, UCIRI has achieved many results: health services, staple food stores, bus cooperatives, etc., but the price of fair trade coffee has hardly changed since the early days of certification, while Mexico's cost of living has done nothing but rise. Fair trade, in spite of all its virtues, is not a cure-all that by itself can completely eliminate all regional – or global – inequalities.

After documenting coffee in eight countries, I discovered other fair trade commodities – cocoa, sugar, handicrafts, bananas, and others. A total of 14 products in as many countries in South America, Asia and Africa, are all described in this book. My visits add up to nearly 600 days of living among peasant farmers, artisans and other workers. I shared in the daily lives of these families, sleeping under their roofs and sharing their food. From them I learned how to thresh rice, recognize the proper fermentation of a cocoa bean and taste tea, whether green, black or white. I was determined that our cultural and economic differences would not keep us from sharing experiences and getting to know each other. Fundamentally, human beings are not that different, whether they live in the countryside of Burkina Faso or on the high plateaus of Bolivia. Everyone aspires to a life with dignity and a promising future for their children.

I wanted to share through my photographs the respect I have for these men and women. I captured these images as they unfolded before my eyes, letting the magic of light and special moments register on film or the sensor of a digital camera. There are photographs of seedlings, harvests and processing – in many cases you can see the complete chain of production for each product. The chapters discuss the main fair trade products – and even a few lesser-known ones, such as quinoa, shea butter and others still awaiting certification (like guarana). The chapters begin with a historical and mythical – at times even poetic – look at these commodities, followed by a text describing encounters and experiences in the field. Each chapter includes a reference text that provides botanical information on the product in question, comparing its conventional trade with fair trade (a few statistics complete this basic information) and a thematic text box helps to illustrate an important fair trade issue.

Without wanting to redefine fair trade, I believe that this movement must be for and by producers in the South. This book is thus a series of encounters with those at the grassroots, the artisans, small farmers, and plantation workers who struggle against the blind adversity of the global marketplace by walking a path paved with hope and solidarity. Fair trade is not a charitable gesture. Rather, it is a pact for justice with some of the most marginalized people on the planet. In the North, we have power over a large portion of the movement's aspirations. As Laure Waridel illustrated so well in her book *Acheter, c'est voter* – buying is voting – our role as consumers deserves more awareness. And the dignity of the producers deserves more respect.

© Rabaya Begum, an artisan with Biborton Handmade Paper Project, in the south of Bangladesh, rearranges sheets of silk paper that are drying in the sun.

handicrafts

" ...**A** nd on the sixth day, God created Adam from the dust of the earth." So it was that the destinies of earth and man were united by art from the very beginning, even before there was agriculture. In Babylonian myth, clay is fertilized by the blood of a god-demon. The hand of the Great Craftsman shaping clay in His own image is not the only myth shared by ancient cultures at the dawn of History; in many cultures, the beings created later produced works that were not always deemed worthy in the eyes of the original artisan. The boisterous descendants of Adam disturbed the holy slumber and God chose to de-

stroy them in the Flood. But if today we are able to replay these tales in our imagination, it's because we were given a second chance. In Greek mythology, when Zeus sent the Flood to destroy the violent men of the Race of Iron, the task of recreating man fell to Deucalion, the son of Prometheus, and Mirrha, his wife. This time they used stones – which are after all just clay. In a lost play by Euripedes, Prometheus himself takes on this task by modelling new men from the abundant and still fresh clay left after the Flood.

In every culture, at the time of creation and later, when man has been given a second chance, God has always been the craftsman-producer of the first added value. The breath of the Word created history – the universal debate about creation and the right to enjoy the wealth that can only be produced by fruitful labour. Thus it is hardly surprising that, at its inception, fair trade promoted objects created by artists and artisans working together in a worldwide solidarity project. 'Solidarity trade' was the term used to describe the first initiatives in what is now called 'fair trade'. The sale of handicraft products in Bangladesh is an important milestone in the history of this movement. You could say that the fair trade sun also rose in the East.

|||

The sun is rising over the Bagdha River, in the Agailjara region in the south of Bangladesh. Already the countryside is full of farmers, fishermen, schoolchildren and many rickshaws. You can feel life breathing all around you. I am in the planet's most densely populated country, with more than one thousand people per square kilometre. At the Charity Foundation's small workshop, women arrive one by one dressed in colourful saris. It's an unassuming place: a roof, braided mats on the beaten earth floor, fans in the ceiling and small wooden benches surrounded by multicoloured fibres. The women sit in a circle, each working at her own rhythm weaving baskets. They are paid according to the type and number of items produced, from 2,000 to 2,500 takas per month ($30-$40). This is what a middle manager in a rich industrialized country is paid for one hour of work, but for these women it is enough to put food on the table, as well as to clothe and educate their children. "Now I can give my children three meals a day, and even have a teacher come to the house to help with their lessons,"

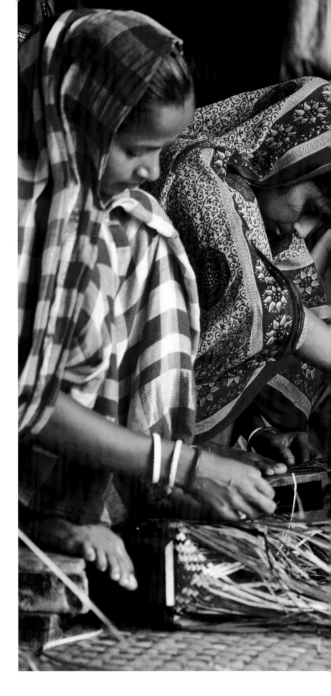

explains Hanufa Begum, who has been working with the Charity Foundation for eight years and was recently promoted to supervisor. "When my husband died, I was three months pregnant with my second child. After the birth, I started working here."

Hanufa's story is just like Salina's, Shefali's, Gita's and Sanjita's – single mothers, sometimes barely 25, but for whom a second marriage remains highly unlikely in their cultural context.

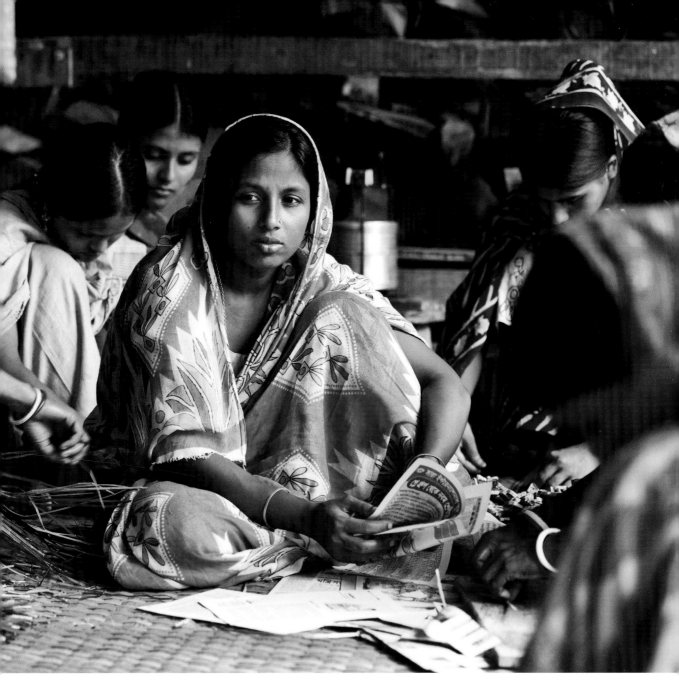

⌂ Hanufa Begum, a supervisor with the Charity Foundation.

"At first, we weren't directly aiming at women, but rather at the most destitute and vulnerable in Bangladeshi society," explains Doug Dirks of the Mennonite Central Committee (MCC), a North-American organization that established many international aid programs in Bangladesh in the early 1970s. The country had just emerged from its war of independence from Pakistan. "Each time, it was suggested we approach women in the country's minority communities –

Hindus in the South and Biharis in the North – and especially single mothers, who had even fewer opportunities for work and greater needs." Over the years, MCC's work in Bangladesh has led to the creation of dozens of artisans' organizations all over the country; these organizations have been able to take advantage of MCC's Ten Thousand Villages stores, in Canada and the United States, among other networks.

THE HANDICRAFTS SECTOR HOLDS A VERY SPECIAL PLACE in the history of fair trade, since it embodied the very first germ of an idea, perhaps even an egalitarian philosophy, sown – according to legend – inside the trunk of a car!

The adventure began in 1946, with the action of a humble volunteer from the American Mennonite Central Committee (MCC) visiting Puerto Rico. Enthralled by the intricate needle work done by local women but equally concerned by their level of poverty, Edna Ruth Byler decided to take home with her to Pennsylvania some samples that she would sell directly from her car to women in the community. This had the proverbial snowball effect and resulted, twenty or so years later, in the establishment of a network of boutiques called SelfHelp. By 1996, the network had grown so large that it was renamed – there are now more than 130 Ten Thousand Villages stores in North America.

But since one good idea soon leads to another, equal credit is given to a similar step taken in Europe by the English organization OXFAM at the end of the 1950s, in this case the promotion of handicrafts made by Chinese refugees in Hong Kong. In the subsequent decade, various Dutch organizations followed their lead, coming up with the Third World Shops concept. The first European shop opened in 1969. The proof that alternative trade is neither a utopian vision nor a string of isolated cases was underlined as well at the second session of the then relatively new United Nations Conference on Trade and Development (UNCTAD) in 1968. This was where the slogan 'Trade, not Aid' was launched, sending a message from disadvantaged countries that trade (preferably fair) is better than charity.

Like a spider weaving its web, fair trade in handicrafts has threads stretching all over Europe and North America. Networking by its advocates soon led to the birth, in the 1970s and 1980s, of many national organizations. These joined together a decade later, forming international structures such as the World Fair

1946 Edna Ruth Byler sells pieces of embroidery done by women in Puerto Rico.

1968 United Nations Conference on Trade and Development (UNCTAD) in Delhi.

1969 The first Third World Shop opens in Europe (Netherlands).

1946

Trade Organization (WFTO), formerly the International Fair Trade Association (IFAT), which brings together 350 fair trade organizations, in the North as well as in the South.

The trail blazed by the handicraft sector would logically open the door to trade in food commodities, starting in the Netherlands with sugar at the end of the 1960s and followed by coffee in 1973. Over time, this totally different sector showed a potential for growth that changed the perception (and interests) surrounding fair trade. The appearance in 1988 of the Max Havelaar label for certifying products – and its emulation – really opened the floodgates and increased tenfold fair trade's visibility in the eyes of the wider public.

"In the North, our members have developed the food market sometimes to the detriment of handicrafts," suggests Paul Myers, President of the WFTO. However, he has every intention of tearing down the walls surrounding the handicraft sector, a process that greatly benefited coffee, tea and other products. "In the South, our groups of artisans ask us to find more markets. So we are going to create a label for them, similar to what's being done for food products." Perhaps this will put handicrafts back in the forefront of fair trade.

$ 5 billion

⊡ Action Bag, in Bangladesh, makes bags, as well as other jute and cotton items.

1988 Max Havelaar Netherlands, the first fair trade certification label, is launched.

1997 Fairtrade Labelling Organizations International (FLO) is founded and brings together 19 national fair trade certification initiatives.

2008 Sales of fair trade products worldwide reach five billion dollars.

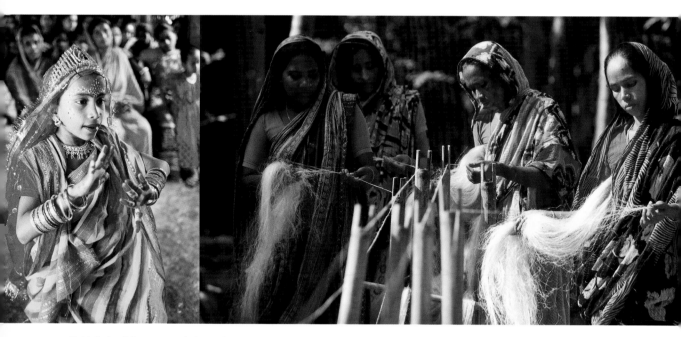

Madhabi Adhikary at Keya Palm's annual meeting. Keya Palm makes decorative objects from palm leaves. ⌐ Shahana Begum and other artisans who work at Bagdha Enterprise spinning hemp fibre. ⌐ After spinning, the hemp fibre is knitted by the skilful hands of craftswomen like Shova Roy. The mother of three children has worked for Bagdha for nine years.

Seven MCC organizations are now grouped under Prokritee, which means 'nature' in Bengali. Prokritee coordinates the design, marketing and administrative support for these businesses. It is May and they are holding their annual meeting. It's a time for taking stock and having fun. Songs, educational plays and traditional dancing are planned. A few children sport elaborate tunics and flashy make-up for their performances. The craftswomen are also awaiting the announcement of the group's profits, which will be shared as annual bonuses. For the roughly 125 women at Bagdha Enterprise who knit jute the year was especially prosperous, thanks to an extra order from their main client. This is very satisfying for Suraiya, Prokitree's dynamic head designer. "A few years ago, we almost had to close Bagdha's doors, sales were so weak," says Suraiya, who looks after her artisans like a mother caring for her children. "For a long time we had been trying to get business from a large company specializing in body care products, but we couldn't meet their quality standard. After a first order of 3,000 bath mitts was rejected, I had to work very hard with the women and the client to keep the contract." The second batch met requirements and orders have grown from year to year, reaching 90,000 mitts in 2008. The resulting bonus is 22,000 takas ($300) per woman, almost doubling their annual incomes.

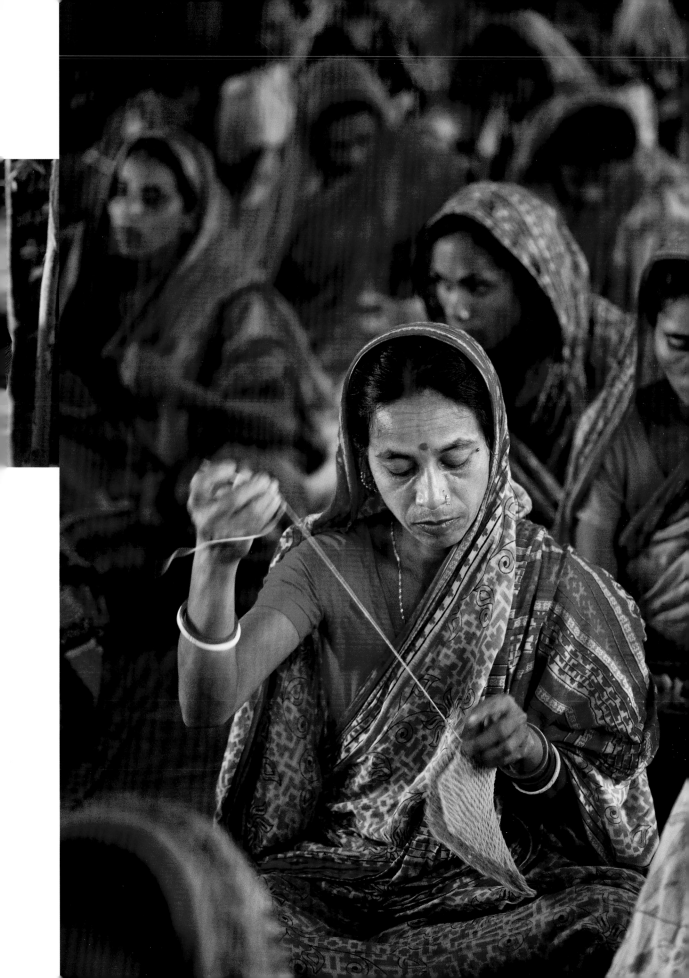

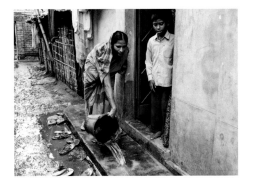

⌃ Nazma, with her son Noshad.

||

Hidden under her black burka, Nazma walks quickly through the narrow alleys of one of the Bihari camps in Saidpur, in the north of Bangladesh. The Biharis are Moslems who left India and its Hindu majority at the time of partition in 1947. More than 20 years later, during the civil war between East and West Pakistan, this group was caught in the middle and neither their country of residence, Bangladesh, nor Pakistan wanted to recognize them. There are now 240,000 Biharis living as stateless persons, marginalized and often in makeshift camps. Nazma finally goes home. When she takes off her burka, she reveals a warm smile. Her house, built entirely of cement, contrasts with those of her neighbours. "With last year's end-of-year bonus and a small loan from my employer, I was able to build my own house," she says proudly. In the main room, measuring barely a few square metres, her two daughters are busily finishing a piece of embroidery. "I used to earn 300 to 400 takas ($5) per month from my embroidery work, but since I've been with Action Bag, I earn ten times more and my daughters have been able to go back to school."

The Action Bag company began operating in the mid-1970s. It was established to produce jute bags, at a time when a campaign against plastic bags was at its height in Europe. "In 1976, with orders from organizations like Gepa, in Germany, we were exporting 25,000 jute bags per month," says Mr. Ghayasuddin, the general manager of Action Bag. "At that time, women received two takas per bag as salary and two takas in savings. When they accumulated 5,000 takas, they could withdraw the total sum and start their own business." Over the years, more than 1,500 women have been able to work in this way for Action Bag, but now the company prefers to hold onto its workforce; today, 75 craftswomen like Nazma are permanent employees and 30 are temporary, within the company.

▣ The Saidpur mosque, founded in 1863.

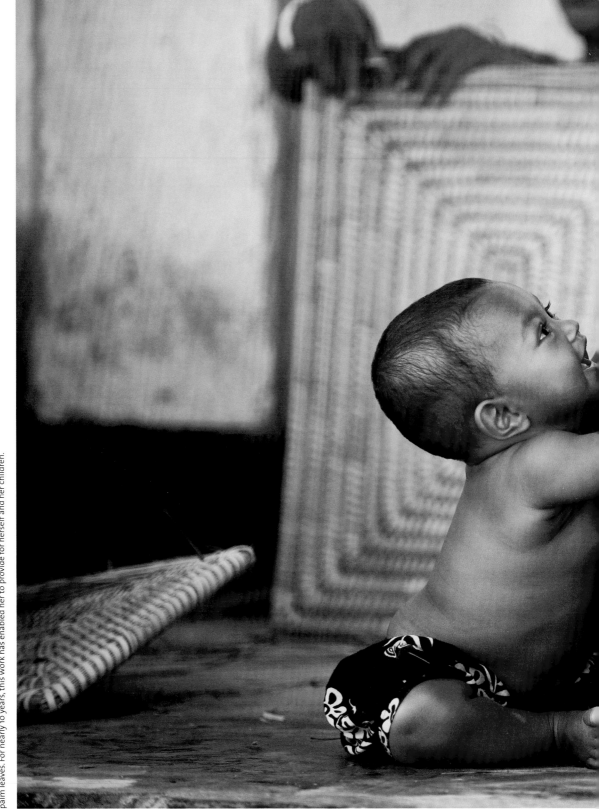

⊙ In Hajiganj Handicrafts' small workshop, located near Saidpur, Rashida takes a few seconds to look after her eight-month-old son Shumy, all the while holding with her feet the lid of a basket made with kaisa grass and palm leaves. For nearly 10 years, this work has enabled her to provide for herself and her children.

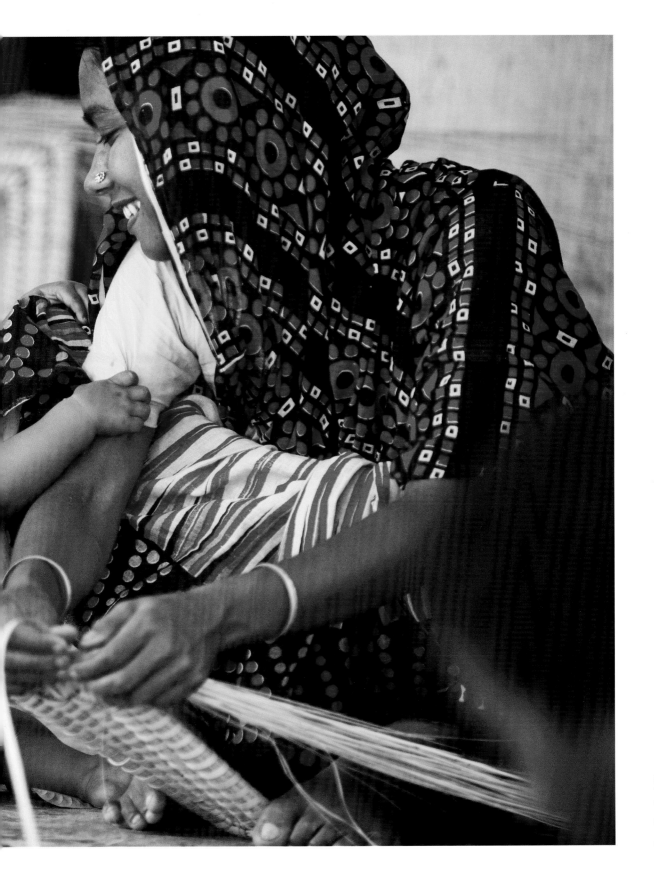

||

One hundred kilometres north of Dhaka, the city of Mymensingh is known for the dearth of motorized vehicles on its streets...but also for its rickshaw traffic jams! In a location downtown, ten or so young Bangladeshi women are gathered. The Mennonite Central Committee (MCC) programs in this urban area of more than 300,000 inhabitants target the disadvantaged of a quite different kind. The women here are neither refugees, nor widows, nor victims of natural disasters. "We often introduce them as survivors," Bita Narua, an MCC Bangladesh community worker, explains delicately. Barely two months ago, these women walked the streets of Mymensingh's red light district looking for clients. "Thanks to assistance from local partners, we've recruited a number of girls, who had to be prepared to leave their old work completely behind to join the program."

Gathered around the meeting facilitator, they recount their painful personal stories, sometimes with laughter but usually with tears. With scars on her left eye and a maturity that belies her 22 years, Shilpi gives the impression that she has lived through a great deal. "When I was younger, I worked as a maid in a wealthy family, where I was raped. We wanted to take the guilty man to court but because my family was poor and they were rich, we didn't succeed," she says,

wiping away a tear. "We were harassed on all sides; my father even lost his job, because his daughter was 'a bad girl'," she says curtly.

Later, in the modest house where she lives with her mother and her three children, Shilpi tells me about her descent into hell. "I remember that my father had to go from door to door to beg for a little rice. I was 15 when he died of a heart attack. That's when I started walking the streets. I wore my mother's dresses, because I didn't have anything to wear." She wipes her red eyes again. "The street isn't a life. You come to an agreement with a client but then you find yourself surrounded by five men. Often, I wasn't even paid or I was beaten." Suddenly, shouts from outside interrupt her story. She says, "Do you hear that? Do you hear that? Those are former clients. They're saying, 'Bangladeshis aren't good enough for you any more? You do foreigners now?'" She gets up to look around outside the house, which is separated from the street only by a few bags hung on a makeshift fence. "I'm afraid for my daughter in this neighbourhood. I wanted to join the [MCC] program to do something different, to give my children a better education so they can find a good job. Tell my story; use my name. I don't want other vulnerable young girls to fall into the same trap. Being a sex worker is not a solution; nobody respects us; we have no dignity in anyone's eyes."

☑ Shilpi and her children. ☑ Fatima visits the neighbourhood she grew up in, where her mother still lives in a makeshift shelter next to the railroad track. ☑ Sacred Mark soaps are sold around the world.

⊡ Shilpi remembering her painful past.

A few minutes' walk from Shilpi's house, in a small workshop, I find another group of young women, all dressed in blue. "These are the first to have joined the program and finished their training. The first semester is devoted to personal training and the second to technical training," says Bita, the community worker. The women are at work mixing palm and coconut oils with other ingredients. On small drying shelves are piles of soaps, labelled by fragrance – *neem*, ginger or lavender. Fatima, barely 18, has a face like an angel. "I was 15 when I was raped by my cousin. My mother threw me out of the house. I left for Dhaka where I was assaulted again. When I came back to Mymensingh, I began working in the sex trade because I was furious

with myself. I had lost everything." Bita notes that Fatima spent a year in Mymensingh's red light district before joining the MCC program and that she is now one of their expert soap-makers.

Assisted by two colleagues, Fatima picks up a stamp and a cube of wax. The wax is melted over hot coals and placed on a bar of soap; the seal, depicting a fingerprint, is then pressed into it. "A fingerprint is a feature that God gives each person; we use it to emphasize the unique identity of those who make our products," explains Austin, the American designer responsible for marketing. "This symbol is also tied in with the brand name of our soaps – Sacred Mark –, which brings to mind the words of a famous poem by Tagore: 'O let me wear secretly (...) the sacred mark impressed by Your own hand'."

The writings of Rabindranath Tagore (1861-1941), a Nobel-prize winning author born in pre-partition India, not only defined the traits of Indian and Bangladeshi society (notably in their national anthems) but also speak to the fates of the craftswomen of Mymensingh. Since the new life they're building with their hands is a resurrection naturally preceded by death, their affinity for these other fateful words is immediately understandable: "Let me drown, let me die!" Death is not to be feared for "(...) the lake of this resurrection (...) knows no depths."

"I'll never forget the day we celebrated our new life. It was a Tuesday, the ninth of June. We cut a big cake and were given beautiful blue saris," recalls Fatima, her eyes shining. "My anger was gone. I was able to trade it in for something happy," she concludes.

As I write these words, I've learned that Fatima got married in the summer and is still working at Sacred Mark. For her part, Shilpi continues her training as an artisan. Both are living this second chance to the fullest and now walk a path paved with dignity.

▷ Inprinted on wax with a stamp, the Sacred Mark symbol, depicting a fingerprint, is a reminder of the unique artisans who made the soap.

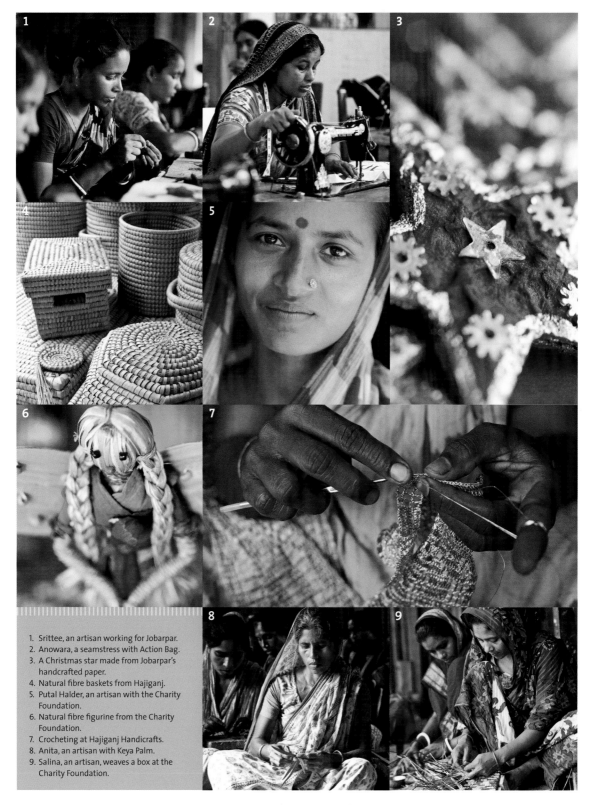

1. Srittee, an artisan working for Jobarpar.
2. Anowara, a seamstress with Action Bag.
3. A Christmas star made from Jobarpar's handcrafted paper.
4. Natural fibre baskets from Hajiganj.
5. Putal Halder, an artisan with the Charity Foundation.
6. Natural fibre figurine from the Charity Foundation.
7. Crocheting at Hajiganj Handicrafts.
8. Anita, an artisan with Keya Palm.
9. Salina, an artisan, weaves a box at the Charity Foundation.

▷ Top : Rita Sarkar, an artisan with Biborton Handmade Paper Project, is making a book out of water hyacinth paper.
▷ Bottom : Nurjahan and Renu Begum gather water hyacinths from a canal in the Agailjara region, in southern Bangladesh.

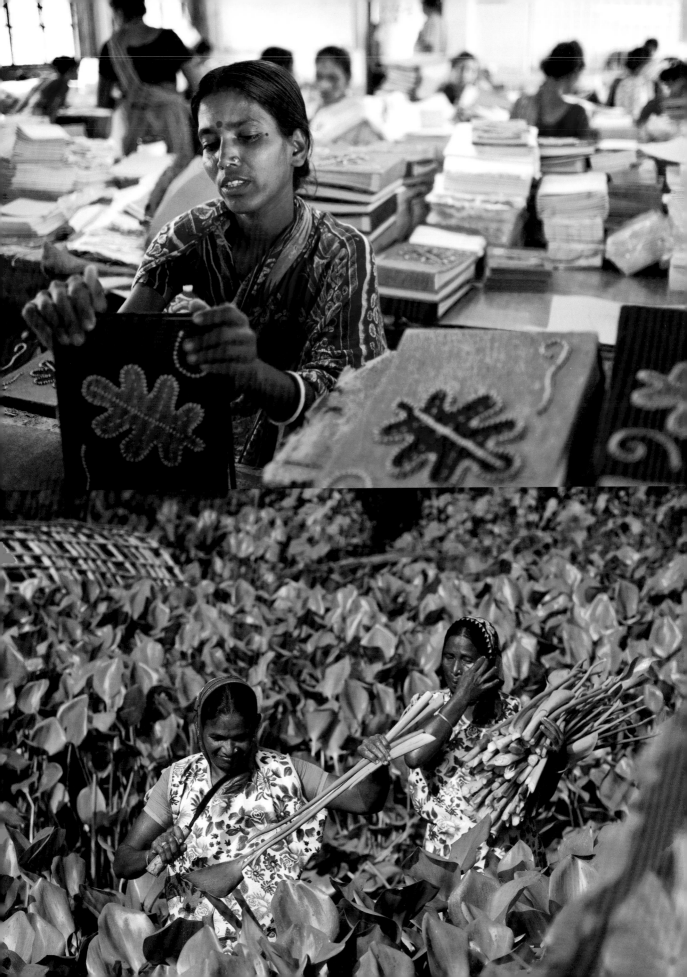

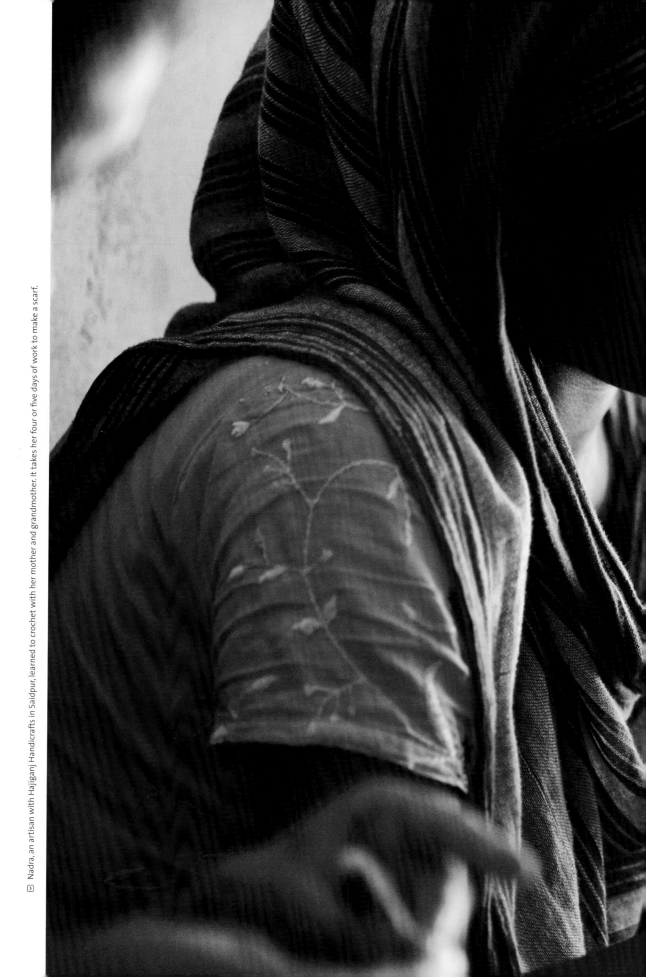

Nadra, an artisan with Hajiganj Handicrafts in Saidpur, learned to crochet with her mother and grandmother. It takes her four or five days of work to make a scarf.

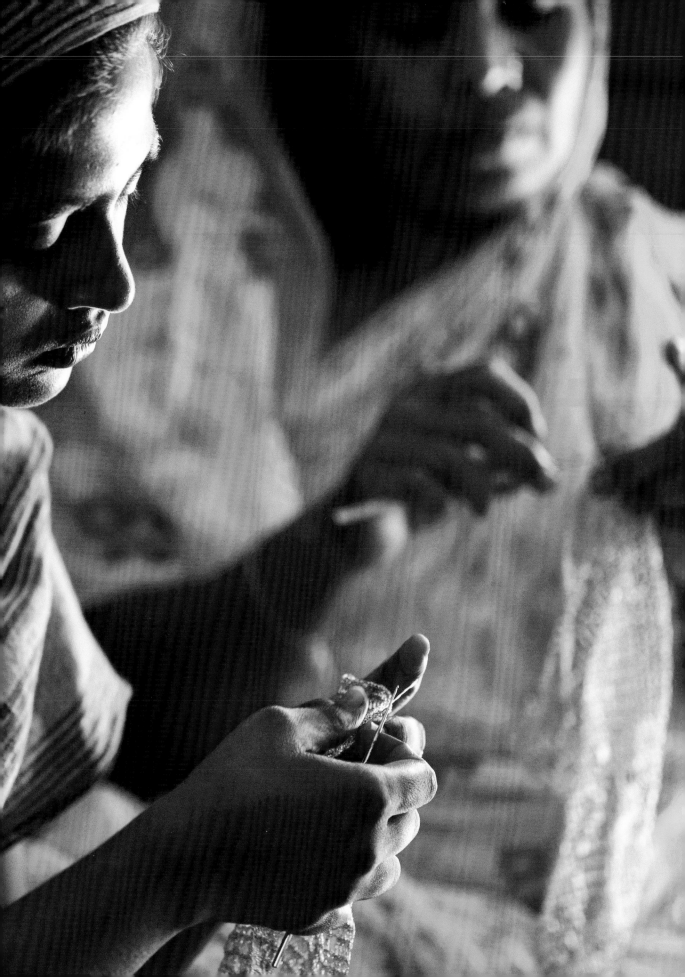

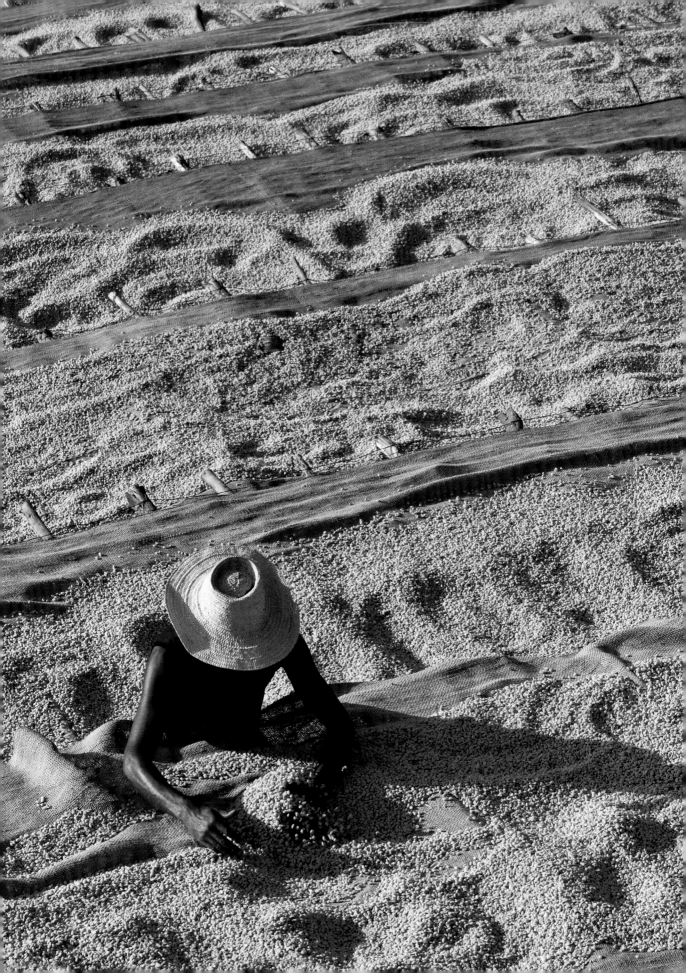

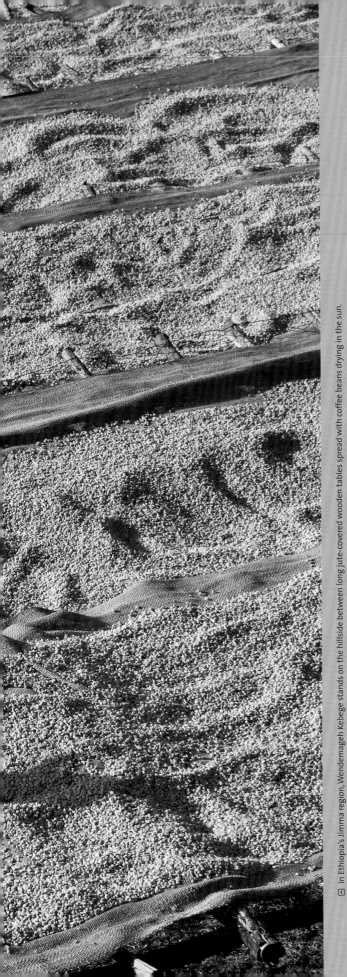

In Ethiopia's Jimma region, Wendemageh Kebege stands on the hillside between long jute-covered wooden tables spread with coffee beans drying in the sun.

coffee

K aldi noticed that his goats were very lively after eating red berries from a bush. This Abyssinian shepherd of the first millennium went on to share his discovery with monks, who found these berries were very beneficial, keeping them awake so they could devote themselves even more to prayer. Coffee was consumed in Arabia from the twelfth century onwards and became widespread in the region, owing in part to Islam's prohibition on alcohol. This was also where growing and exporting coffee beans to North Africa, Turkey and then Europe began.

In the seventeenth century, coffee took passage on colonizing ships to conquer Asia, the Caribbean and the Americas. Today, coffee plants are grown in more than 60 tropical countries and produce more than seven million tonnes of beans, of which 80% are for export. Grown in the South but consumed mainly in the North, coffee is the object of perpetual stock market speculation, during which sacks change hands without ever leaving the warehouse. This contributes to the fact that coffee is often deemed to be the

second largest raw material market in the world, after petroleum.

In Ethiopia, 15 million people are involved in its production, accounting for 50% of the country's export revenues. The highlands of this vast region in the horn of Africa are where the first coffee trees appeared and today are home to more than 5000 native species. However, this paternity was not evident in the botanical name (*Coffea arabica*) that scientists gave the coffee plant in 1753, reflecting its export via Yemen. Near Jimma, in Kaffa province, the arboretum of the Coffee Biodiversity Centre is a mosaic of *arabica* from all over the country. "Each has its own morphology depending on its region of origin," explains Jara Nagash, one of the centre's employees. "Jimma has been designated as the birthplace of coffee because of the wild coffee plants, some of them 200 years old, that are found in its forests. Less than one kilometre away, symbols carved into a large rock bear witness to an ancient trading site; Kaldi the shepherd must have been here!

According to Tadesse Meskala, the founder and director of the Oromia Coffee Farmers Cooperative Union, "Coffee comes specifically from the Oromia region. The word *buna*, which means 'coffee', is the name of a community near Jimma." A mainly rural area, Oromia produces 60% of the nation's coffee. The Oromia Coffee Farmers Cooperative Union was founded in 1999 with 34 members. Today it brings together 129 cooperatives representing 230,000 families. "The producers used to get 30 to 40% of the export price. Now, it's at least 70%," declares Meskala, who can be seen in *Black Gold*, the British documentary about Ethiopian coffee growers and the global coffee market. The Oromia region has some of the most famous coffee-growing areas, such as Limu, Sidamo and especially Yirgacheffe, whose 2000-metre-high hills offer ideal conditions for coffee growing.

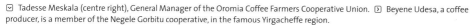

On his small plantation in Yirgacheffe, Beyene Udesa and his neighbours harvest the red fruit from small bushes. "My family has always grown coffee trees," he says. Overhead, several native trees offer shade. Large beige and black Colobus monkeys greet us; as a way of welcoming the new arrival, they remember to mark their territory; "No, it's not rain," one of the farmers tells me. Everyone has a good laugh – even the high-perched primates make noises that could easily be mistaken for giggling.

A coffee plant produces fruit after four years of cultivation and continues to produce for at least twenty years. Green berries are left on the tree awaiting the next round of harvesters. When I look away from the harvesters at work, a movement in a tree attracts my attention. As I approach, I can see the comings and goings of a little bird transporting all sorts of small insects to its brood of hungry fledglings. This performance

Tadesse Meskala (centre right), General Manager of the Oromia Coffee Farmers Cooperative Union. ▷ Beyene Udesa, a coffee producer, is a member of the Negele Gorbitu cooperative, in the famous Yirgacheffe region.

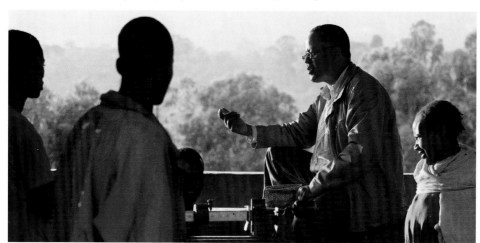

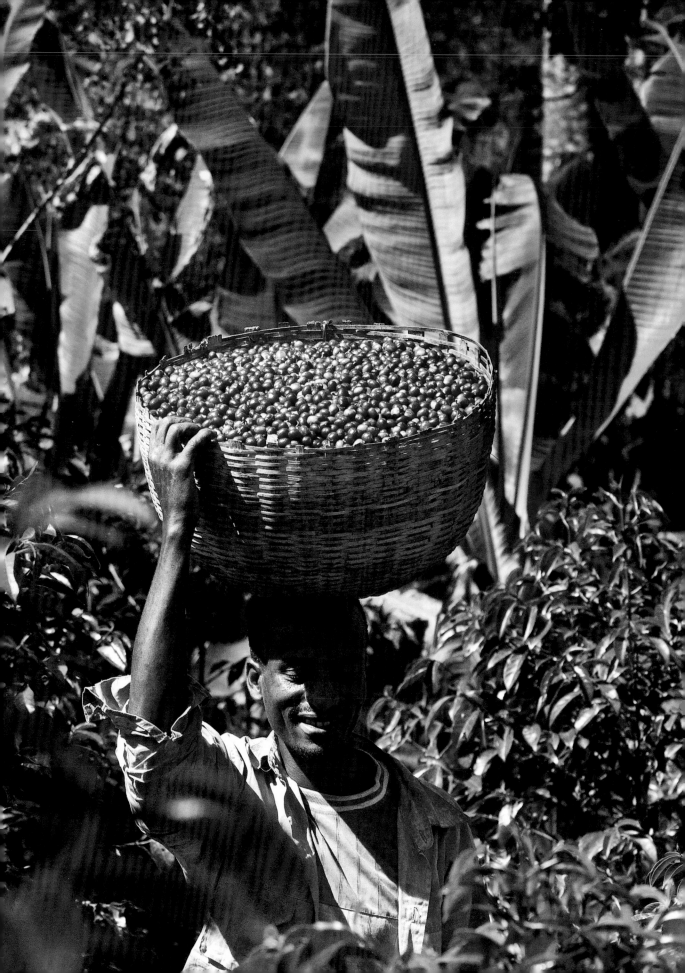

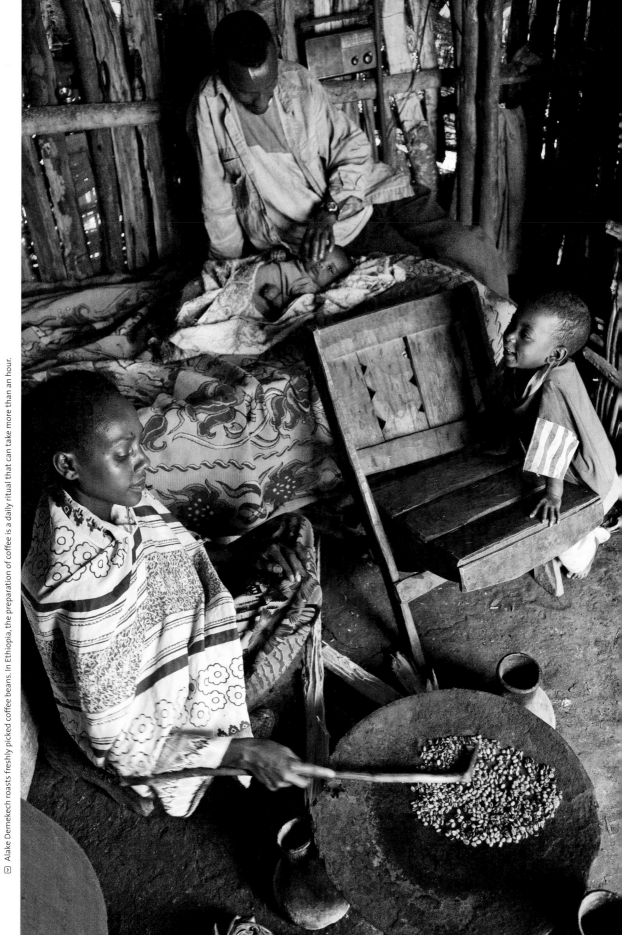

◻ Alake Demekech roasts freshly picked coffee beans. In Ethiopia, the preparation of coffee is a daily ritual that can take more than an hour.

shows the great biodiversity – both animal and plant – that exists in coffee plantations under the forest cover. Regional tree species grow next to avocado, papaya and mango trees. From a distance, it is not obvious that these ecosystems are home to a plantation; the layman's eye sees only a natural forest. In Ethiopia, 400,000 hectares are given over to coffee. In the 60 coffee-producing countries combined, it is estimated that 10 million hectares are under coffee cultivation, or the equivalent of the entire area of Portugal. A large portion of these lands has now been turned into monocultures, harming biodiverse habitats and sometimes even destroying refuges for a great many migrating birds, among other species.

At 11 o'clock, Beyene places a heavy basket of red berries on his head and says, "I'm taking these berries to the house. My wife is going to make coffee for the lunch break." Of all the coffee-producing countries I've visited over the years, Ethiopia has, without doubt, the most elaborate coffee-drinking tradition. Its preparation is a daily ceremony lasting more than an hour and is as common in a peasant hut as in the trendy restaurants of Addis-Abeba.

At the house, Alake, Beyene's wife, takes a large handful of fruit and expertly depulps each berry, squeezing the cherry between her thumb and index finger. From each fruit she extracts two seeds, the coffee beans. When her bowl is full, she places the beans on a large metal plate, adds several pieces of wood to the fire and fans the charcoal. After a few minutes, she removes the beans, slips them out of their hulls and puts them on the fire a second time to roast. With a small stick, she stirs the green beans so they roast evenly. Quickly, the aroma of coffee fills the room, while Beyene plays on the bed with his fourth child, who is barely three months old.

After being thoroughly roasted, the beans are put into a mortar and Beyene picks up the pestle, while Alake puts the earthenware coffee pot on the fire. She will add the resulting powder in small quantities several times over, until the mixture boils. Carefully, she pours the rich elixir into the cups. The oil gradually rises to the surface and I then savour the freshest coffee in the world. "Every day, a different neighbour prepares coffee and everybody gathers to chat and catch up on the news," adds Beyene.

☑ A bird's nest in a coffee tree shows the biodiversity of traditional shade-grown coffee plantations.

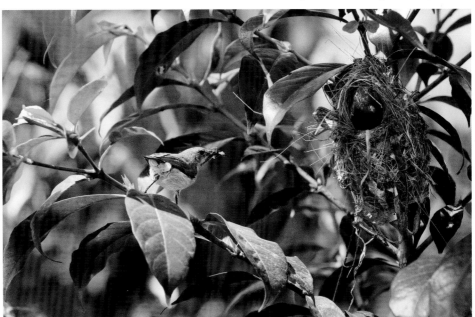

TECHNICALLY, COFFEE IS NOT A 'DRUG' – it is not controlled, nor is its consumption prohibited by any act or regulation. But if we pause and consider the figures surrounding its distribution and adoption worldwide, it can only be defined as 'drug-like' in a figurative sense: seven million tonnes produced by 125 million small farmers and workers, to fill, at the end of the day, 400 billion cups per year.

Sixty different species of the genus *Coffea* belonging to the family of shrubby madders have been identified; of all these, two species divide the lion's share of trade – *arabica* and *robusta* (or *canephora*), along with other less important varieties, such as *liberica* and *excelsa*. *Arabica* has a more delicate aroma, is generally found in cooler moun-

⌃ The flower of the *arabica* coffee plant.

tainous regions and tends to be less productive and more susceptible to disease – but it remains the most widely grown, making up 70% of world production. *Robusta*, favoured by espresso fans, is less temperamental as to the land it is grown on and produces more; its beans take longer to ripen and have a higher caffeine level.

In general, demand and prices for *arabica* are higher than for *robusta*. Jamaica's Blue Mountain and Hawaii's Kona are, of course, famous names for *arabica*, but it is a very special variety of *robusta* that takes the honours for the most expensive coffee. Sold for $350 per kilo, the beans of Indonesian Kopi Luwak actually have to pass through the digestive tract of a civet – a small native mammal – before purists deem them worthy of glory.

Nearly three-quarters of the world's coffee plantations are small in scale. Individually, none of these small players carries much weight in a market nearly 70% controlled by five multinationals and governed by the speculative laws of major stock markets. In both New York (for *arabica* prices) and London (for *robusta*), coffee prices are notoriously volatile. Strong growth in Brazilian production and the thunderous arrival of Vietnamese *robusta* are cited as the reasons for recent overproduction and declining tariffs.

Happily, the advent of fair trade in the coffee world has made it possible to limit the damage to small producers in cooperatives who have chosen this alternate path. By ensuring advantageous conditions for small farmers, the sector has developed loyalty among suppliers in the South, while its effort to create awareness among consumers in the North has reaped growing dividends. When it threw itself into the commercial arena of the second most traded raw material in the world (after petroleum), the fair trade movement gave coffee top billing and made it the flagship product for certification.

coffee in figures

CONVENTIONAL TRADE

Global production: 7,792,960 tonnes
Global trade: $11,075,000,000

MAIN PRODUCING COUNTRIES

Brazil	27%
Vietnam	14%
Colombia	9%
Indonesia	9%
Ethiopia	4%

FAIR TRADE

Year of certification: 1988
Global imports: 65,808 tonnes
Retail sales: $1,784,230,000
Growth (2007-2008): 14%

CERTIFIED ORGANIZATIONS

291 small producers' organizations in 25 countries.

ORIGIN OF CERTIFIED ORGANIZATIONS

Mexico	16%
Peru	14%
Colombia	12%

MAIN IMPORTING COUNTRIES

	Imports (t)	Growth (2007-2008)
United States	24,141	7%
United Kingdom	9,642	16%
France	7,116	8%
Canada	5,029	49%
Germany	4,787	10%

PRICES AND PREMIUMS

Fair trade price: washed *arabica*: $2.75/kg; washed *robusta*: $3.31/kg
Fair trade premium: $0.22/kg
Organic premium: $0.44/kg
Proportion of organic coffee: 48%

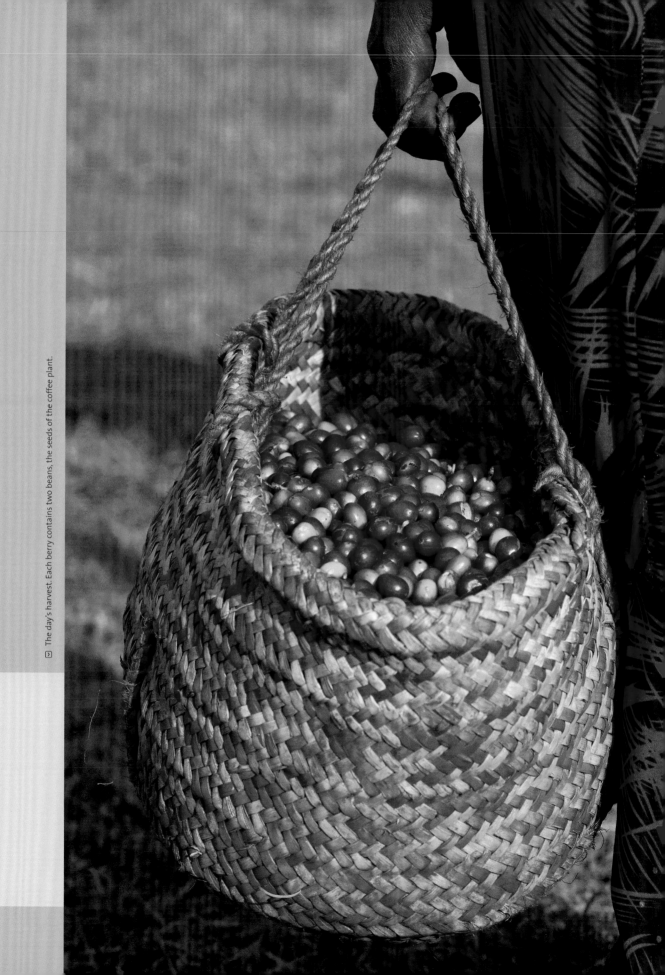

The day's harvest. Each berry contains two beans, the seeds of the coffee plant.

At the end of the day, Beyene takes the harvested berries to Negele Gorbitu's small cooperative. At the coffee-washing facility, men and women are bustling around. Some are at the mill where the cherries are depulped, others stir the contents of large fermentation vats and still others carry the newly washed beans to the drying stage. The golden beans lie on dozens of long tables covered with jute. Itanish Wolde and his colleagues sing to keep their spirits up during the long and painstaking manual selection process. These beans will be sent to the Union, either for their own external market or for auction in Addis-Abeba. Last year, the Union exported 3250 tonnes of certified fair trade coffee, or less than 5% of the coffee produced by its members. But as the director, Tadesse Meskala, notes, "All of our new clients are in the fair trade market."

The small hotel in Yirgachaffe is a crossroads where buyers and exporters of the golden bean cross paths. Each year, Jean-Pierre Blanc, the director of Cafés Malongo, pays a visit to the organizations he works with. He became involved in fair trade as a result of meeting, at the beginning of the 1990s, Francisco Van der Hoff, a Dutch missionary, founding member of the UCIRI coffee cooperative in Mexico and co-founder of Max Havelaar, the first label for certified fair trade

products. "I understood that this was the way of the future, that there could be no healthy coffee businesses without respect for the producers," Jean-Pierre Blanc explains. "Today, nearly 50% of our imports are certified fair trade coffees." The company, with sales figures in the neighbourhood of 80 million euros, is the leader in fair trade coffee in France.

Two other representatives of a big coffee company have come to meet Tadesse Meskala. They work for Nestlé, which, among its many other activities, controls 55% of the global market in instant coffee, a giant among giants. In 2005, Nestlé received fair trade certification for one of its brands of coffee in the United Kingdom. "This came as a big shock to some, but we had been approaching them for several years," says Ian Bretman, vice-president of the board of directors of Fairtrade Labelling Organizations International (FLO) and director of the Fairtrade Foundation in the United Kingdom from 1997 to 2008. "Nestlé imports many containers annually and we have never had any problem agreeing on prices," Tadesse tells me. Despite much handshaking, Nestlé's representatives categorically refused me an interview.

Francisco Van der Hoff recalls, "I would have preferred that a minimum of 10% be required

The coffee beans are raked regularly to ensure even drying.

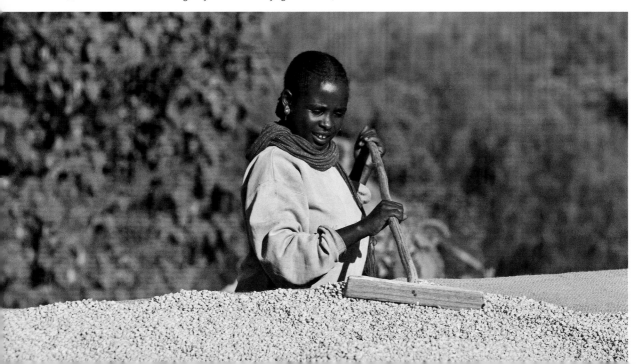

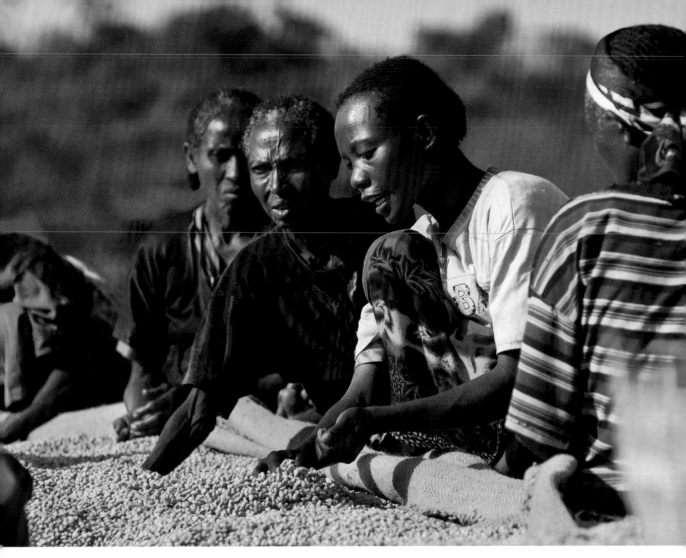

⊡ Itanish Wolde and co-workers at the Negele Gorbitu cooperative manually select parchment coffee beans.

before a company could use the fair trade label, because companies could do a little bit of fair trade just for the image, while continuing to employ unfair practices in 99.9% of their coffee production." According to Ian Bretman, "The initial commitment is not as important as the final result. Today, 100% of Starbuck's espresso coffees in the United Kingdom are certified as fair trade, but this took time." In the world of coffee, Starbucks fires the imagination. Its ten billion dollars in sales amount to just 10% of Nestlé's annual sales, but the Seattle-based company is the leader in specialty coffees (which are increasingly in demand). After having obtained its fair trade certification in 2000, Starbucks roasted 9000 tonnes of fair trade coffee in 2008 – just 5% of its imports – but this amount nonetheless makes it the largest fair trade coffee distributor in the world, with 15% of the market. In 2009, the company

committed itself to increasing its fair trade imports to 20,000 tonnes.

Starbucks' commitment to fair trade is the end result of many battles. Ethiopia was at the centre of one of them. In 2004, Starbucks filed an application in the United States to register the name 'Sidamo', also the name of one of the most famous coffee-growing regions in Ethiopia. The Ethiopian authorities reacted quickly by filing their own trademark applications for the names 'Sidamo', 'Yirgacheffe' and 'Harar'. Following bitter negotiations, an agreement between the two parties recognized Ethiopia's intellectual property rights to the names. The Ethiopian initiative does not include any direct financial compensation. Ethiopian authorities are counting instead on more widespread recognition of their coffees to increase prices and thus to reflect more accurately the effort the coffee growers put into their work.

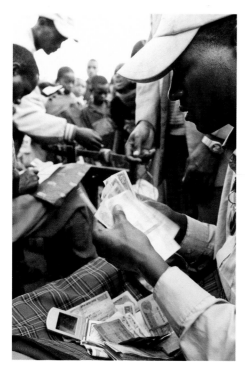

⊡ At the cooperative's coffee purchasing point, birrs change hands.

|||

A few kilometres from Negele Gorbitu is the Hoomma cooperative, with nearly 1,000 members in six villages. At the end of the afternoon, Amara Elema leaves the cooperative with a wad of Ethiopian birrs and his calculator, heading for the village of Buchessa, one of three berry purchasing points. Hundreds of people arrive with heavy sacks on their backs. Three buyers have set up shop in the centre of the village. The fruits are paid for on the spot – nearly 6 birrs/kg ($0.50), or twice last year's price. "It was an exceptional year," Tadesse says. "Once the agreement with Starbucks was signed, local buyers quickly posted higher prices at the start of the season and we followed the trend. Our fair trade clients are aware of the situation and are willing to pay more for our coffees."

Higher incomes mean an increasing number of meat stalls, in a country where raw meat is an important culinary tradition. "During the harvest, oxen are slaughtered every day, but in six months, there will only be *kocho* (bread made

from the 'False Banana') to chew on," Tadesse remarks. We visit the region with Takile, the young manager of the Hoomma cooperative, who continues, "Many people here cultivate rented lands and have to share the income. Some come out of it quite well, but more than three-quarters of the families in the region are poor. Their problems are greatest in July and August, when the coffee money is gone and food reserves are low. Getting a loan here costs 100% in interest."

"Even if the price for berries went up to 20 birrs, it would still not be enough to give all these families and their children a decent standard of living. More education and new work opportunities are needed to reduce the number of people dependent on coffee growing," adds Tadesse. In the group of six villages served by Hoomma, improvements have been made to three primary schools and a medical clinic has been built thanks to fair trade premiums. "Next year, the members hope to build two small stores to sell staple foodstuffs and, if possible, a secondary school; otherwise, the nearest school is 45 kilometres away!" Takile tells me. Back at the Negele Gorbitu cooperative, the village's elementary school teachers are proud to show me their four new classrooms. In total, the union's certified cooperatives (28 out of 129) have built more than 20 primary schools, four dispensaries and 36 fresh-water wells with their fair trade premiums.

Realizing where our consumer goods come from and giving credit to the work done by those at the grassroots level are some of the founding principles of fair trade. Fair trade certification directly supports more than a million producing families. Sales of fair trade products now reach five billion dollars each year. The fair trade market may not create enormous wealth in the South, but often it makes the difference between abject poverty and dignity, between disillusionment and hope. "There is nothing wrong with poverty; it's exploitation that is unacceptable," Francisco Van der Hoff says, reaffirming evangelical values that should not be mistaken for the support of a status quo based on injustice. "Fair trade is not a question of charity, but of justice," *'el padre'* concludes.

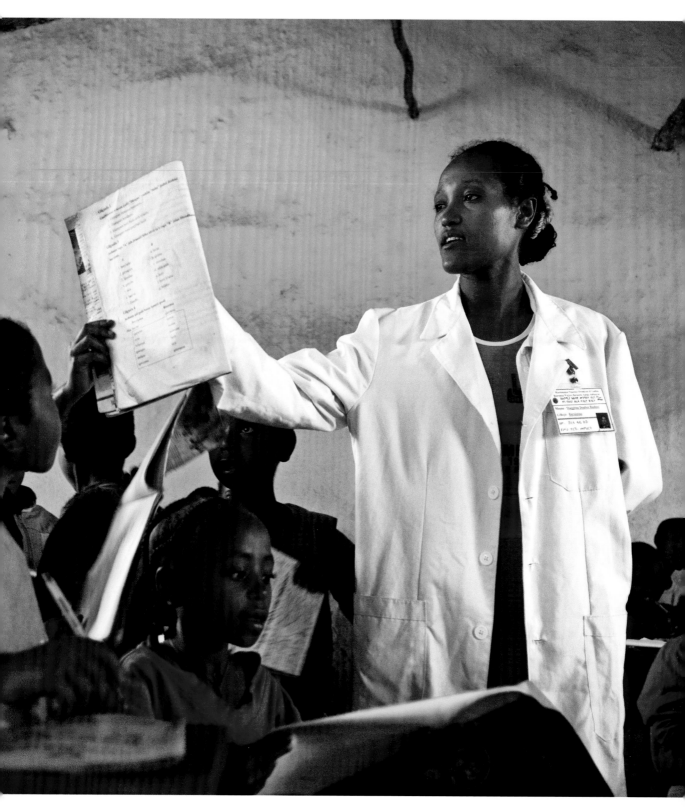

Shegitu Dube is a third grade teacher in Negele Gorbitu's primary school. Six hundred students attend the school, where four new classrooms have been built thanks to the cooperative's fair trade premiums.

I N 1985, WORKER-PRIEST FRANCISCO VAN DER HOFF met up with his countryman Nico Roozen, an economist working with the international aid organization Solidaridad. Seated at a table in the Utrecht train station in the Netherlands, the two men mapped out a framework for fair trade certification; it was a pivotal moment in the movement's history. For small-scale producers and their cooperatives, certification means guaranteed minimum prices covering production costs, development premiums, pre-financing on demand and healthy environmental management. For the consumer, it gives the product legitimacy and indicates its true socioeconomic value. "The criteria were written on a table napkin…that still exists!" recalls Van der Hoff. Three years later, the Max Havelaar organization – named after a Dutch literary hero known for battling injustice – was created in the Netherlands. Today, there are 19 national fair trade labelling initiatives under the umbrella of Fairtrade Labelling Organizations International (FLO), founded in 1997.

☐ Labels for fair trade certified products in Canada (top) and internationally (bottom).

"The purpose of certification was to enable fair trade to expand beyond the limits of alternative networks, so as to make it more accessible to a larger pool of consumers," explains the 'father' of certification. Certifying products – and not organizations – means they can be imported by big companies and sold more easily in large retail stores, their labels attesting to their fair trade credentials.

The growth of the movement has been spectacular (1300% between 2000 and 2008), but there are also criticisms; the dominant role of FLO certification and the increasing participation of multinationals worry many. "Our rules are strict and the same for everybody; we continually raise the bar on our requirements for distributors of fair trade products," FLO's Ian Bretman assures us. "We are not just a certification organization like the others; we are a development organization using certification as a tool."

After twenty years of certification, fair trade has accumulated some convincing successes. "Fair trade coffee accounts for 22% of the market in the UK; in Finland, 20% of pineapples are certified and in Switzerland, 53% of bananas sold are fair trade," Bretman reminds us. Currently, FLO certifies more than 6000 products made by 746 producers' organizations and sold by 2700 companies, resulting in retail sales estimated at nearly 5 billion dollars. "Our challenge is to continue to grow for the benefit of producers in the South, without jeopardizing the integrity of our principles," he concludes.

"The purpose of certification was to enable fair trade
to expand beyond the limits of alternative networks, so as
to make it more accessible to a larger pool of consumers."

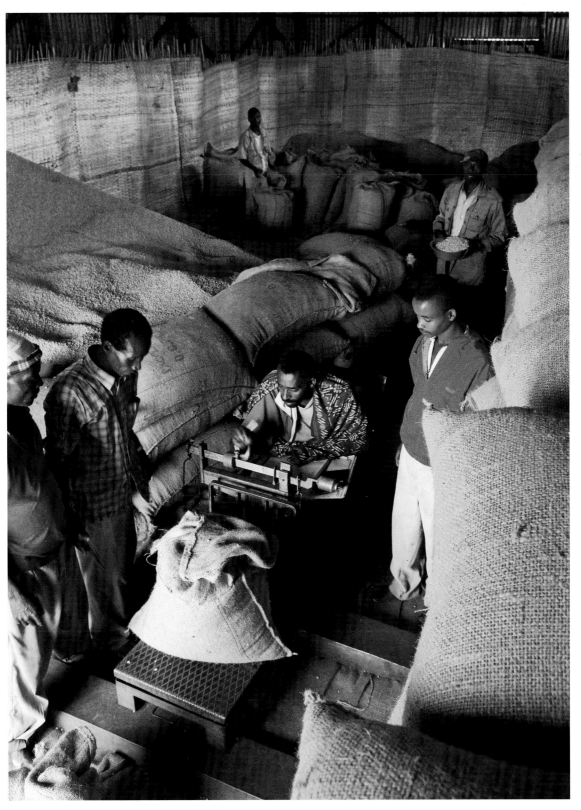

⌃ It's weighing time in the Negele Gorbitu cooperative's small warehouse.

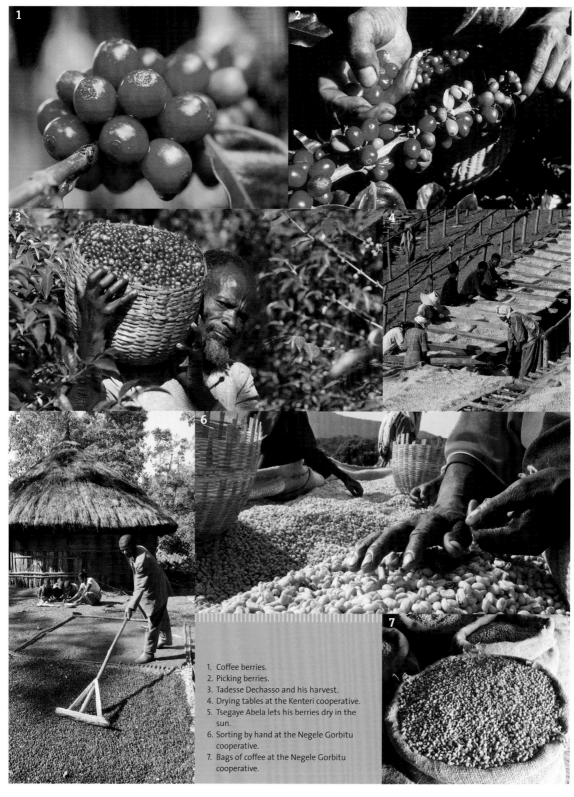

1. Coffee berries.
2. Picking berries.
3. Tadesse Dechasso and his harvest.
4. Drying tables at the Kenteri cooperative.
5. Tsegaye Abela lets his berries dry in the sun.
6. Sorting by hand at the Negele Gorbitu cooperative.
7. Bags of coffee at the Negele Gorbitu cooperative.

▷ Top : Galgale Shorbu, a member of the Hoomma cooperative.
▷ Bottom : A traditional house in the Yirgacheffe region.

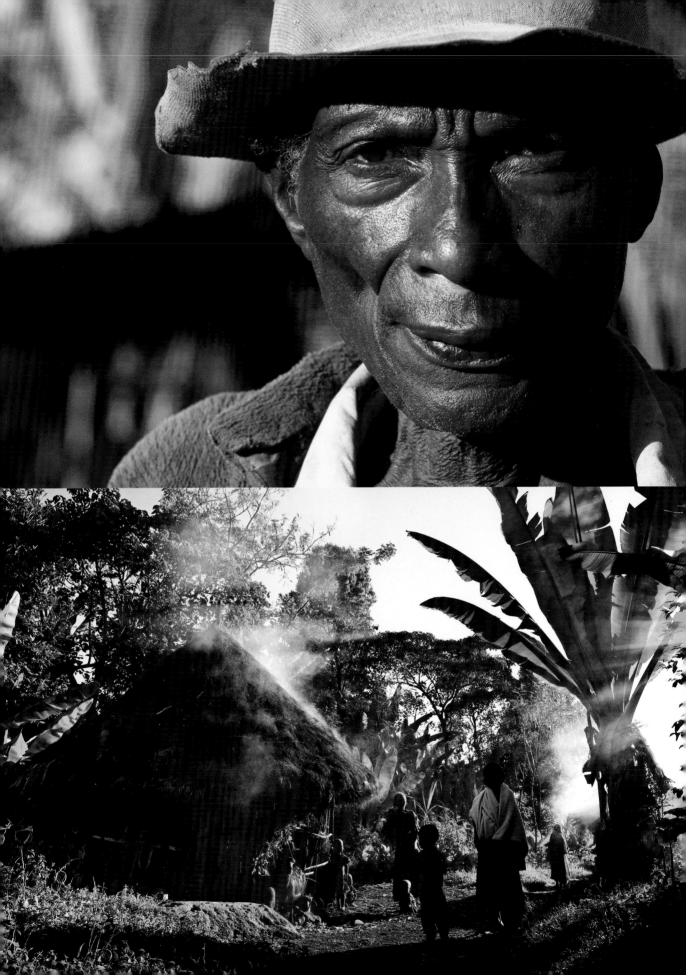

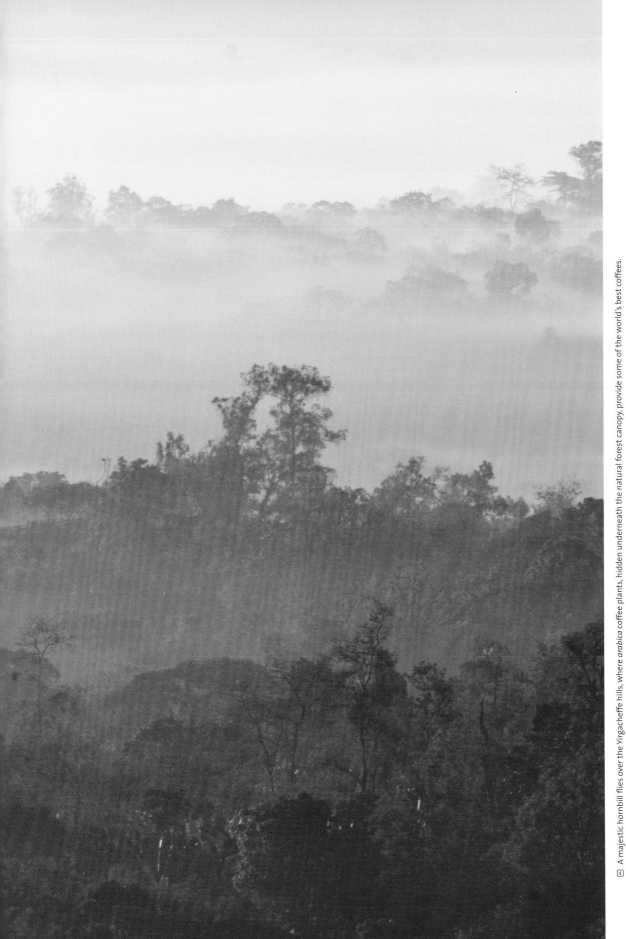

Ⓒ A majestic hornbill flies over the Yirgacheffe hills, where *arabica* coffee plants, hidden underneath the natural forest canopy, provide some of the world's best coffees.

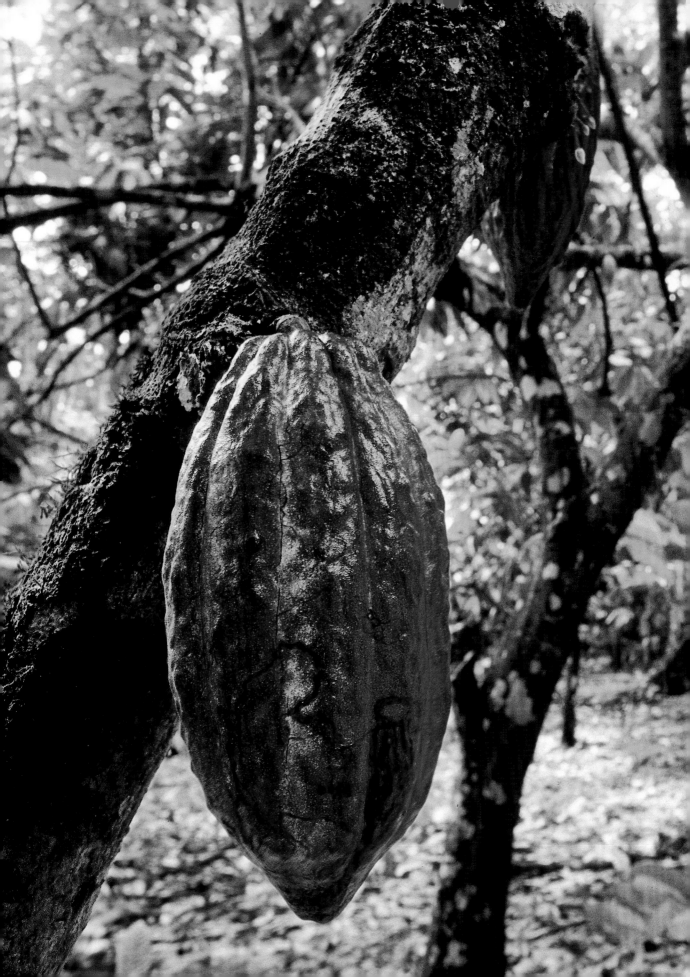

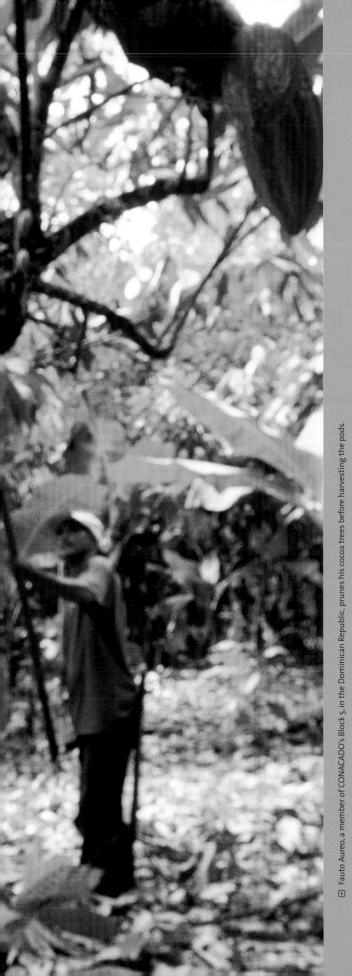

cocoa

Not even the rivers of honey watering the valleys in our most grandiose myths of abundance could make us forget the acrid taste of the malevolent cocoa trade worldwide. The cocoa tree was born out of the blood spilled by a Toltec princess and was therefore infused with bitter original suffering. Toltecs, Mayas and Aztecs made cocoa a central element in their cultures. Widely used as currency, cocoa beans were also roasted and ground on burning hot stones and mixed with water to make a paste, to which were added vanilla, pepper, cinnamon, anise or other spices. This mixture was the basis of a sacred beverage called *xocolatl*, a word created from *xocolli* and *atl*, which mean respectively 'bitter' and 'water' in the Nahuatl language. The 'food of the gods' was therefore quite bitter, but these peoples did not find the dominant taste of chocolate unpleasant, since they believed in an idea of equilibrium in which bitterness was as important as sweetness.

It was quite a different story for the European elite, who mixed chocolate with another product from the colonies that was then equally rare and expensive: cane sugar. Thrilled by the difference in its taste and by its effects, the burgeoning middle class adopted the fruit of the cocoa tree, to the point where it became an essential element in their newly comfortable lives. To satisfy a growing demand for chocolate, large cocoa tree plantations were established on the Abya Yala continent, renamed America. The new masters of the world then raped another continent, Africa, where they found the labour force needed to grow the new crops in the colonies. Much later, it would be cocoa's turn to be exiled to Africa. Today, one third of the world's cocoa comes from Côte d'Ivoire. Along with Ghana and Nigeria, West Africa produces almost two-thirds of this commodity.

||

T he bright red cocoa pod protrudes from the trunk of the cocoa tree. Fauto Aureo, a Dominican cocoa producer, armed with a long pole with a blade on the end, cuts off several branches at the top of the tree. "You have to look after your plantation if you want a good harvest," he says. With roughly 40,000 producers, the Dominican Republic produces 50,000 tonnes of beans annually, around 1% of global production. Above the cocoa trees spreads the natural Dominican forest. From overhead, there is no sign that a plantation is hidden below. Cocoa trees are grown in 25 % of the country's forests; they are concealed in their wooded environment, in contrast with other cocoa-producing regions – notably in Africa, where monocultures have already despoiled 10 million hectares of the equatorial forest, including 13% of the total area of Côte d'Ivoire.

Deforestation is unfortunately not the most serious of the tragedies linked to the cocoa industry. Studies carried out by the International Institute of Tropical Agriculture have revealed the widespread use of child labour – really pure and simple slavery – in the cocoa fields of West Africa, where 284,000 children are forced to carry out dangerous tasks, including handling toxic chemical products like lidane, an insecticide similar to DDT.

Exploited by producers, who are themselves underpaid, these children are caricature-like victims of this unfair arrangement. The cocoa-exporting countries earn two billion dollars from this activity every year, but the chocolate industry in the North comes out of it much better, earning more than 60 billion. Bitter cocoa, produced by small injured hands, is processed by an industry that, ironically, makes a large proportion of its products for children in the North.

||

O n his plantation in the Dominican Republic, Francisco Alcantara examines his cocoa trees to see how ripe the pods are. "Colour is not a guaranteed indicator; it's better to thump the pod to see if it's fully ripe," he says. With a machete, he gently detaches the pod from the trunk of the tree, without damaging the flowers and young fruits. "In December, the harvest is small; all the young pods will ripen until April and then we'll have a lot of cocoa." Once his bag is full, he unloads the pods at a meeting place in the middle of the plantation. Francisco sits down and with a precise movement makes a cut in the pod to divide it in two; the white beans appear in a cluster. Removing beans from their pods takes all afternoon; a white heap piles up in the trunk of a banana tree. "It's time to take it all to the cooperative," Francisco tells me.

Francisco is a member of 'Block 2' of the Confederación Nacional de Cacaocultores Dominicanos – the National Confederation of Dominican Cocoa Producers, or CONACADO. CONACADO is a national federation of eight regional cooperatives (called 'Blocks') consisting of 150 associations and 10,000 producers. "We represent 25% of the country's cocoa producers!" declares Isodoro de la Rosa, the executive director of CONACADO. However, ten years after it was founded (in 1988) and despite its large membership, the federation was exporting just 7% of Dominican cocoa. "Everything changed with hurricane Georges." Georges was certainly not kind when it hit the Dominican Republic on September 22, 1998; the storm caused hundreds of deaths and 185,000 refugees. As for the cocoa industry, the hurricane laid waste large areas, reducing the annual harvest by two-thirds. "It set us back five years," he added.

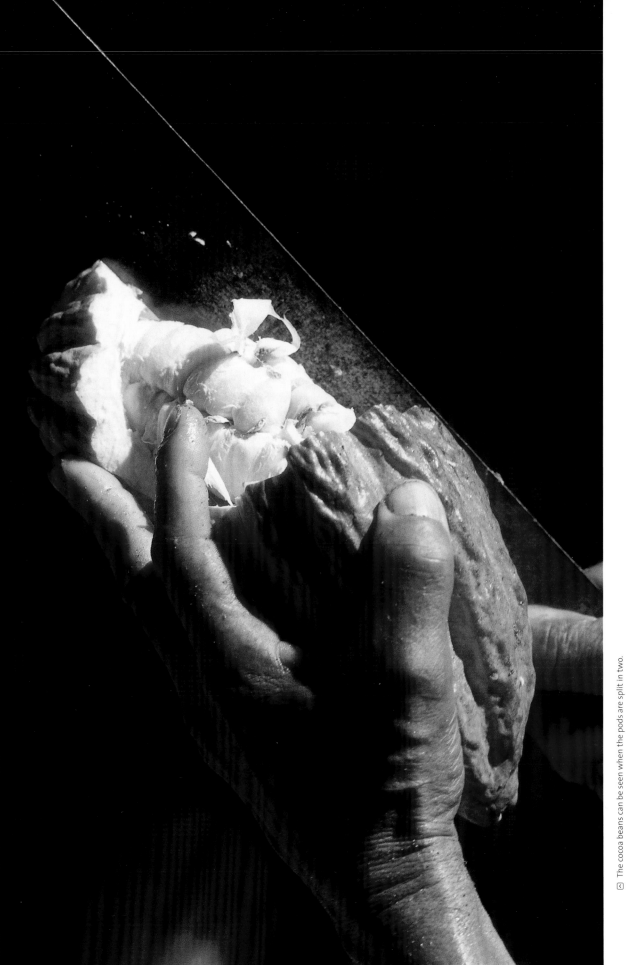

The cocoa beans can be seen when the pods are split in two.

THE COCOA TREE is from the Sterculiaceae family, genus *Theobroma*, which literally means 'food of the gods'. It is a cauliflorous plant, with the fruit growing right on the trunk or branches. The cocoa seed contains caffeine and theobromine. Although it originated in Mexico, the cocoa tree has been introduced into the Caribbean, South America and Africa – where two-thirds of the world's cocoa is produced.

The cocoa economy is highly concentrated. Eighty percent of the chocolate market is controlled by six transnational corporations, three of which are European: the British company Cadbury-Schweppes, the Italian Ferrero and the Swiss giant Nestlé.

Only Brazil and Malaysia produce cocoa using the large-plantation model. It is mostly small producers and their families who are responsible for 90% of world cocoa production. In African countries such as Côte d'Ivoire (the largest producer in the world) and Ghana, growing and selling cocoa is the main economic activity for millions of families, which makes these countries extremely dependent on the commodity's market prices.

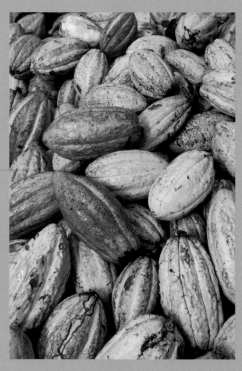

Fair trade cocoa comes from 30 producers' organizations in West Africa, the Americas and the Caribbean. More than 10,000 metric tonnes of fair trade cocoa were exported in 2008. In Canada, 22 million chocolate bars have been sold under the fair trade label. This figure may double with the launch of Cadbury's fair trade Dairy Milk, which will support 40,000 Ghanaian cocoa growers and 6000 small sugar producers.

cocoa in figures

CONVENTIONAL TRADE

Global production: 4,161,631 tonnes
Global trade: $8,380,000,000

MAIN PRODUCING COUNTRIES

Côte d'Ivoire	33%
Ghana	18%
Indonesia	15%
Nigeria	12%
Brazil	6%
Dominican Republic (14th)	0.8%

FAIR TRADE

Year of certification: 1997 (FLO)
Global imports: 10,299 tonnes
Retail sales: $275,300,000

CERTIFIED ORGANIZATIONS

30 small producers' organizations in 15 countries.

ORIGIN OF CERTIFIED ORGANIZATIONS

Peru	27%
Dominican Republic	13%
Côte d'Ivoire	10%
Nicaragua	10%

MAIN IMPORTING COUNTRIES

	Imports (t)
United Kingdom	3,612
United States	1,745
France	1,349
Germany	694
Netherlands	518

PRICES AND PREMIUMS

Fair trade price: $1600/t
Fair trade premium: $200/t
Organic premium: $150/t
Proportion of organic cacao: 48%

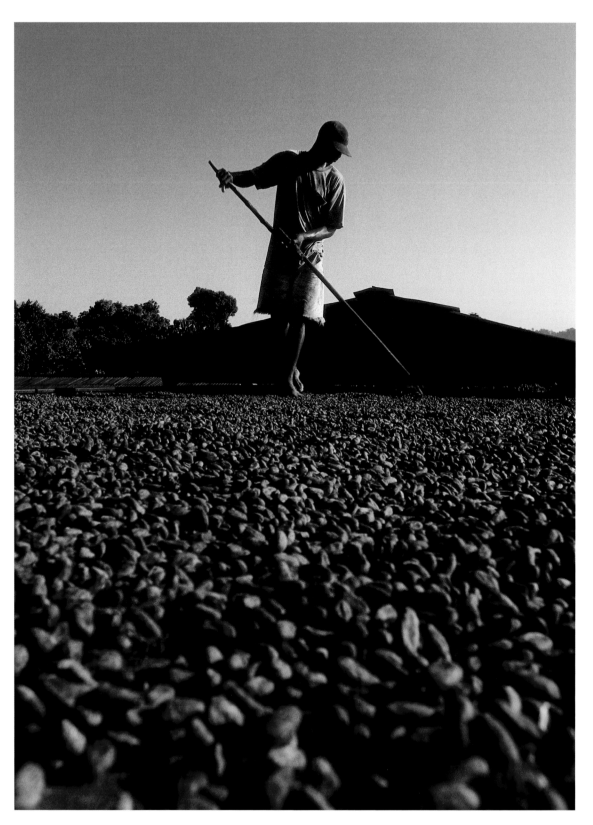

In CONACADO's Block 2, Pepin Gregoria rakes the cocoa beans to make sure they dry evenly.

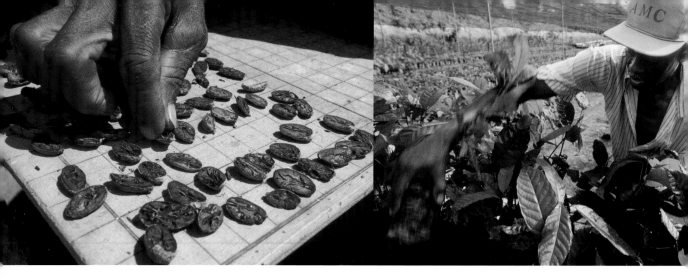

⊡ After fermentation and drying, the beans are checked for quality. ⊡ Roque Pérez Cruz selects his young cocoa plants at the CONACADO nursery, paid for by fair trade premiums.

Before Hurricane Georges, the farmers, who only earn money for a few months of the year, had to use credit in the general stores to buy basic commodities, construction materials and agricultural tools. "Interest was charged at from 3 to 5%...per month! And everything was guaranteed by the future cocoa crop," Fauto Aureo says indignantly – a vicious circle of indebtedness that forced small farmers to sell all or part of their harvest to stores connected with the country's large export companies. After Georges passed through, small producers were unable to pay their debts. The Dominican government therefore set up a program to manage the loans. Although creditors were the first to benefit, the fact remains that small producers were able to get out of debt and were no longer obliged to sell to private buyers. Several producers joined CONACADO at this time. "Not only did we increase our membership, but our producers now sell all of their cocoa to the confederation's cooperatives," Isidoro adds. During the 2001-2002 harvest, by which time Dominican cocoa production had reached three-quarters of what it had been before Georges, CONACADO exported 30% of national production, ranking for the first time at the top of the country's cocoa exporters! "It was an exciting moment, but some people on the island were jealous of us," whispers Isidoro. In Fauto's opinion, the current situation is completely different from that of the past. "If I need a loan for agricultural work, I go to my cooperative and I can get it at a good interest rate."

Late in the afternoon, the farmers arrive one after another at CONACADO's Block 2 warehouses to deliver the day's harvest. The white seeds are emptied into plastic tubs so the quality can be checked. "A few poor quality seeds and the whole batch is affected," says José, the director of the cooperative. "In the past, Dominican cocoa was penalized for its poor quality; it's now a priority to have higher standards." The seeds are then transferred into large wooden boxes for fermentation. It is during this very important fermentation stage that the pulp is removed; even more importantly, fermentation turns the seed into a bean by destroying the embryo and creating the chemical precursors that give cocoa its aroma. Dionisio, one of the workers, lays a few banana leaves on top of the seeds, under the eye of Michel, a European expert who has come to evaluate and advise CONACADO on how to improve the quality of its product. "Traditionally, Dominican cocoa was merely dried – 'Sanchez' cocoa, as it is known here. But 'Hispanola', which is fermented, is in greater demand and earns 10 to 15% more on the world market," Michel explains. Its organic and fair trade premiums make CONACADO cocoa one of the most value-added in the world.

After six days of fermentation, the white mucilage has completely disappeared and the hot and sticky beans are spread on wooden platforms, where they will dry naturally in the sun. The yard behind Block 2 is a labyrinth of these wheeled platforms, whose sheet metal roofs are used to cover up the cocoa in case of a storm. Pepin goes from platform to platform with his rake to stir the beans, so they dry evenly. Over a period of from one to two weeks, the moisture level in the beans will drop from 60% to 8%.

At the warehouse, Dionisio and the other workers take turns carrying the 60-kilogram sacks on their heads. One of the employees cuts the beans from a sample in two and spreads them out on a small board divided into squares. "A brown bean, fully fermented, is top quality, whereas a brownish purple or purple bean is of second or third quality," he explains. "The tolerance threshold for lower quality beans is 5%, no more."

A stone's throw from the warehouses, Roque Pérez Cruz arrives at the cooperative's nursery to pick up 200 seedlings. "Cocoa trees, but also native trees," he points out, while filling up his truck with small shrubs. He wants to reforest the part of his aging plantation that was damaged by the latest hurricane. This nursery was built with fair trade premiums.

⊟ Dionisio Arcangel places a banana leaf on top of the cocoa beans, which will then ferment for six days.

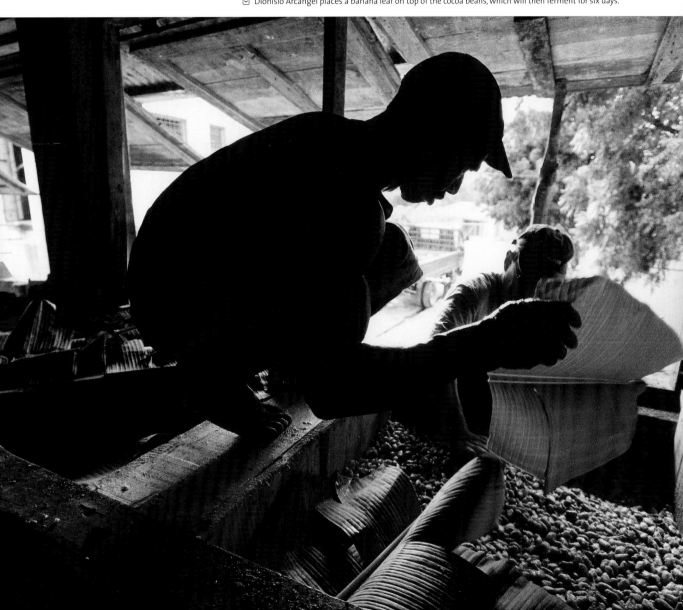

"A FAIR PRICE IN A LOCAL OR REGIONAL CONTEXT IS MUTUALLY AGREED on through dialogue and participation. It covers not only production costs, but also encourages production that is socially fair and respects the environment." This definition is taken from the WFTO's ten standards for fair trade. According to FLO, "The fair trade price ensures that producers can cover their average costs of sustainable production. It acts as a safety net for farmers at times when world markets fall below a sustainable level. Without this, farmers are completely at the mercy of the market."

The cocoa market, listed in London and New York like coffee, is highly volatile and affected by stock market speculation. The volumes of cocoa and coffee negotiated on financial markets are far greater than the quantities actually produced. Natural disasters or even political crises in the principal producing countries have a major influence on prices. Just as frost in Brazil can cause coffee prices to increase suddenly, recent political tensions in Côte d'Ivoire have caused cocoa prices to rise. In November 2009, the price for cocoa was $3,300 per tonne, or more than twice the minimum guaranteed price ($1600), whereas in November 2000, it was $700, less than half the fair trade price.

It's important to understand that the fair trade price is not fixed, but is instead a guaranteed minimum price. When prices exceed the minimum fair trade price, buyers have to pay the higher market price. Producers and clients may negotiate higher prices according to the quality, specific character or other characteristics of the exported product. Organic production guarantees a premium of $200 per tonne in the case of cocoa.

A fair trade development premium is also added to the basic price ($150 per tonne for cocoa), a fundamental tenet for the movement. "These amounts go into a joint fund for the benefit of workers and small farmers, to improve their social, economic and environmental conditions. How these funds are used is decided democratically by the producers," FLO says. More than 60 million dollars in fair trade premiums were paid in 2008.

In addition to the minimum price and the premium, companies that sell fair trade products must pay an advance (60%, six weeks before delivery) when producers' organizations require it. These advance payments are an absolutely necessary way to pre-finance production in many producers' communities where credit is expensive and often unavailable. Pre-financing exceeded 150 million dollars in 2008. In addition, businesses in the North have to sign contracts that allow organizations in the South to plan for the long term and maintain sustainable production methods.

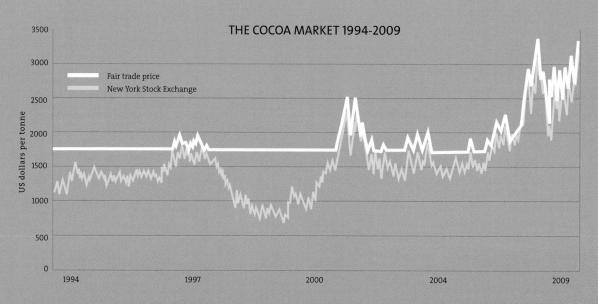

THE COCOA MARKET 1994-2009

Fair trade price
New York Stock Exchange

III

A neighbour of Fauto's, Carida, invites me to taste real home-made hot chocolate. "We have to go to my little house in the woods," she says. With a firm step despite her 71 years, Carida avoids roots and steps over furrows, umbrella in hand. She adds, "I haven't come here very often since I've been living alone." She roasts the cocoa beans simply in a large steel bowl over a wood fire. Crushed by hand in a mortar, the cocoa beans turn into a paste. Once dried, it becomes a hard stick that will last for many months. "I won't use this one today, but I have others in storage," she says. Then she grates a stick and adds a pinch of sugar and some spices, according to the local recipe. On the surface of the brownish beverage, the natural cocoa bean oils slowly ooze out; the aroma is wonderful and the taste incomparable. Carida takes out a tobacco pipe and enjoys a well-deserved break.

III

T housands of kilometres away, another hot chocolate recipe is generating great enthusiasm. In Ottawa, the La Siembra cooperative has been manufacturing Cocoa Camino products with CONACADO's fair trade cocoa since its founding in 1999. In 2006, when CONACADO acquired a bean-processing factory, the managers of La Siembra decided to use the powdered cocoa produced by the Dominican producers in their hot chocolate. "As soon as the opportunity arose, we tried the cocoa from Cafiesa (the name of the factory) and were delighted to discover the quality of the product," explains Henk van der Molen, the director of operations. In addition to fair trade prices and premiums for their cocoa, this decision guarantees the producers a larger portion of the added value. Like the ancient sacred beverage of their ancestors, a food of the gods made by mortals, fair trade cocoa is a celebration of a new and fairer covenant between human beings and the land.

▷ Carida.

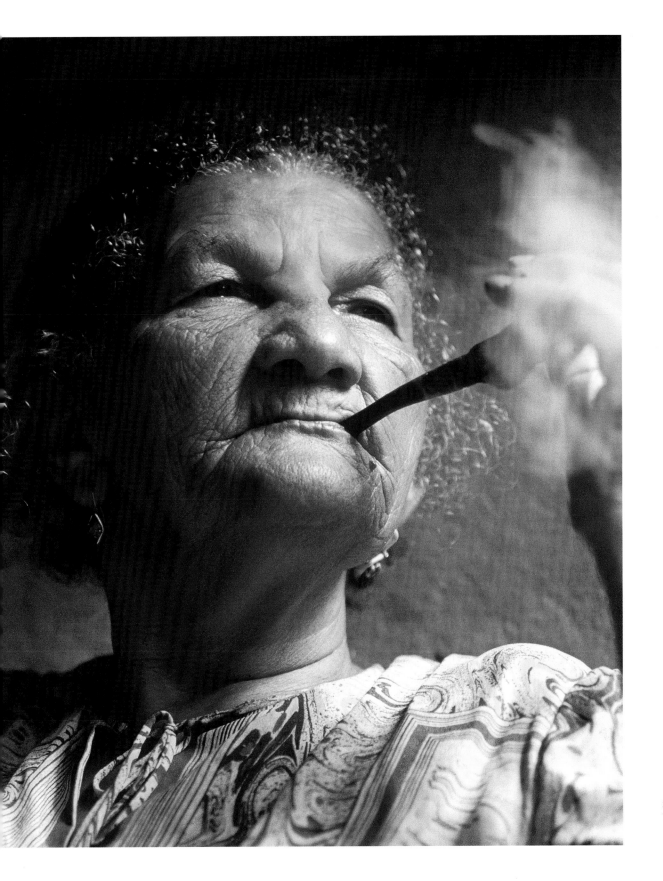

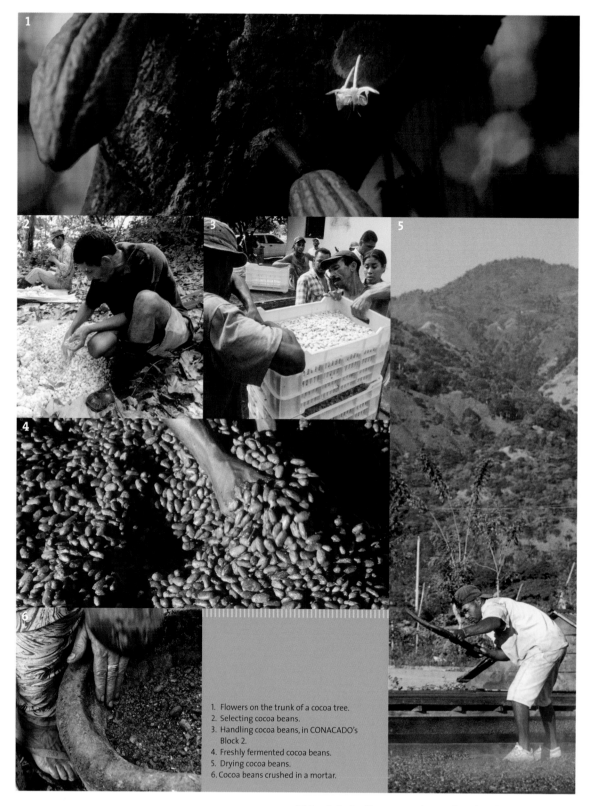

1. Flowers on the trunk of a cocoa tree.
2. Selecting cocoa beans.
3. Handling cocoa beans, in CONACADO's Block 2.
4. Freshly fermented cocoa beans.
5. Drying cocoa beans.
6. Cocoa beans crushed in a mortar.

▷ Top: Carlos Bonilla, a cocoa producer and member of CONACADO's Block 8.
▷ Bottom: Dionisio Arcangel carries 60-kilogram bags of cocoa beans into CONACADO's Block 2 warehouse.

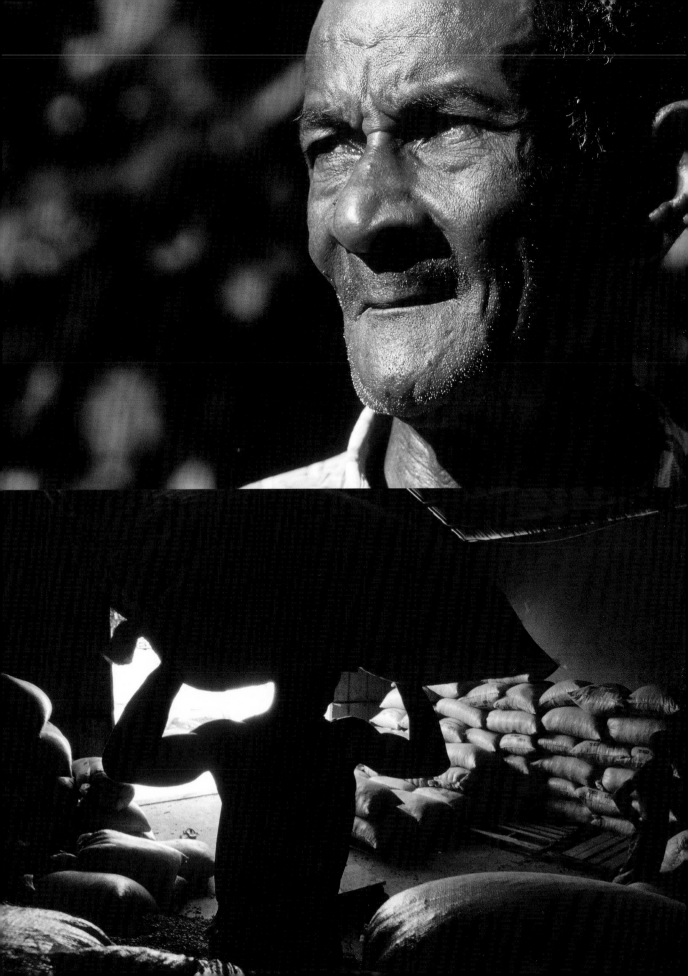

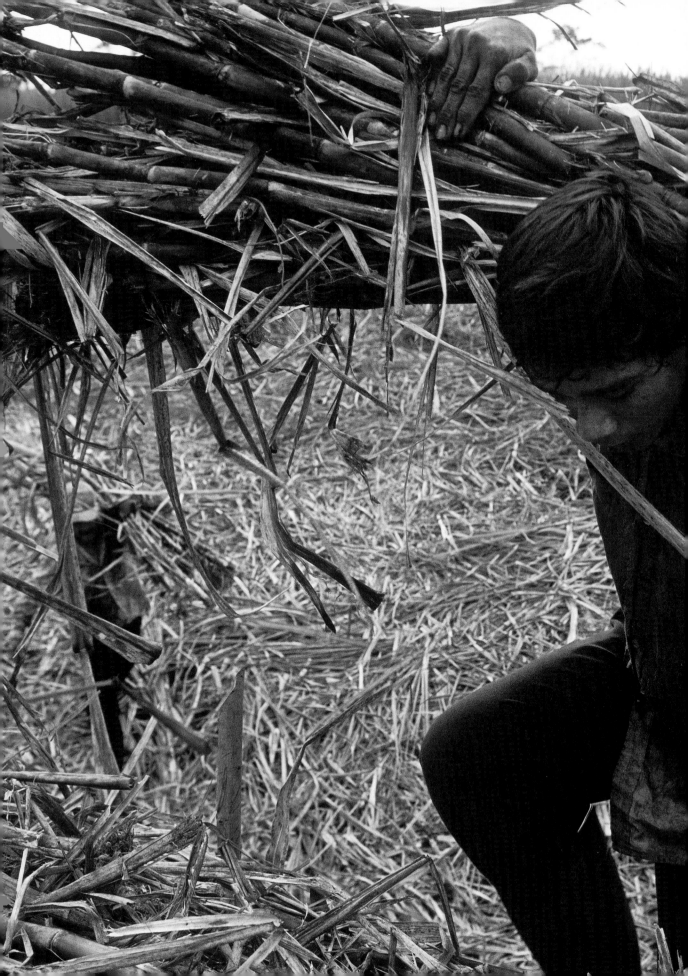

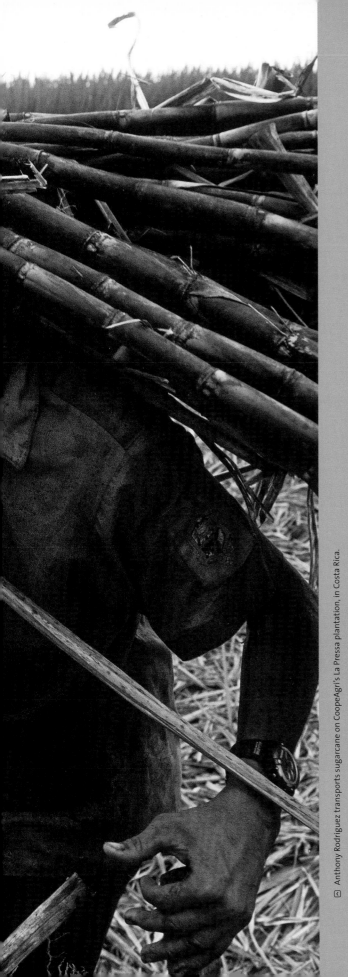

sugar

K âma, the Hindu god of physical love, has a sugarcane stem for his bow. A being of irresistible beauty and infinite gentleness, Kâma's mission is to seduce.

Sarkara in Sanskrit, *sukkar* in Arabic, *seker* in Turkish, *saccharum* in Latin, *zucchero* in Italian, *sucker* in German, *sugar* in English, *azucar* in Spanish, ζάχαρη in Greek, sugar is on every tongue, in every mouth. But the history of this universal substance does not have much to do with fairness and justice. It is impossible to overstate the close ties between sugar and the slave trade. Millions of men and women were sacrificed to produce a powder that from the moment it began to be sold helped speed up the process of wealth accumulation in the new economic system.

Will we ever really know how much ecological damage has been caused by introducing sugarcane cultivation into societies subjected to global mercantilism? Agronomic engineer Narciso Aguilera Marin, a professor at the Granma

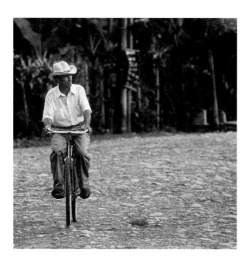

Wilson Conejo Guzmán, a member of CoopeAgri.

agricultural school in Cuba, notes that when the Spanish arrived, 94.5% of Cuba was covered in forests. "Sugarcane monoculture is largely responsible for reducing this cover to only 14% by 1959! It has taken us 40 years to get back up to 24.5%." Understanding the history of sugar and its devastating effects on civilizations may lead us to ask ourselves many other disturbing questions. Why do societies agree so passively to pay the astronomical costs – in terms of public health – resulting from excessive consumption of this product? And how is it that, even today, the world allows the sugar economy to perpetuate production relationships like those endured by Haitian workers in the bateyes* of the Dominican Republic, which bear an astonishing resemblance to the old master-slave relationships of bygone centuries?

In any event, sugar is here to stay, having become an essential product for the entire economy. Building just relationships around this type of production is a major challenge for producers and consumers united in pursuit of fair trade.

||

Wilson Conejo Guzman, proud of his 74 years, rides his bicycle in between two sugarcane fields, in Costa Rica. "For 45 years, I've been riding my bike; that's how I stay in shape," he explains. "There's never a day when I don't ride. My fields are only a little more than two kilometres from my house." Wilson is a member of CoopeAgri, a large cooperative that has been contributing to development in Costa Rica's Pérez Zeledón

||||||||||||||||||||||||||||||||

*Camps where sugarcane cutters live, in the Dominican Republic and Cuba.

A sugarcane plantation in Pérez Zeledón county, Costa Rica.

county for 45 years. Founded in 1962, with 391 members, CoopeAgri now boasts 10,000 members in a region with 125,000 inhabitants. Fifteen percent of CoopeAgri's members produce sugarcane, while the vast majority produce coffee. "I've had coffee and tobacco, but for 11 years I've devoted myself to sugarcane," says Wilson, who cultivates three hectares of sugarcane on his five hectares of land. "I also grow peppers and other vegetables that I sell at the farmers' market on Thursdays and Fridays." On his plantation, this father of six, with several grandchildren, is checking to see whether his sugarcane is ripe. More than two metres tall, cane takes 12 months to reach maturity. His granddaughter, Pamela, her eyes twinkling, joins us in the small field. Her grandfather cuts a chunk of cane, peels it, and gives her a piece, which she eagerly eats.

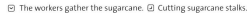

A few kilometres from Wilson's fields, it's harvest day on the La Pressa plantation, owned by CoopeAgri. "Here we don't fire the cane before harvesting," states Miguel Navaro, one of the cutters. Fires are often used to lighten the cutters' workload, but they deplete the soil, lower the quality of the sugar and produce their share of greenhouse gases. "But you have to watch out for snakes," says Miguel, a machete in his hand. The tall reeds are cut, their leaves are removed and they are laid methodically on the ground. The cutters cut the cane a few decimetres from the ground so it can grow back. Sugarcane can regenerate in this way for four or five years before the soil is ploughed and the cane replanted, this time from cuttings.

Metre by metre the cane is cut down, but a lot remains on the plantation's 11 hectares. "We still have a few days to go before finishing," Miguel informs me. Fifty to sixty tonnes per hectare will be harvested here, an output comparable to the world average of 58 tonnes. Sugarcane is grown in 150 countries. Its production worldwide reaches the astronomical figure of 1.56 billion tonnes annually, weighing far more than the entire human population. At the end of the afternoon, Miguel and the other cutters begin to gather up the cut cane and pile it onto trailers. With a heavy bundle of cane on their shoulders, they climb up one after the other on a shaky little ladder to get to the top of the stack.

The cane is taken to the factory for processing the same day. The sooner it is processed, the higher the sugar level will be. Right next to the Peñas Blancas River, the CoopeAgri factory rules supreme in the midst of vast fields. White smoke rises from the facilities. Trailers piled with cane are lined up near the crane for unloading. The cane is fed into the mechanical processing system, where it is cut and put into the grinder to be

⊡ The workers gather the sugarcane. ⊡ Cutting sugarcane stalks.
⊡ Miguel Navaro, on the La Pressa plantation.

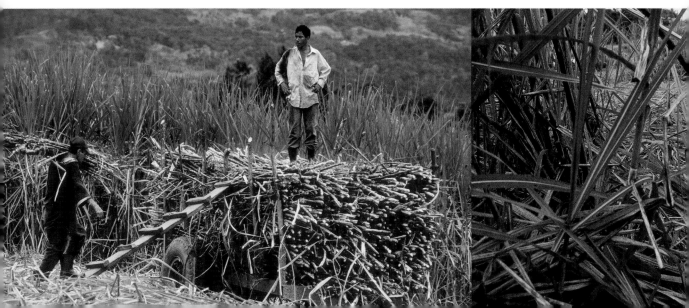

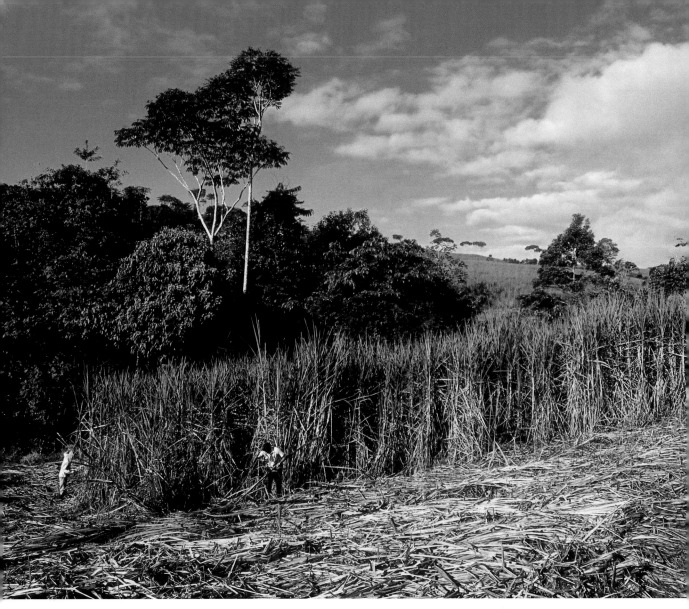

It's harvest time on CoopeAgri member Carlos Salasar's plantation.

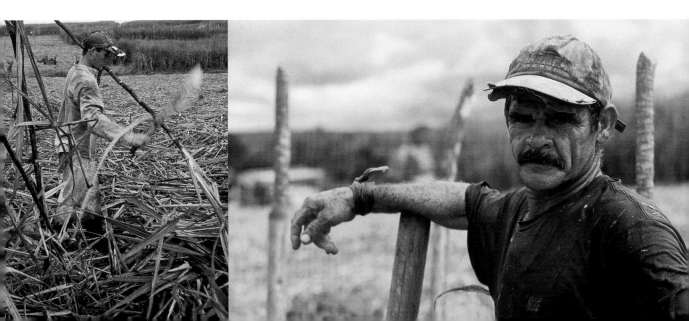

THE WORD 'SUGAR', IN THE BROADEST SENSE, first brings to mind a taste, but it is also a food compound with considerable energy value, adored by some and loathed by others, leaving no one indifferent.

The saccharide family includes the natural sugar in fruits and honey (fructose) as well as that in starch (glucose), but it is sucrose, a combination of the two, extracted in large quantities from sugarcane and sugar beets, that has been turned into commercial sugar for centuries. From different stages in the refining process and from residual molasses, various kinds of sugar are obtained – whole, red, yellow, white, each with its respective nutritional advantages and disadvantages. In general, refining enhances the taste but not the nutritional value, with a notable loss of mineral salts, potassium, magnesium, calcium, phosphorus and iron, all necessary for a healthy metabolism, and which otherwise will be drawn from the body's own stores.

⊡ Doña Maria, CoopeAgri's own sugar brand.

World production is divided between two poles: in the North, which has roughly 20% of the pie, sugar beets are cultivated, with France being the largest producer; in the South, sugarcane remains historically the main source of supply, with environmental and human costs that are truly reprehensible. Brazil and India alone produce 56% of all sugarcane.

Between these two geographically opposed plants there is an unequal competition. In the 1990s, protectionism and subsidies (especially on the European side) led to overproduction and dumping at the expense of the prices agreed upon with less advantaged producers in the South. Since 2004, the World Trade Organization (WTO) has been arbitrating the match so as to strike a balance between the two sides.

For its part, fair trade sugar often flies 'under the radar' when compared with coffee, bananas and the movement's other star commodities – although it is, by weight, fair trade's third largest product, at 57,000 tonnes. Of course more is used as an industrial ingredient – especially in chocolate – than is bought by individuals at the supermarket.

The problem is that sugar – fair trade or not – is *persona non grata* for many consumers concerned about their food; if fair trade nicotine existed, it would have the same marketing problem! Unable to put 'sugar free' on their products, food companies avoid mentioning it any more than necessary, keeping quiet about efforts toward greater fairness in this sector.

sugar in figures

CONVENTIONAL TRADE

Global production (sugarcane):
 1,557,664,978 tonnes
Global trade: $20,092,000,000

MAIN PRODUCING COUNTRIES

Brazil	33%
India	23%
China	7%
Thailand	4%
Pakistan	4%
Costa Rica (34th)	0.3%

FAIR TRADE

Year of certification: 1997 (FLO)
Global imports (sugar): 56,990 tonnes
Retail sales: $257,440,000

CERTIFIED ORGANIZATIONS

15 small producers' organizations, in seven countries.

ORIGIN OF CERTIFIED ORGANIZATIONS

Paraguay	40%
Costa Rica	20%
Philippines	13%

MAIN IMPORTING COUNTRIES

	Imports (t)
United Kingdom	43,832
United States	3,364
Germany	1,701
France	1,588
Belgium	1,038

PRICES AND PREMIUMS (white sugar)

Fair trade price: $520/t
Fair trade premium: $60 to $80/t
Organic premium: $120/t
Proportion of organic sugar: 13%

Harvesting sugarcane on Carlos Salasar's plantation.

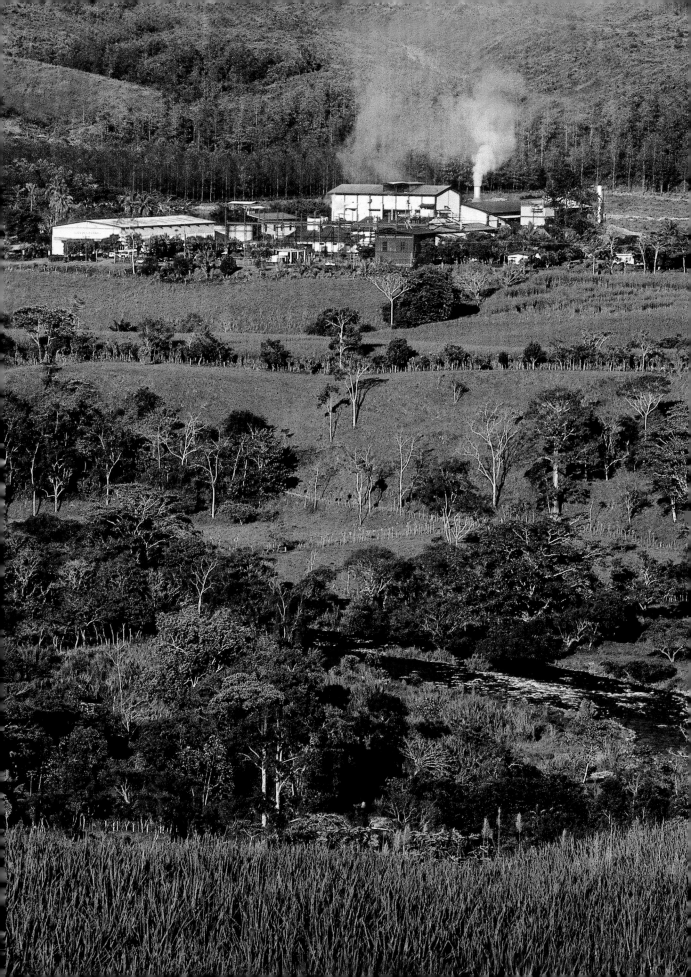

crushed. The extraction of the juice (which makes up three-quarters of the weight) leaves behind the bagasse, used here for fuel in juice-processing. The juice itself is first bleached with lime, which causes impurities to settle out, before being filtered. After this comes evaporation by boiling. The resulting syrup is then poured into a vacuum-sealed vat and powdered sugar is added to speed up the crystallization process. The sugar crystals will be washed and dried before being sifted, classified, weighed and stored. They contain 99.5% sucrose. From each tonne of cane, the factory extracts between 120 and 130 kilos of sugar, for a total production of more than 35,000 tonnes available for export.

In 1974, it was extremely rare for a small-scale producers' organization to have its own sugar-processing facility like that of CoopeAgri. Even today, getting their own factory is a challenge for small producers in some countries, like Paraguay, where six of the 15 fair trade certified sugar cooperatives are located and there is a long tradition of cooperative labour. "The cooperative movement here is the extension of a cultural tradition, that of the *mingas*, collective work projects based on mutual assistance. This movement was interrupted during the military dictatorship, when all workers' organizations were considered 'evil'. Today there are over 800 cooperatives. Between 1.5 million and 2 million Paraguayans belong to a cooperative," says Andres González

Aguilera, the director of Paraguay's Manduvirá cooperative, founded in 1975 and today consisting of more than 1000 members.

Manduvirá had to wait three decades before being able to process its own sugarcane. "By renting our own factory in 2005, we broke the pattern. We defied the social classes who kept the privilege of factory ownership for themselves," explains Andres. In Canada, Martin Van den Borre, from the La Siembra workers' cooperative, remembers that era. "When we began to import fair trade sugar for our chocolate bars, it was hard to forge a direct relationship with the producers, because private mills controlled all the distribution. It was the white oligarchy against the native Guaranis," he explains. "When a few co-ops took over the mills again, a number of fair trade buyers didn't believe that the producers could successfully make quality sugar. We imported the first container of sugar that the Manduvirá cooperative processed and they've always been very grateful for this sign of confidence. Even though some buyers tell us they have problems finding organic sugar, Manduvirá always has sugar for us. We've been able to build up a loyal relationship with them." For Andres, in Paraguay, the adventure is just beginning. "Thanks to fair trade, we've been able to take the first step in exporting our sugar. In 2011, we'll have our own factory. This will shatter another taboo."

In Costa Rica, the CoopeAgri sugar-processing factory is only one of the organization's huge facilities. In addition to its coffee-processing factory, there is also a facility for producing compost, with an annual production of more than 100,000 bags of organic fertilizer. From its founding, CoopeAgri has played a major role in Pérez Zeledón county's development. In 1969, when the first Worldshop opened its doors in the Netherlands, CoopeAgri opened the first supermarket in the region. Today, the organization runs four supermarkets, an agricultural products centre, a hardware store, a café and even a gas station with its own auto mechanic shop. Its commercial activities make up 55% of the cooperative's sales figures, which reached more than 80 million dollars in 2008.

"Social programs are at the heart of the cooperative; that's why it was founded," says Director General Victor Hugo Carraza. "We offer work that is as professional as that of other companies. What makes us different is our track record on social projects." CoopeAgri invests more

◁ ⊡ CoopeAgri's sugar factory near the Peñas Blancas River.

than $750,000 annually in its social programs, including scholarships, emergency funds, technical assistance and a medical clinic. Of this amount, $166,000 comes from fair trade premiums, but the remainder, more then three-quarters, comes out of its own funds. "We have a doctor who offers free consultations for all our members and their families," adds Victor Hugo. In 2008, more than 15,000 people visited the cooperative's doctor. "Our various services directly affect 50,000 people, which is nearly half the county's population," he concludes.

||

Not far from the CoopeAgri offices, its financial arm, Credecoop, is teeming with people. Founded by CoopeAgri in 1994, Credecoop is an independent organization open to the county's entire population. You can find everything here: agricultural loans, payment for the sale of coffee or cane, short- or long-term investments, foreign currency, credit cards – you would think you were in a branch of the Desjardins co-op, right in downtown Montreal. As of December 31, 2008, Credecoop had more than 20 million dollars in assets and 22,000 members.

||

The forestry sector is without a doubt another area where CoopeAgri is having an effect. Forestry technician Raphael Solones heads up the mountain towards Silencio Cortez's small farm in the community of Santa Fé. The forest is mild and humid, fertile and green, like all the tropical forests in the country. "We have a good network of national parks, but there is also a lot of private land whose forests have remained almost undisturbed because of their location," Raphael says. Around us are large ferns; further on, a toucan comes to greet us; further still, a spring gushes out of the ground, turning from a little source into a stream. "Thanks to a program financed by carbon exchanges, we've been able to protect thousands of hectares of private land," he tells me. In 2008, the forestry program managed 15,000 hectares of forest, more than 20 times the surface area of Manuel-Antonio Park, one of the most famous protected areas in the country. Raphael continues, "The owners get financial compensation but they must, in return, maintain the forests in their current state. In this way we are creating migratory corridors between the national parks."

While sugar cultivation has had its share of tragedies and abuses – even today – there are organizations where democracy and collective labour put the needs of producing members first, instead of being ruled by the principle of 'profits at any price'. CoopeAgri's track record is not just a shining example of social programs, regional development and environmental protection; the cooperative is also a force to be reckoned with in Pérez Zeledón county. And all of this work was started long before the arrival of fair trade and extends far beyond its premiums. By being associated with democratic organizations run by small producers, fair trade lends its support to institutions rooted in their communities and offering a true development alternative, one that really does come from the grassroots.

▷ Forestry technician Raphael Solones (right) admires the virgin forest on Silencio Cortez's land.

small producers' organizations

"**F**OR 46 YEARS, WE HAVE HAD POSITIVE RESULTS, thanks to the continuing efforts of a group of men and women who believe in a model of socioeconomic organization built on an entrepreneurial vision," writes Amado Castro Fernandez, the president of the CoopeAgri cooperative board of directors.

According to the International Co-operative Alliance (ICA), a cooperative is "an autonomous association of persons united voluntarily to meet their common economic, social, and cultural needs and aspirations through a jointly owned and democratically controlled enterprise."

The ICA's seven cooperative principles are:

1. Voluntary and open membership.
2. Democratic member control.
3. Member economic participation.
4. Autonomy and independence.
5. Education, training, and information.
6. Cooperation among cooperatives.
7. Concern for community.

In the North, just like in the South, the cooperative movement enjoys a long and rich tradition. In Tanzania, the Kilimanjaro Native Cooperative Union (KNCU) was founded more than 75 years ago, on the slopes of Africa's highest mountain. In Quebec, the savings and credit union founded by Alphonse Desjardins in 1900 has 5.8 million members.

Cooperatives, unions, federations, – democratic organizations of small producers have always been at the heart of fair trade. According to FLO standards, for a democratic organization to be admitted, "a majority of the members of the organization must be made up of small producers not dependent on full-time salaried workers but who run their farm mainly with their own labour and that of their family. The profits must be distributed equally among the producers. All members have a voice and a vote in the organization's decision-making process."

The first role of cooperatives is often to combine resources to allow for commercial activity without depending on local intermediaries and to thus guarantee a larger portion of export revenues for producers. The infrastructures – warehouses, trucks and joint processing equipment – make it possible to improve the quality of the product and are a great source of pride for the producers. From a social perspective, the cooperatives themselves are engines of regional development, the benefits of which eventually extend into entire communities. Their initiatives are varied – common transportation, microcredit, health centres, literacy and training of all kinds, orphanages, drinking water, community gardens, reforestation – and highly participatory.

According to the International Co-operative Alliance (ICA), a cooperative is "an autonomous association of persons united voluntarily to meet their common economic, social, and cultural needs and aspirations through a jointly owned and democratically controlled enterprise."

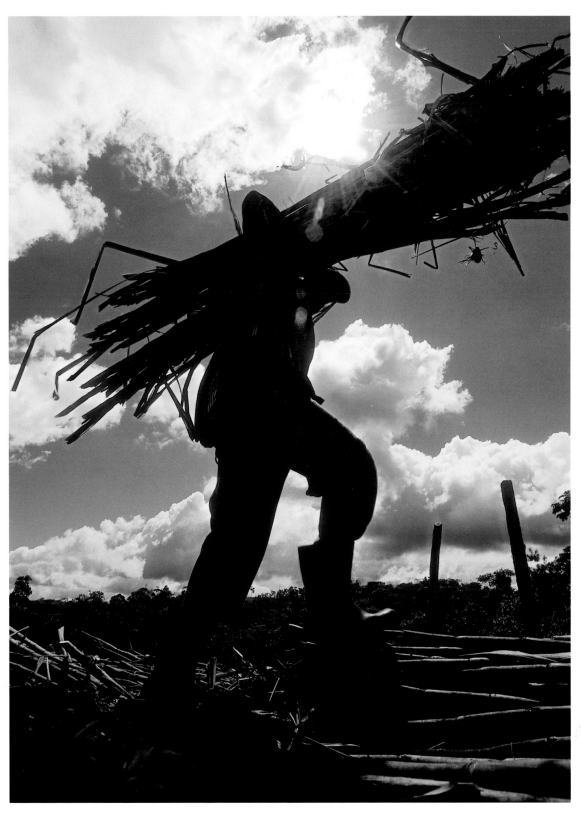

A worker transporting sugarcane on Carlos Salasar's plantation.

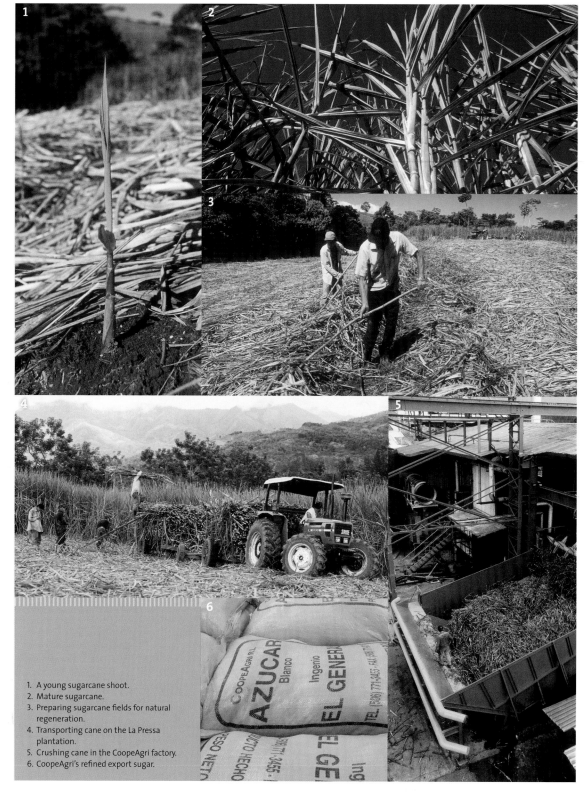

1. A young sugarcane shoot.
2. Mature sugarcane.
3. Preparing sugarcane fields for natural regeneration.
4. Transporting cane on the La Pressa plantation.
5. Crushing cane in the CoopeAgri factory.
6. CoopeAgri's refined export sugar.

▷ Top: Pamela, Wilson Conejo Guzman's granddaughter, enjoys a piece of sugarcane.
▷ Bottom : Oxen can come in very handy for transporting cane.

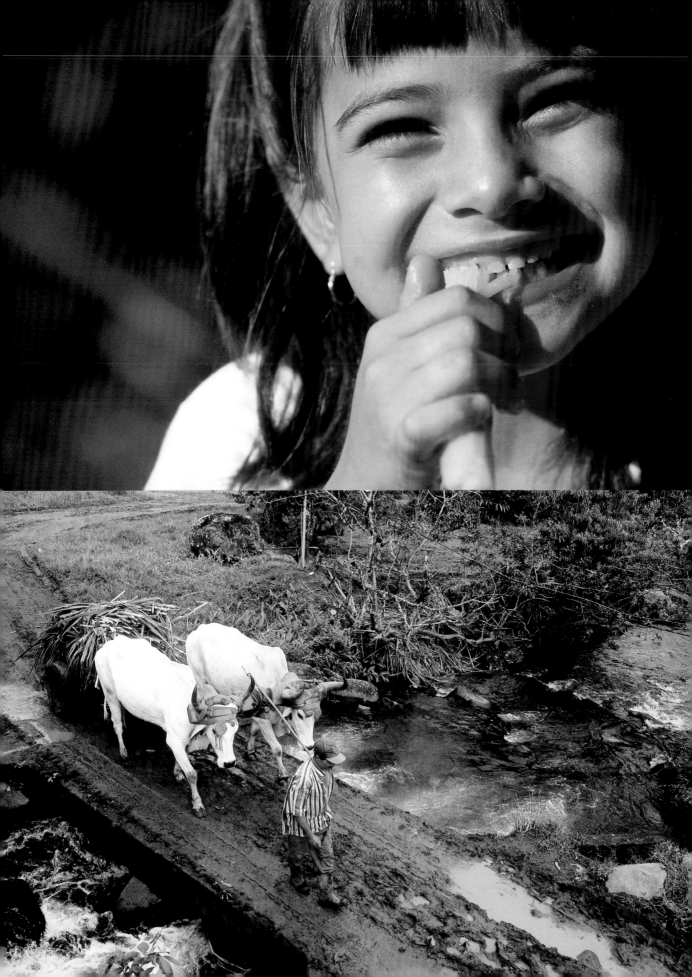

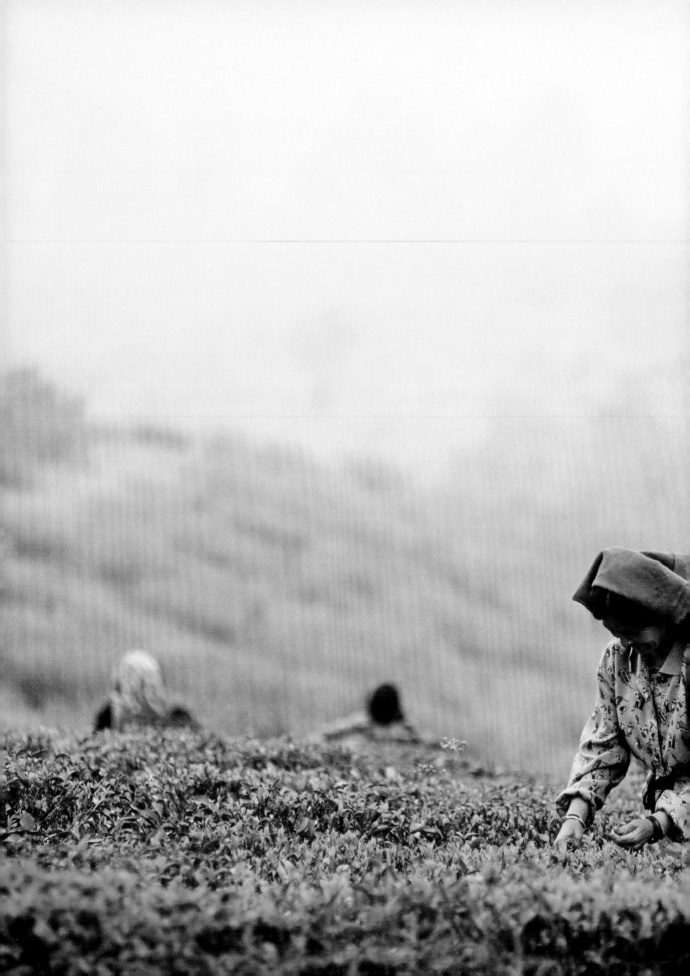

Patali Sarki picks organic fair trade tea in the Ambootia tea garden, located in the mythic Darjeeling region, where the 'champagne of teas' is grown.

There are those who say that some tea leaves fell into the boiling water of a quasi-divine emperor. Still others believe that leaves found a resting place in the Gautama Buddha's bowl while he was meditating...The origin of tea remains mysterious but the reasons why it has become so popular are less so. Indeed, it was a powerful wind that shook the leaves of tea plants in China and elsewhere when the British Empire planted tea gardens throughout its colonies. Very little time elapsed between the planting of the first tea seeds in 1840 in Doctor Campbell's garden in Beechwood, Darjeeling, India, and the end of China's monopoly on production. Tea plantations multiplied in the Indian countryside in response to growing demand worldwide. In Assam, entire jungles gave way to these new operations.

Tea became an integral part of the world's economy and its cultures. Age-old India welcomed it into the Hindu pantheon like a new god. There, tea became a cultural symbol, a national beverage that shaped various aspects of life. Conversion to tea knew no borders: next to water, tea is now the world's most consumed drink.

Heading toward the high peaks of the Himalayas, a train straight out of another era climbs metre by metre with the 'slowness' of a Japanese tea ceremony. Far from the crowded streets and the torrid heat of Calcutta, the Darjeeling region is quiet and rather calm. Buddhist temples line the small roads and, when the weather cooperates, a few majestic summits, among them Kangchenjunga (the third-highest summit in the world, at 8598 metres), are seen to adorn the horizon. Along the roadsides, tea plants stretch as far as the eye can see over the mountainous terrain, a mythical region where, according to experts, the 'champagne of teas' is grown.

In the middle of this imposing landscape lies the Ambootia tea garden; in the centre is the large director's bungalow, which is really more of a guesthouse, since the owner lives in Calcutta. Botu, the amiable caretaker, greets me with a silver platter bearing two fine porcelain cups giving off a delicate aroma. A few hundred metres away, the pickers are busily harvesting tea. In their colourful clothing, baskets on their backs with a strap around the forehead or on their shoulders, gloves on their hands or bandages wrapped around their fingers, they bustle rapidly from bush to bush to pick the young leaves. "The harvest is small, as it is the beginning of the season, but these first leaves, the first flush, are the most in demand and are worth the most money," explains the plantation manager who, in shorts and a polo shirt, contrasts with the workers. For the first time, I am visiting a large private plantation that is certified fair trade.

During the break, an employee goes around the field with a teapot full of cool water that she offers to each picker. Working conditions are governed by the *Plantation Act*, promulgated in 1951, which, among other regulations, grants the right to organize a union, sets a minimum salary and determines employees' working conditions (clothing, tools, breaks, holidays) and living conditions (housing, roads, schools, day care centres, medical clinics, etc.). Just like workers' cities of the industrial past, with their paternalist capitalism, tea gardens are actually small cities where sometimes over a thousand people live and work.

"I was born in the director's bungalow," owner Sanjay Bansal tells me a few weeks later, in his air-conditioned Calcutta office. "My father was the manager of the garden and became its owner in the middle of the 1980s. In India, there are no more than half a dozen managers who have eventually become owners!"

Ambootia has won many prizes at the Calcutta auctions for the quality of its teas. Its secret lies in their high quality. "There is always a market for a good tea," declares Sanjay Bansal. "Once it was taken over by my family, Ambootia conver-

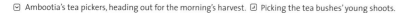

⊡ Ambootia's tea pickers, heading out for the morning's harvest. ⊡ Picking the tea bushes' young shoots.

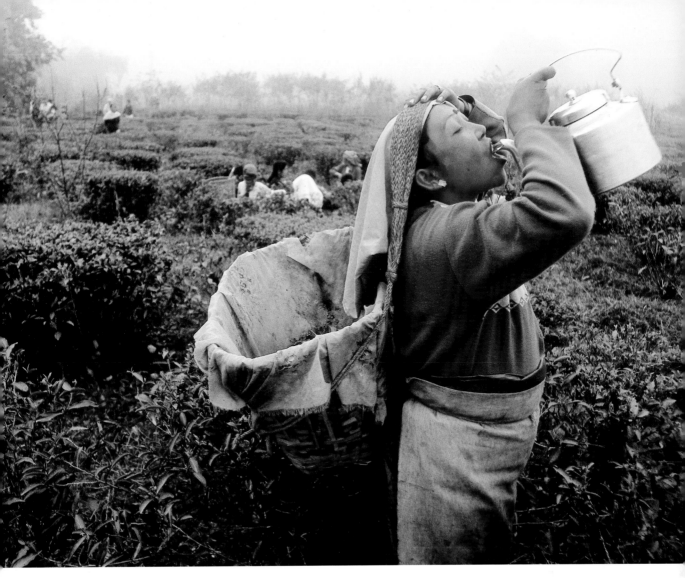

⌃ A well-deserved break for Ambootia's tea pickers.

ted to organic production and today even the workers' gardens are certified." Organic, biodynamic and fair trade, Ambootia's recipe is very simple according to its owner. "We are directly involved at every stage, from tea plants to tea sales. Three percent of Ambootia tea is sold through fair trade networks. For us, fair trade is a niche market like any other." During the previous three months, Ambootia had acquired five new gardens 'in trouble', in the Darjeeling region. As Sanja explained at the time, "We've gone from 150,000 to 600,000 kilos of tea annually. This has never been seen before in the region. Let's see how we succeed!" Today, a few years later, Ambootia Tea Group Exports has 11 gardens.

After many visits over the years to various small-scale producers' cooperatives, I find visi-

ting large fair trade certified gardens a little bit perplexing. A legacy of British colonialism, they still have a traditional hierarchy, with an owner who is lord and master over the workers. "We are responsible for a large population," Sanjay stresses. This means a lot of responsibility, of course, but also a lot of power. Ambootia's owner himself admits that "the marriage of fair trade and private gardens is not the most natural of unions." In certified gardens, it's not unusual to meet workers who refer to their owner as their 'king' or their 'god'...We are a long way away from organizations run by small producers, the symbol of fair trade, where democracy and the self-sufficiency of member families are important principles.

TWENTY-FIVE THOUSAND CUPS A SECOND – in the time it takes to read these words, that's the volume of tea worldwide that has been swallowed by innumerable tea-drinkers. It makes no difference how many mythological hypotheses surround its origins or how many colours it comes in – white, black, green, blue, red and even yellow – all teas come from one kind of tree, *Camellia sinensis*, with two varieties, *sinensis* and *assamica*, found naturally all over Asia, but historically concentrated in China.

In its natural state, *Camellia sinensis* can grow up to 20 metres tall – which is not very practical for harvesting! Domesticating tea trees restricts them to a height of 1.2 metres, to maximize production and make picking the leaves easier. The science, if not the art, of harvesting, lies in a strategy that has to take into account the time of day – tea picked in the morning is higher in tannins – but also the conditions necessary for growth and quality; you can choose to pick only the first leaf below the bud, for the most delicate flavour, or else the remaining leaves in order, which encourages plant growth.

Then come decisions concerning the fermentation of the leaves – light, medium, full or simply not at all – to produce the different types or 'colours' of tea. The Japanese have made green tea (not fermented but roasted) their sole passion, whereas semi-fermented teas (oolongs) are Chinese in origin. Black tea, allegedly the result of accidental prolonged fermentation during a delayed delivery in the seventeenth century, became so popular with the subjects of the British Crown that they thenceforth demanded only tea produced by this method for trade and again when they began growing tea in India and Africa in the nineteenth century.

Nowadays, the conventional tea market is controlled by a small number of multinationals that greatly influence the prices at regional auctions. The overproduction of recent years is pushing prices down and as a result there has been an attempt to encourage higher consumption in producing countries (India and China), which are already quantitatively the biggest tea drinkers. On the other hand, per capita, Indians drink only 650 grams per year, compared with 2,200 for the British.

As for fair trade tea (which includes in the mix herbal infusions like camomile, mint or South African rooibos), we are seeing a recent explosion in demand – a growth of 112% between 2007 and 2008 – mainly because of a commitment to purchase made by one of the biggest food chains in the United Kingdom at the end of 2007. This tripled sales all at once, resulting in a 10% market share for fair trade teas among the English, who are key consumers.

tea in figures

CONVENTIONAL TRADE

Global production: 3,871,339 tonnes
Global trade: $3,750,000,000

MAIN PRODUCING COUNTRIES

China	31%
India	25%
Kenya	8%
Sri Lanka	8%
Indonesia	5%

FAIR TRADE

Year of certification: 1996
Global imports: 11,467 tonnes
Retail sales: $294,640,000
Growth (2007-2008): 112%

CERTIFIED ORGANIZATIONS

31 certified small producers' organizations and 43 certified organizations with hired labour, for a total of 74 orgsanizations, in 12 countries

ORIGIN OF CERTIFIED ORGANIZATIONS

India	25%
Kenya	23%
Sri Lanka	16%

MAIN IMPORTING COUNTRIES

	Imports (t)	Growth (2007-2008)
United Kingdom	9,330	149%
United States	600	33%
France	432	33%
Canada	271	215%
Germany	202	2%

PRICES AND PREMIUMS

Fair trade price: from $1.20 to $2.00/kg
Fair trade premium: $0.50/kg
Proportion of organic tea: 17%

⊡ To obtain a high quality tea, one or two leaves and the bud are picked, while a royal picking consists of buds only.

In the Makaibari tea garden, at first sight everything exudes tradition. The owner, Rajah Banerjee, is from the fourth generation of 'planters' in his family. "My great-great-grandfather was the first Indian tea garden owner," he says. Today, of the 87 tea gardens in Darjeeling, Rajah is the only owner to live on his plantation. "It's tea time," he announces with a mischievous smile, as if to suggest that any time of day is good for tea. The cups are all lined up and, in front of them, a variety of leaves: green tea, black tea and the legendary silver tips of Makaibari. "In 1996, this tea beat the sales price record at the Calcutta auction," Rajah says proudly, pointing to the certificate on the wall. He first smells the tea and then tastes it. Staring at his plantation manager, his verdict leaves no room for doubt – "It's good, but we can do better!"

Near the offices, the weathered wooden floors of the old factory buildings have seen many a tonne of tea. At noon, the pickers, men and women, bring their baskets to weigh the morning harvest's leaves. Then the leaves are spread out on long sheets of wire mesh to dry; during this stage they will lose 50% of their water content.

After the normal greetings to Ganesh, the Indian god of wisdom and intelligence, Rajah takes me to the home of a family of workers. "You absolutely have to see the production of biogas. Several families have been given cows and equipment for producing fuel out of manure. They can now cook without cutting down trees and what remains is composted to fertilize the tea plants," explains the enthusiastic owner, before adding, "The tea trees cover only 30% of our land; the remainder is virgin forest full of diverse animal species. We even have leopards!"

And indeed, there are stuffed tigers and other wild cats in his house, treasures of family hunts in the British colonial period. "It was another era," he admits. In Rajah's opinion, it's also time to rethink a plantation model left over from the colonial past. "The tea garden system was a very clever model that forced workers to be dependent and, in reality, was very close to slavery," he says. The goal of this unusual owner: to enable his workers to hold shares in his garden. "I'm not going to give them anything. They'll have to earn them. But a few years from now, I think it will be possible. And I'm thinking particularly about the women," he adds.

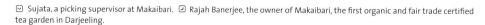

☑ Sujata, a picking supervisor at Makaibari. ☑ Rajah Banerjee, the owner of Makaibari, the first organic and fair trade certified tea garden in Darjeeling.

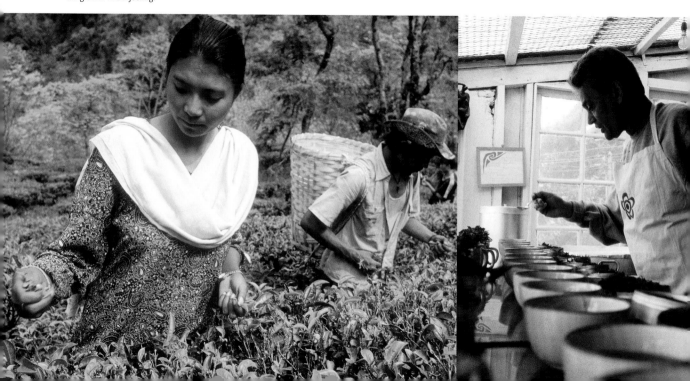

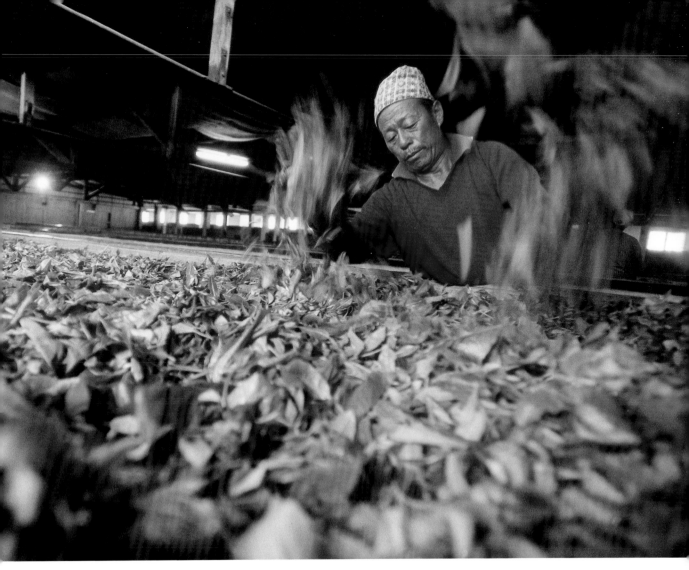

⌃ Tes Rai ensures that these organic tea leaves are withering evenly, in the Makaibari factory.

At Makaibari, seven women have already been promoted to a supervisory level, one of few Indian tea plantations where this has happened. Sujata, 23, got her job when her mother retired. As she tells me, "In 2003, I took training to become a nurse, but there were six candidates for only one position in the plantation's dispensary. I didn't get the job, but a few months later I was promoted to supervisor, my salary went from 1000 to 1500 rupees a month ($38), and I manage a group of 20 pickers. Yes, yes, all men from 19 to 49!"

Sujata is also a member of the joint committee responsible for the funds derived from fair trade sales, 15% of Makaibari's annual produc-

tion. This committee administers fair trade premiums (0.5 euros per kilo of tea) earmarked for setting up social projects, such as training for midwives, computer courses, micro-credits for workers and an ambitious ecotourism project. Rajah explains, "The ecotourism project is entirely managed by the workers and helps make them self-sufficient." The committee consists of 12 members, a majority of whom are women. Rajah is nonetheless president. "The workers insisted that it be me," he explains. "Things don't change overnight. The committee meets every week. I'd like its role to extend far beyond the management of fair trade premiums."

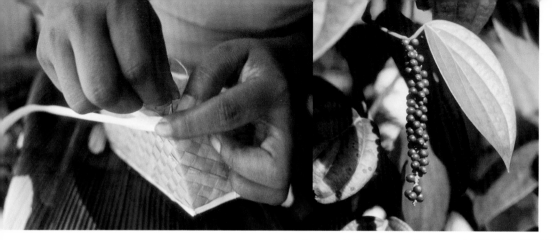

⌂ A handcrafted reed box for exporting SOFA tea and spices. ▷ A bunch of peppercorns. ▷ Sripali, a member of SOFA, picking organic tea leaves.

While most fair trade tea comes from large plantations, there are also small-scale producers' associations, the first of which was established in Sri Lanka. Founded in the middle of the 1990s with 193 members, the Small Organic Farmers Association (SOFA) now has nearly 2500 small producers of tea and spices both organic and fair trade. The producers work in partnership with Biofoods, a family business responsible for processing and export, which is at the heart of SOFA's development.

Near Kandy, in the middle of the island of Ceylon, the Biofoods factory blends into the luxuriant tropical forest. Doctor Sarath Ranaweera, the founder of Biofoods, raises cups of tea one by one to his face to inhale their fragrance. "Our organic green tea is especially aromatic, but it is hard to sell because of the prices China sets for its organic green tea. Biofoods was founded in 1993 and a few years later we created producers' organizations. By the beginning of the 2000s, SOFA was self-sufficient, but with strong collaboration," he explains.

In the village of Nillembe, Chamdi and Sripali, members of SOFA, go from tea plant to tea plant picking the fresh leaves. Around them are pepper, clove, cinnamon and vanilla plants, the famous climbing orchid from which vanilla is extracted. All of SOFA's producers practice diversified agriculture; they grow tea, spices and various subsistence foodstuffs. "We harvest tea on Mondays and Thursdays, as those are the days the buyers come," Chamdi explains. At the end of the afternoon, a truck arrives, a scale is hung on a tree, and a calculator and account book are placed on a stool. The bags of leaves are weighed one by one. The producers are paid on the spot. "My little piece of land provides me with a third of my income, but most of us have another job in addition to our farms," says Chamdi, who also worked for several years as household help in the Middle East before getting married.

In the neighbouring village, ten women are gathered, their agile hands bending and re-bending delicate reeds into magnificent small boxes. They will be used for exporting SOFA's tea and spices. "It's additional income that is important to us," says one of the women tea-growers. Fifteen rupees ($0.13) for each box goes to the artisan, eight rupees to buy the materials and one rupee for the social fund. From its tea sales through fair trade networks, SOFA earns social premiums in the order of five million rupees ($45,000) each year. These funds make agricultural development possible, providing free tea plant seeds and even animals to diversify members' incomes and provide manure for their organic agriculture. The association's social fund is also used for school supplies and clean drinking water projects, a service for the whole community, members and non-members of the cooperative alike.

In addition to SOFA, 31 small producers' organizations, only two of which are in India, export 29% of fair trade tea. Just as the 1980s saw an organic revolution in Indian tea production, let's hope that fair trade can sow the seeds of change and lead to a democratic revolution in the Darjeeling region and in all the traditional tea estates in this country of a thousand gods – a wind of change to carry on the work of Mahatma Gandhi, Nehru and other fathers of the largest democracy on Earth.

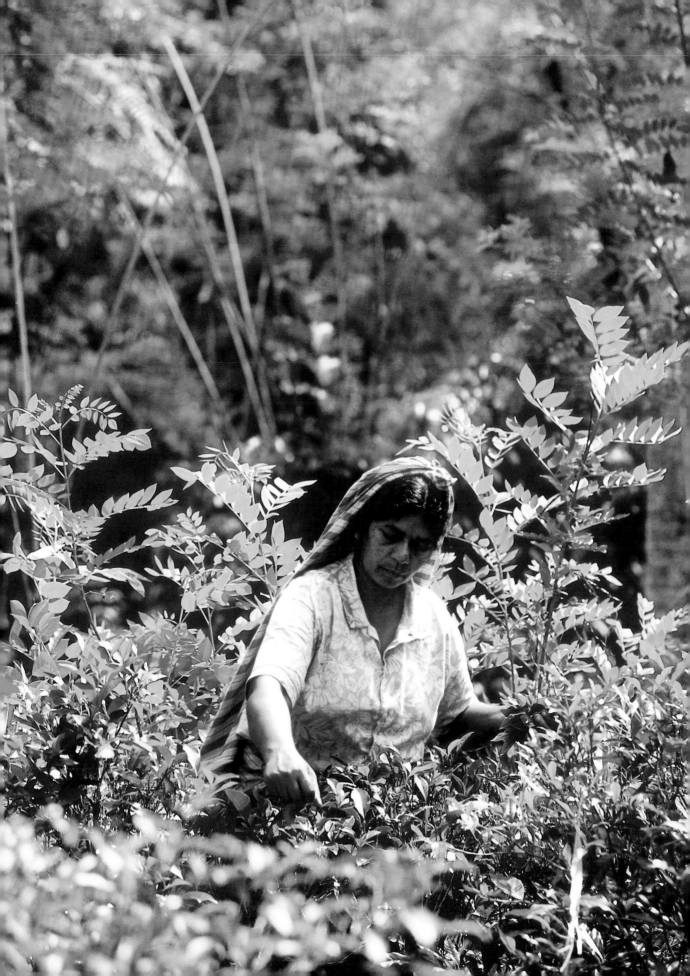

Little Sirome's family are members of SOFA, one of 31 organizations of small producers exporting fair trade tea.

THE CERTIFICATION OF TEA PLANTATIONS in 1997 sent a shock wave through the fair trade movement, and met with its share of resistance. For the first time, fair trade standards were developed for private producers dependent on hired labour – a marked difference from the democratic organizations of small-scale producers who had been until then the symbol of the fair trade movement.

The response was especially strong in the coffee sector, where certified organizations represent 400,000 small producers, or half of all the small FLO-certified producers. Since these organizations export only 50% of their coffee in the fair trade market, including large growers in the equation is not justified. There are now 16 FLO-certified sectors restricted to small producers' organizations (sugar, coffee, cocoa, rice, and spices), while five also include large growers (fruit juices, fresh fruits, bananas, tea and wine), and two involve only private companies with a salaried work force (flowers and sports balls).

"Workers without land are among the most disadvantaged in the world," says FLO, which bases its certification of plantations on the standards of the United Nations' International Labor Organization (ILO) and on several general principles:

• a joint committee, composed of workers and management must manage the fair trade premium;
• the premium must be used to improve living and working conditions;
• forced labour and employing children fifteen years old and under is prohibited;
• workers have the right to set up or join an independent union;
• salaries must be equal to or higher than the regional average;
• security measures must be in place to avoid workplace accidents.

"When plantations first began to be certified, they had to have a joint committee and a form of collective bargaining, but often no more than that," explains Markus Staub, of Max Havelaar Switzerland, which was involved at the start of fair trade certification in the flower industry, in the early 2000s. "With the experience gained from flowers, we have been able to move the certification standards forward. In addition to premiums and joint committees, fair trade certification is now looking at organizing workers, so that they can concretely improve their working conditions. These workers need a system like a union to help them organize. Their employer has to give them time off to meet regularly with each other and with management," he concludes. FLO certifies 206 businesses in the South that employ 150,000 people.

"Workers without land are among the most disadvantaged in the world."

▷ It's harvest time at Makaibari.

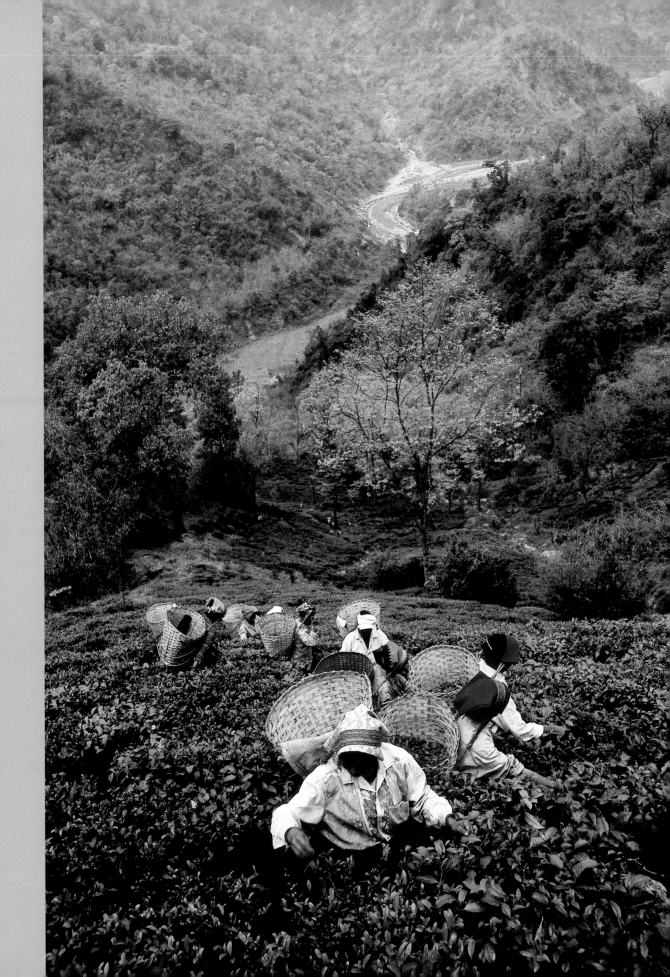

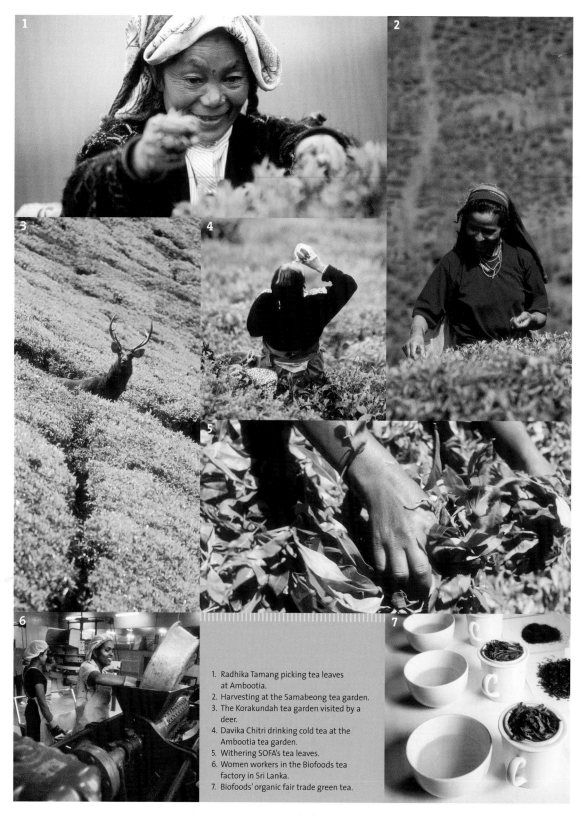

1. Radhika Tamang picking tea leaves at Ambootia.
2. Harvesting at the Samabeong tea garden.
3. The Korakundah tea garden visited by a deer.
4. Davika Chitri drinking cold tea at the Ambootia tea garden.
5. Withering SOFA's tea leaves.
6. Women workers in the Biofoods tea factory in Sri Lanka.
7. Biofoods' organic fair trade green tea.

▷ Nine-month-old Josmaya Sorma in Makaibari's daycare centre.

flowers

Broken bones found in the Shanidar cave tell us a good deal about the importance of solidarity in our ancient cousins' culture. These fractures occurred in the youth of individuals who died in the fullness of old age, in Neanderthal terms. They bear witness to a race with noble sentiments, whose strongest members looked after the weakest until death – a death beyond which lay another horizon for beings who were not yet human, but who made tools, wore clothes and buried their dead on elaborate carpets of flowers, signs of a growing faith in the existence of a god or gods.

Flowers have always been intimately connected to gods. Botticelli reminds us that Venus was born surrounded by roses in the presence of Zephyr and Flora, whose celebrations, the Floralies, have been the occasion for enjoyable festivities as well as for unleashing passions and conflicts.

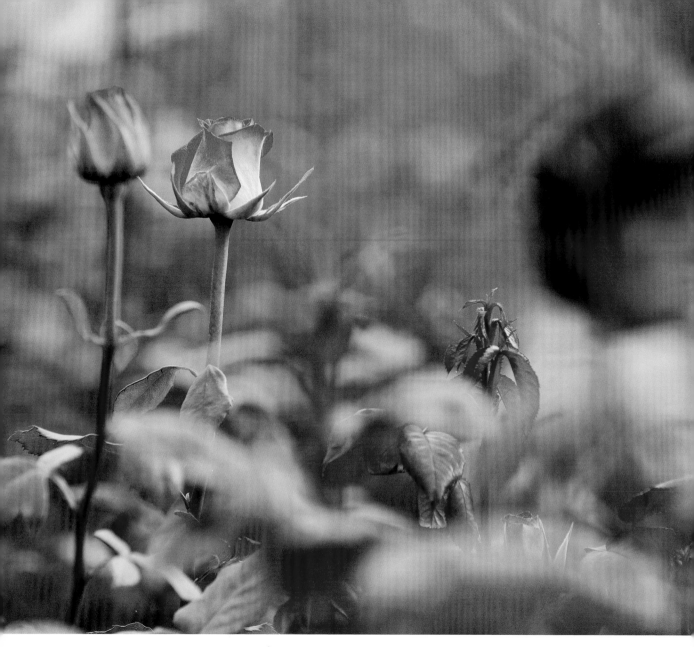

⌄ Rosebuds in Ecuador's Agrogana greenhouses.

For while flowers are fascinating to human beings, it is not only because of the promise of resurrection they bring. Flowers bloom again every season without trying to erase the memory of their death, but their radiant beauty quickly fades and decays, beginning the cycle anew. From one extreme to another, humans associate flowers with everything: birth and death, peace and war. In Roman mythology, Juno – angry with Jupiter – asks Flora for a flower that would enable her to conceive a child by herself. Mars was conceived as a result of this disturbing wish and encouraged men to make war from the day the founding twins were born.

Over the centuries, women have received flowers as tokens of men's love, although flowers also evoke other kinds of love as mysterious as their inaudible secrets... inaudible, that is, to most mortals, but not to poets. "In the morning, I listened to the sounds of the garden, the language of the perfume of flowers." Thus says the Sicilian philosopher-singer, Manlio Sgalambro, revisiting *Les fleurs du mal – The Flowers of Evil* – by Baudelaire through the moving voice of another Sicilian, a singer-philosopher this time, who is equally fascinated by unusual scents, *il maestro* Franco Battiato. Battiato's musical triptych begins with *Flowers 1*, followed by *Flowers 3*, and concludes

with *Flowers 2* (his way of avoiding an infinite number sequence), and is truly a garden whose flowers speak of forbidden medieval loves and subtle caresses.

Flowers represent man's most cherished hopes, even vain ones – what difference does it make! The rose has inspired generations of people "who refused to crawl slowly toward old age," as recalled by Jacques Brel in his song *Jaurès*. It was with carnations in the barrels of their guns that Portuguese captains gave freedom back to their people on the morning of a particular April 25th. In a different kind of Portuguese, Brazilian poet Vinicius de Moraes asks us not to forget the "Rose of Hiroshima, the hereditary rose, the radioactive rose, idiotic, maimed, the rose of cirrhosis, the atomic anti-rose, without colour and perfume, without a rose, without anything."

Reassured by one myth or another throughout history, human beings have bent down to pick flowers – moved by the inexplicable forces of Nature, which they thought they were totally separate from, a Nature stripped of its holiness and subsequently reduced to the demeaning status of a 'resource'.

The prophets of our era declared that intensive export-driven flower cultivation would be good for nations with the 'privilege' of comparative 'advantage': low salaries, minimal environmental laws, an insecure labour force...what the language of modern myths defines as 'highly flexible production conditions'.

This is how Kenya, Ecuador, Zimbabwe, Zambia and Colombia, among others, have become flower-producing countries symbolic of 'happy globalization'. In their greenhouses, where our symbols of love are grown, 65 to 70% percent of workers are women excluded from the romanticism of a global chain that nonetheless begins on their production lines. Working upwards of 60 hours per week, they are constantly exposed to toxic chemicals. 'Globalization' for these workers means sexual harassment, skin and respiratory diseases, and crippled knee joints resulting from being forced too often to adopt the position of the world's downtrodden.

Against this backdrop fair trade has stepped in, once again, to tilt the balance toward justice. "At the beginning of the 1990s, there were campaigns to raise the awareness of Swiss and German consumers about the poor working conditions and extensive use of chemicals in the flower industry," explains Markus Staub of Max Have-

laar Switzerland, which was responsible for the fair trade certification in the flower industry. The idea gained ground, but there was some hesitation about its fair trade certification. "Flowers were not a food product and suppliers used hired labour and not small-scale producers working in cooperatives. Furthermore, flowers are shipped by plane," adds Markus. "Today, we know that producing roses in the Netherlands causes 5 or 6 times more CO_2 emissions due to heating costs than producing them in Kenya, in spite of the air transport." Old prejudices had to be overcome in order to bring about pragmatic changes in an industry that really needed them. "We were the only national certification initiative to support and organize this new fair trade product," Markus adds. In 2001, 21 million stems of certified fair trade flowers from Zimbabwe and Kenya made their way to Switzerland. In 2004, the number rose to 89 million. "We succeeded in claiming a 50% share of the national market, a rare occurrence in fair trade. We couldn't have done this without the participation of the producers in the South."

|||

Midway along the 140 kilometres between Quito, the capital of Ecuador, and the Nevado Ecuador greenhouses, the Cotopaxi volcano's white summit, 6000 metres high, touches the clouds. The sun shines with the full force of its rays, yet June is cool on the Ecuadorian Altiplano. "Here, at 2750 meters, the conditions for growing roses are perfect," according to Roberto Nevado, the owner of Nevado Ecuador. "We have the perfect balance of maximum sun without the risk of frost." A Spanish citizen, he has worked in the flower business for more than forty years. "I worked as a broker for 30 years before becoming a producer." Established in 1998, Nevado Ecuador has 45 hectares of greenhouses where 550 people are employed. This is one of 46 FLO-certified flower-growing operations.

Miriam Chusing walks quickly along a path lined with magnificent blooms, selecting mature rose buds. She cuts a stem, examines the corolla, occasionally removes a petal and places the rose in a bucket that she pulls along the ground. Once she has enough flowers, she gathers them into bunches, aligns them and then delicately wraps them in a large piece of plastic mesh. This package is next placed on a conveyer system, which carries it to the postproduction

factory, where the roses are sorted by variety. Nevado Ecuador produces 50 varieties of roses; some are exclusive to the company and some were created on the property. "We harvest 60,000 stems daily," says Roberto, "and that goes up to 180,000 for Valentine's Day!" Inside the factory, a few men and about 50 women are at work. Their salary is slightly over $200 dollars per month. They wear warm sweaters and hats bearing the company logo, as well as gloves and yellow waterproof aprons. Those who have to stay in one place stand on a wooden platform to protect them from the cold concrete floor.

Patricia Coronel picks up a perfectly white rose, examining its length and bud; she then lays it down behind her with others of the same length. Several flowers are a metre or more in length. "Some of our roses reach two metres!" Roberto says proudly.

There is something missing from this sensory experience. I can't detect any aroma, delicate perfume or soft fragrance. "Most commercial roses have no smell," Roberto says. Of the 50 conventional Nevado rose varieties, only one has a perfume. For several years now, Nevado has also been developing organic roses. According to Markus Staub of Max Havelaar Switzerland, these organic roses are evidence of changes in alternative agriculture techniques. "Barely ten years ago, we were told that organic roses would be an impossible venture. Today, there are more and more of them." Four of Nevado's eight organic roses give off a soft fragrance.

In another section of the factory, Juliana Ataballo is sorting roses into bouquets of 10, 12, 20 or 25. These roses are carefully wrapped in protective cardboard. Juliana takes a quick look in a mirror to make sure they are properly aligned. She places her last bouquet on the conveyer belt. It is 1:00 p.m. and she must attend the meeting of the joint committee responsible for managing fair trade premiums, of which she is deputy chair. "The company gives us four hours per month for meetings and other committee-related activities," she explains. These committees are an FLO requirement for fair trade certification. "The fair trade premium and its management by a joint committee were the first step in the recognition of the workers' true value," Markus Staub adds. For each flower exported with FLO certification, a premium of 10% is paid into a separate account over which the joint committee has authority and which must be used to fund social projects that will benefit the entire workforce.

Nevado Ecuador's sixteen-member joint committee, half men and half women, represents everyone working on the plantation, including

⊡ First, Miriam Chusing cuts the roses... ⊡ ...then Juliana Ataballo packages them. ▷ The same day they are picked, the flowers leave the Nevado Ecuador facilities for Quito airport, for shipping to Europe and North America.

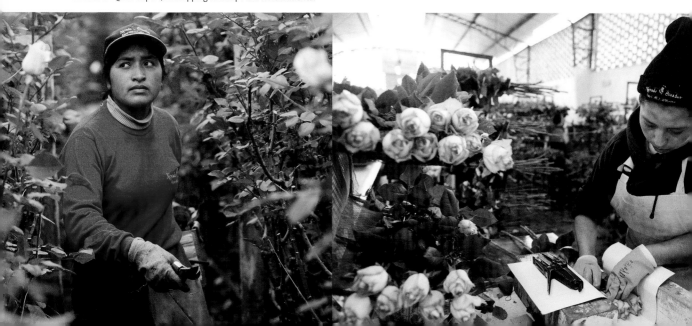

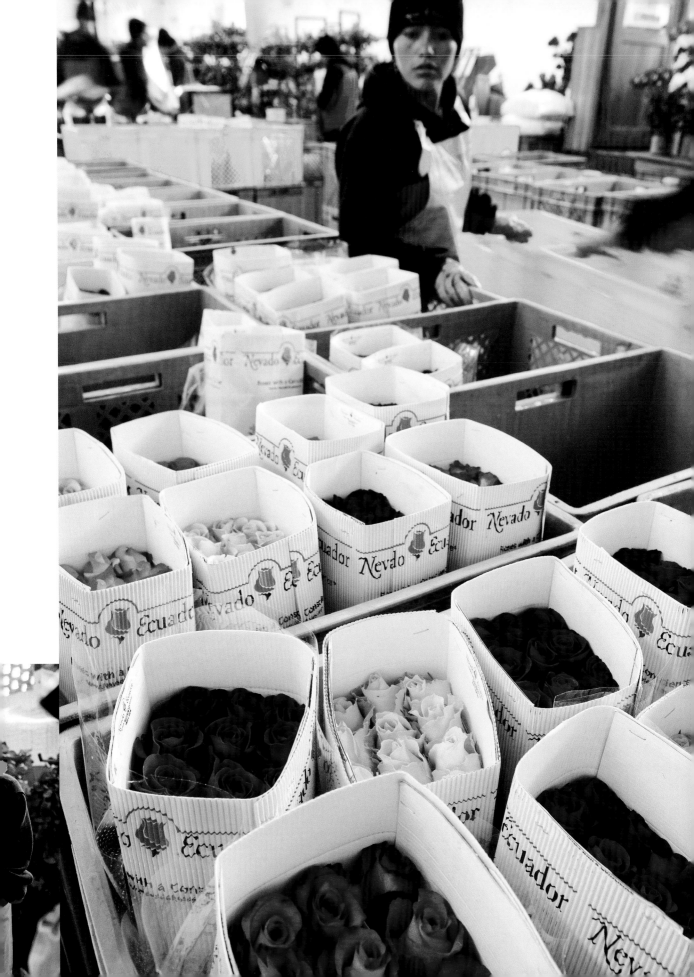

I N SPITE OF THE VARIETY OF SPECIES SOLD on colourful stalls in our markets, one flower holds the title of 'best seller' across the western world, thus claiming a good portion of the producers' attention. Grown since time immemorial in ancient China, Egypt, Persia and Greece, the genus *Rosa* continues to fascinate us and arouse our passion even today. From the supreme excesses of Cleopatra and Mark Anthony – it's said they spent their nights on a bed of rose petals almost half a metre thick – to the 189 million stems sold for Valentine's Day in the United States alone, roses elicit all kinds of superlatives from those who buy them, but also cause their share of suffering to those who grow them.

While the Netherlands is a hub for the flower trade, more and more producers are setting up operations in the equatorial regions of the globe, where climatic stability and cheap labour are in their favour. Colombia and Ecuador thus meet part of the demand in North America, while Kenya, Ethiopia and India mainly supply Europe.

Unlike the food sectors, flower cultivation is not legally subject to any kind of quota with respect to the quantity of pesticides used for pest control – it can be up to 75 times higher than in conventional agriculture in the North. The disastrous consequences for human health and the environment are just what you might expect and affect workers (especially women), who are often afforded no protection by their employers.

This is one sector where the precepts of fair trade can bring about real change. The pioneering initiative of the Swiss in promoting fair trade in flowers speaks volumes: in just a few years, fair trade roses have grabbed 50% of the market nationally. This proves that at the other end of the production line the client in North doesn't mind paying a little more for a purchase that is not a basic necessity, out of respect for the workers. Fair trade premiums, managed in a consensual way, support social projects that improve living conditions in flower-growing communities. What's more, the fair trade initiative decreases the environmental footprint of flowers grown far from western markets (up to 90% of pesticides are eliminated), which actually pollute less than those grown locally in the North in energy-guzzling greenhouses.

flowers in figures

CONVENTIONAL TRADE

Global trade: $3,716,800,000

MAIN PRODUCING COUNTRIES

Netherlands	56.5%
Colombia	14.1%
Israel	4.2%
Kenya	2.7%
Ecuador	2.7%

FAIR TRADE

Year of certification: 2004 (FLO)
Global imports: 311,000 000 stems
Retail sales: $255,950,000
Growth (2007-2008): 31%

CERTIFIED ORGANIZATIONS

46 organizations with hired labour, in eight countries.

ORIGIN OF CERTIFIED ORGANIZATIONS

Kenya	43%
Ecuador	28%
Zimbabwe	15%
Colombia	4%
Tanzania	4%

MAIN IMPORTING COUNTRIES

	Imports (stems)	Growth (2007-2008)
United Kingdom	105,400,000	26%
Switzerland	88,000,000	0%
Germany	46,800,000	138%
Finland	14,000,000	40%
Sweden	13,500,000	35%

PRICES AND PREMIUMS

Fair trade price: unknown
Fair trade premium: 10% of the export price
Proportion of organic flowers: 0%

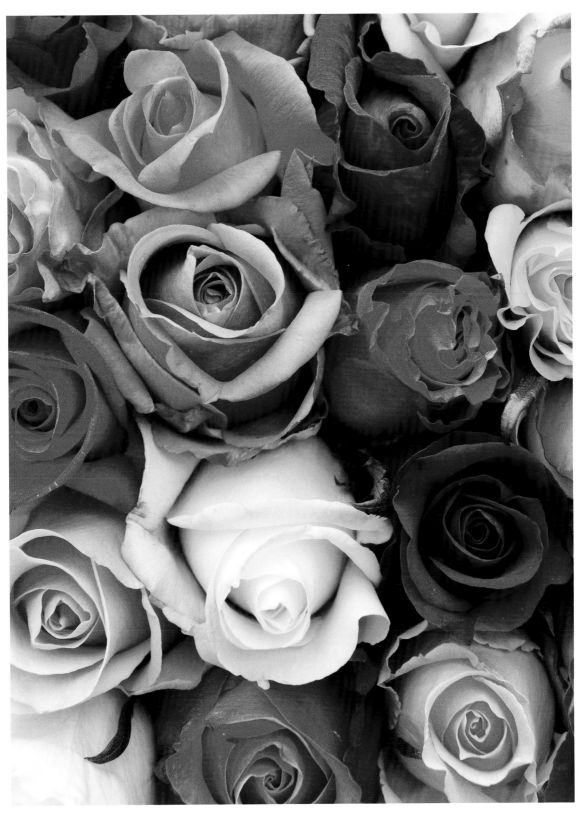

Nevado Ecuador grows 50 varieties of roses, some of which are exclusively theirs.

management. Ruben, the president, who works in the greenhouses, greets me earnestly before beginning his presentation. "In 2008, we received $123,690 in fair trade premiums, which was distributed among five projects: $42,000 for collective organic gardens and the purchase of tools for employees' private gardens; $15,000 for the dental clinic, right here on the grounds, with free consultations for workers and their children (the plantation already has a doctor, a nurse, and a day care centre); $25,000 for a microcredit program to improve housing or for certain emergencies; $29,000 earmarked as scholarship funds for workers and especially for their children; and finally, a computer centre and various training programs in home economics, nutrition, etc. have been set up." The projects are varied, dynamic and participatory. In 2008, more than 200 workers received loans of $150 to $250. "Before, when you borrowed, you had to pay back twice the amount," Ruben adds. Furthermore, 250 young people have received scholarships, twice as many as in 2007, and all employees have had their first visit to the dentist.

Juliana, on the other hand, is worried. "Could you tell us why the premium dropped from 12% to 10%?" Markus responds, "Because of Switzerland's positive experience, flowers became an FLO-certified product in 2005. A number of national certification initiatives then applied a great deal of pressure to lower the fair trade premium rate. They wanted to give producers just 5% in premiums, although there isn't even a guaranteed minimum price. We managed to reach a compromise at 10%."

Flowers are one of the only FLO-certified products with no minimum price guarantee. "I have always wanted to establish guaranteed prices, but this doesn't work with so many varieties of flowers. I even asked the industry to make us an offer. Right now, there is a lot of pressure on prices; it would be a good time to find a satisfactory way of determining fair trade prices," Markus adds.

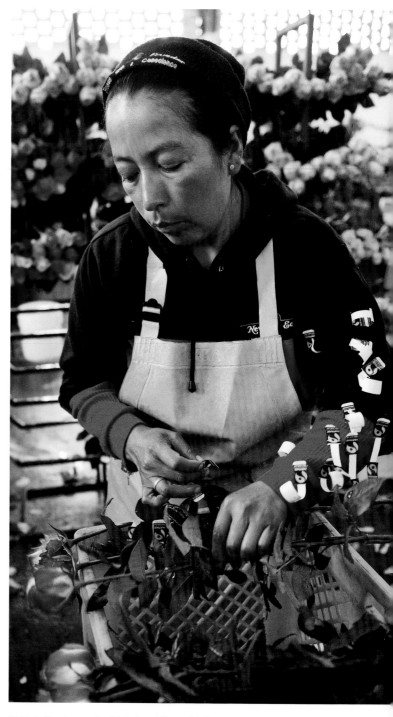

⌂ Maria Tipantuna applies fair trade certification labels as a guarantee for consumers that these flowers were produced and marketed according to FLO criteria.

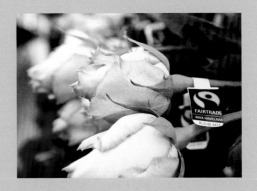

I N ADDITION TO THEIR DOÑA NATALIA and Nevado Ecuador logos, the packaging and even the flowers of the two flower-growers bear many labels: Flower Label Program (FLP), FlorEcuador, Veriflora, Ecocert, USDA Organic, Rainforest Alliance, Max Havelaar-FLO and others. Nevado Ecuador is certified by ten international organizations! I had never seen so many for a single company.

All these labels mean costs for the producers amounting to thousands of dollars. "It costs us on average $4000 for each label, but these fees only cover the certification itself; we also have to invest in other ways and pay better salaries and other benefits," Roberto Nevado explains. "We've estimated that in companies certified by FLO, our production costs per stem are 17% higher than those of conventional growers." FLO also collects licensing fees from importers on the volumes imported that on average amount to 1.4% of the sales price of fair trade products. The revenues from certification amount to tens of millions of dollars worldwide for FLO and its national certification initiatives.

These certification organizations neither import nor sell any products. FLO is an independent third party in transactions between certified producers and importers. It ensures that fair trade criteria and the integrity of its label are respected. FLO establishes fair trade standards in association with producers, whereas FLO-CERT, an affiliated independent certification agency, is responsible for inspections and certifying producers and importers according to these standards. In contrast to organic agriculture, fair trade has no national and international legal framework. This means that anyone can boast of being 'fair'; let the buyer beware.

UTZ Café, which also certifies plantations, has an extremely sophisticated traceability system, but its criteria do not include any minimum price guarantee for producers. Ecocert, with lengthy experience in organic certification, has added to its environmental criteria a series of social norms under the name of Ecocert ESR (*équitable, solidaire, responsable* in French – fair, united, and responsible). The fact that Ecocert ESR does not receive any licensing fees based on import volume makes its certification much less expensive for distributors of fair trade products. For the WFTO, "All members are subject to a follow-up process based on a self-evaluation with regard to the ten principles of fair trade." Formal certification for members of the WFTO is underway.

Large corporations have also created many programs, sometimes linked to charitable initiatives, such as Coffee Kids, or have developed intra-company codes of ethics. Unfortunately, in the absence of a third party to enforce these commitments, it is often left to the companies themselves to measure results and evaluate their own contribution to society.

In contrast to organic agriculture, fair trade has no national and international legal framework. This means that anyone can boast of being 'fair'; let the buyer beware.

◄ This rose will soon be cut... ► ...and then packaged in the Agrogana factory.

||

Not far from Nevado, Agrogana's greenhouses are also full of fair trade roses. "Our entire crop is grown according to fair trade regulations, but we only export 15% to 20% to this market," explains Anita Orozco, in charge of production at Agrogana. Founded ten years ago by the Espinosa brothers, Agrogana employs 150 workers in its 14 hectares of greenhouses and exports 30,000 roses per day. "Growing fair trade flowers is more expensive. You have to use permitted pesticides and herbicides, give three weeks of paid vacation, provide better protection for your employees and pay overtime. In other words, we must fully abide by the law, something that plantations around here rarely do."

On all Agrogana rose packaging, there is a little hat perched atop the Doña Natalia brand, named after the founders' great-grandmother.

"Her legacy is our devotion to agriculture, our commitment to quality and to humanity" can be read on the walls of the post-production factory. The international flower trade is still in large part full of disconcerting contradictions that might cause lovers' enthusiasm to fade, but the fair trade experience does offer a real alternative. For Switzerland, where fair trade flowers account for 50% of the national market, it's not only an alternative – it's very much a new norm. These multicoloured symbols of affection are much more appealing when you know they were picked by female workers in conditions that respect regulations. The right to work in dignity will always be an essential step in turning hands that produce wealth into the creators of a better future.

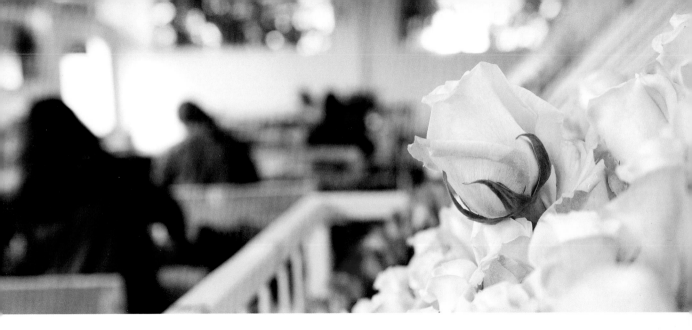

☑ Rosa San-Pedro enjoys three weeks of paid vacation annually as required by the fair trade certification standards for organizations with hired labour.

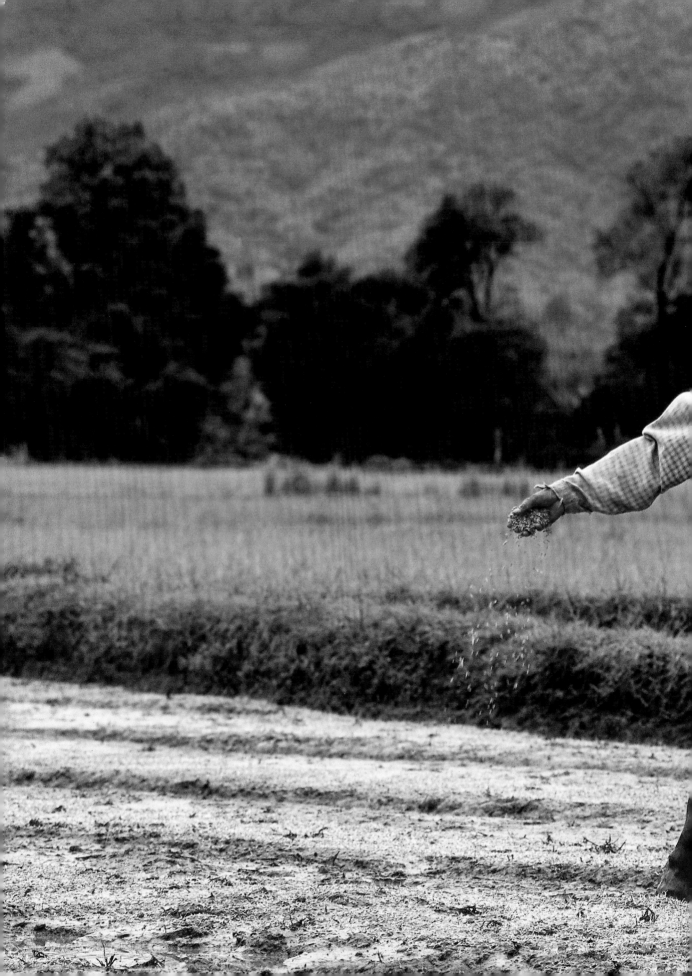

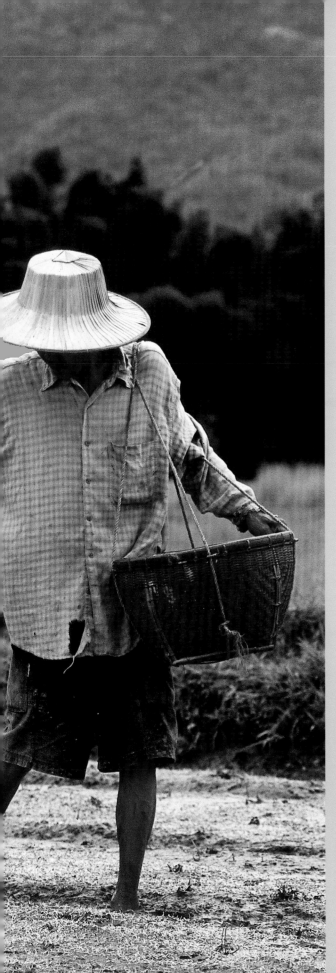

◁ Sowing rice in Chiang Maï province in northern Thailand.

rice

With rice began the cultivation of land. A plant from the dawn of time, a gift of the new bond between newly sedentary man and the soil where he would put down roots, rice – a cereal grain closely related to the most primitive grasses – is still the basic foodstuff for nearly three billion human beings, or half of the world's population. A symbol of abundance and immortality, the seed of a divine farmer or the fruit of a lovers' embrace between heaven and earth, rice spread across continents. When the *Vedas* speak to us of 500,000 varieties of rice, we should really interpret this as an expression of an extraordinary diversity. In fact, it is thought there are more than 130,000 kinds of rice, either cultivated or wild. More than 650 million tonnes of rice are harvested every year, in 113 countries.

Thailand produces less than 5% of this amount, but is still the largest exporter of this wondrous grain. Rice producers in Thailand, where half the agricultural land is dedicated to growing rice, are self-sufficient in food. In the kingdom of Thailand, where it is said that "when the rice farmer suffers, the country suffers", rice is not just fundamental to the economy, it is a mainstay of national culture.

The subtle soft green tones of Thai rice fields elegantly blanket the countryside. Bamboo shelters on the edges of these immense green spaces add a final touch to this bucolic traditional Thai image. The serene gaze of the visitor could mistake this coloured effect for a natural phenomenon or for an artistic folly of Mae Phosop, the omnipresent goddess, the Earth Mother.

At the edge of his patch of land, Kampun has placed a small receptacle made of banana leaves filled with offerings for the goddess. This gesture is essential in a land where rice is treated like a god in many rituals of daily life. He reaches into his basket for a big fistful of barely germinated rice that he sprinkles onto little mounds of soil. "This is my own rice, left in the river for a few days to germinate," he explains. His neighbour Pirun arrives in the field, where he is welcomed by the greeting "gin khao" – a term commonly used to ask "How are you?" but which really means "Have you eaten any rice?"

Pirun invites us to visit his fields, where young twigs have already begun to appear and glisten with drops of dew. Alongside the seedlings, mature plants are already bearing their first grains of rice. "This is sticky rice I sowed 12 weeks ago. It's for us," explains Pirun. "I plant one-third sticky rice and two-thirds jasmine rice on my two hectares." Close by, twenty or so cows are grazing in a small enclosure. "Thanks to them, I can grow everything organically," Pirun tells me proudly. Kampun continues, "I used to use chemical fertilizers, but their price increased year after year, while my production decreased. The more I produced, the more I went into debt. I was left with less than 10% of the selling price for my hard work! Since I've been farming organically, my work represents 50% of the sales price and I've been able to pay back all my debts."

In Thailand as elsewhere, the green revolution led to increased production based on the use of high yield seeds and the widespread use of pesticides and chemical fertilizers. In addition to health problems and soil and groundwater contamination, these practices, which require a great deal of capital, led the small farming class into greater debt and promoted land concentration. Chemical agriculture means that only large intensive farms can hope to make money on their investments, through economies of scale. I found this same vicious circle of debt among producers of coffee, cocoa, cotton, and many other commodities. In this context, Kampun's choice of

⊡ Offerings to Mae Phosop, the Earth Goddess. ⊡ Kampun, sowing his land. ⊡ Kam Pa ploughing a flooded patch of land, which will soon turn into a rice paddy.

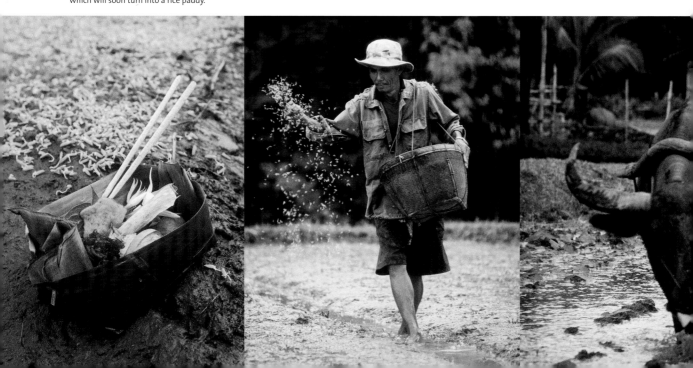

⌂ A rest hut beside a rice paddy in northern Thailand.

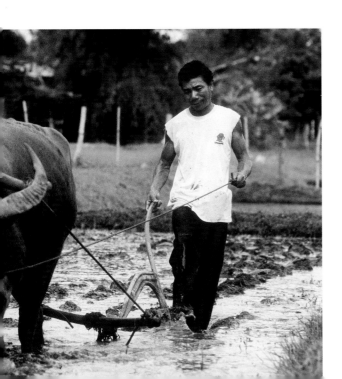

organic methods stems from a good dose of far-mer's common sense and his desire to keep on making a living from agriculture.

As members of a small cooperative consis-ting of 36 families in the Chiang Maï region in the north of Thailand, Kampun and Pirun export their organic jasmine rice through Green Net, the largest exporter of Thai organic products. The goal of this organization, a pioneer in the deve-lopment of fair trade in Thailand, is to guarantee fair prices for farmers so they can free them-selves from a vicious circle of debt, thus slowing down the rural exodus. Green Net, which brings together 1000 farmers in five regional associa-tions, also has as its mission providing Thai and international consumers with high quality orga-nic products.

"RICE IS LIFE"; the slogan of the recent International Year of Rice, declared by the United Nations in 2004 (the first was in 1966), summed up the rightful place this cereal holds in the planet's human equation. It is the only major cereal grain that can subsist and even prosper in flooded terrain – the genus *Oryza sativa*, originally found in Asia, and its West African cousin, *Oryza glaberrima*, manage to feed half the Earth's population.

Rice is an amazing grain, initially covered by an inedible husk and made up of a brown layer, the bran, and a white starchy interior, the albumen. When it is removed from the plant, the 'paddy' rice (unrefined) is turned into brown (or 'whole grain') rice at the mill and is then refined, which causes it to lose its amber coating – but unfortunately a considerable portion of its nutritive substances as well – in return for a shorter cooking time and longer shelf life. White rice is the most widely consumed worldwide.

The largest food-producing crop in the world is grown mainly by small farmers to feed their countrymen – only 7% of all rice produced crosses an international border. While China and India are by far the biggest producers, Thailand and Vietnam are the predominant exporters.

Fair trade in rice began in 2000. With 4685 tonnes imported in 2008, it could be said that fair trade rice is like a single grain in the big sandbox of the more than 650 million tonnes produced worldwide. In Canada, it represents barely 0.0006% of retail sales. Switzerland is the main importer of fair trade rice, at nearly 1,300 tonnes.

rice in figures

CONVENTIONAL TRADE

Global production: 651,742,616 tonnes
Global trade: $10,527,000,000

MAIN PRODUCING COUNTRIES

China	29%
India	22%
Indonesia	9%
Bangladesh	7%
Vietnam	5%
Thailand (7th)	4.3%

FAIR TRADE

Year of certification: 2001
Global imports: 4685 tonnes
Retail sales: $28,270,000
Growth (2007-2008): 11%

CERTIFIED ORGANIZATIONS

15 small producers' organizations in four countries.

ORIGIN OF CERTIFIED ORGANIZATIONS

Thailand	59%
India	27%
Laos	7%
Egypt	7%

MAIN IMPORTING COUNTRIES

	Imports (t)	Growth (2007-2008)
Switzerland	1,298	-2%
France	953	-1%
United Kingdom	833	33%
Germany	451	48%
Italy	289	17%

PRICES AND PREMIUMS (Thailand)

Fair trade price: $231 to $354/t
Fair trade premium: $24/t
Organic premium: $20 to $32/t
Proportion of organic rice: 44%

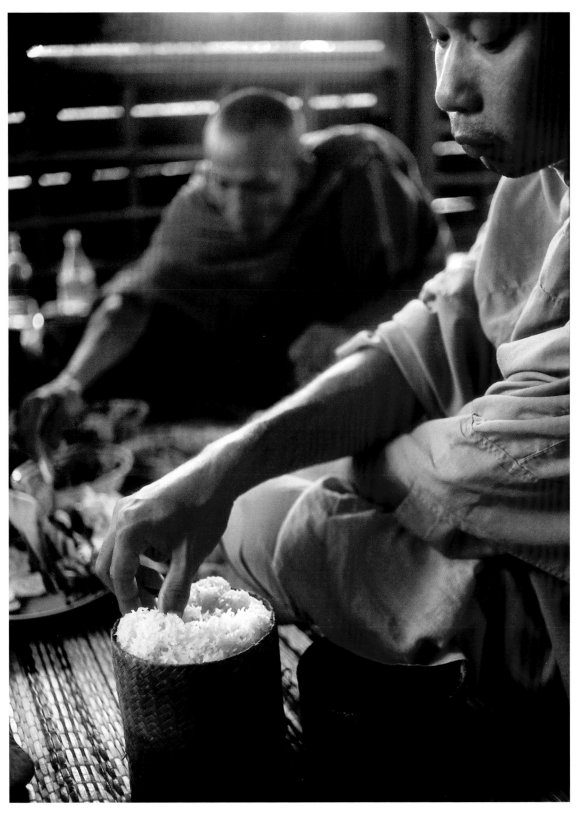

⌐ After receiving rice as an offering from peasants in the Yasothon region, these Buddhist monks are eating breakfast, traditionally their only meal of the day.

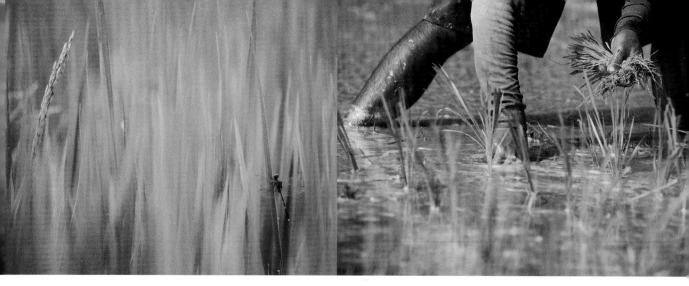

⊡ A dragonfly in an organic rice paddy, a sign of environmental health. ⊡ Samon Skiradee is replanting, at regular intervals, bunches of three to five rice seedlings. ⊡ In Thailand, 90% of the rice fields are irrigated for replanting, to increase yields and reduce the amount of weeding.

||

In the Yasothon region, in the northeast of Thailand, transplanting is in full swing. The rice fields are all flooded (90% of Thai rice fields are irrigated) and everyone is bustling around performing his or her respective tasks. In one field, the young shoots are already more than 30 centimetres tall and ready to be pulled up. The peasant farmers tap the roots gently on their heels to shake off the soil. Others use long bamboo poles to transport the sheaves. These sheaves are carried a bit further away, into a new rice paddy flooded for transplanting. Here and there, bent over and with their feet deep in the sticky earth, the farmers replant the stalks in clusters of three to five blades. It's as if their hands, pulling up the seedlings, and their feet, walking in the mud, were copying the movements of a ritual dance performed in celebration of life.

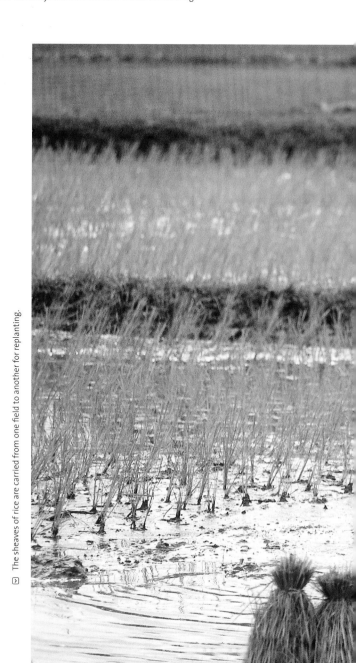

▷ The sheaves of rice are carried from one field to another for replanting.

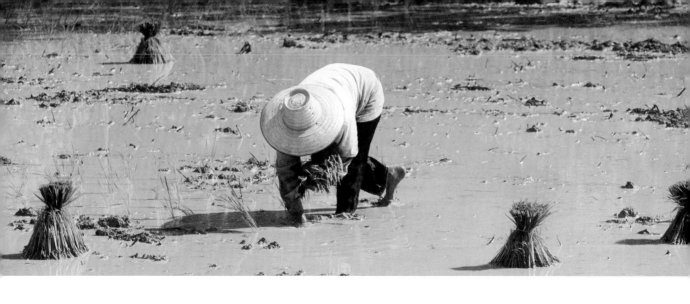

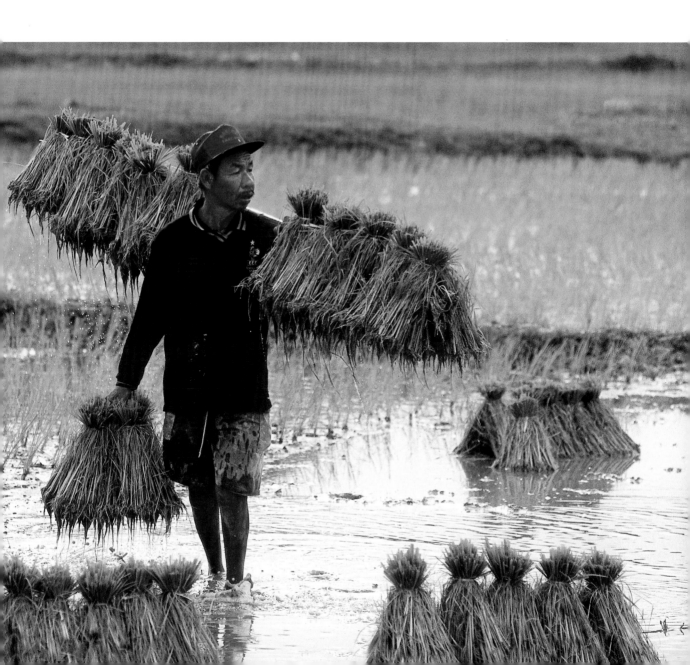

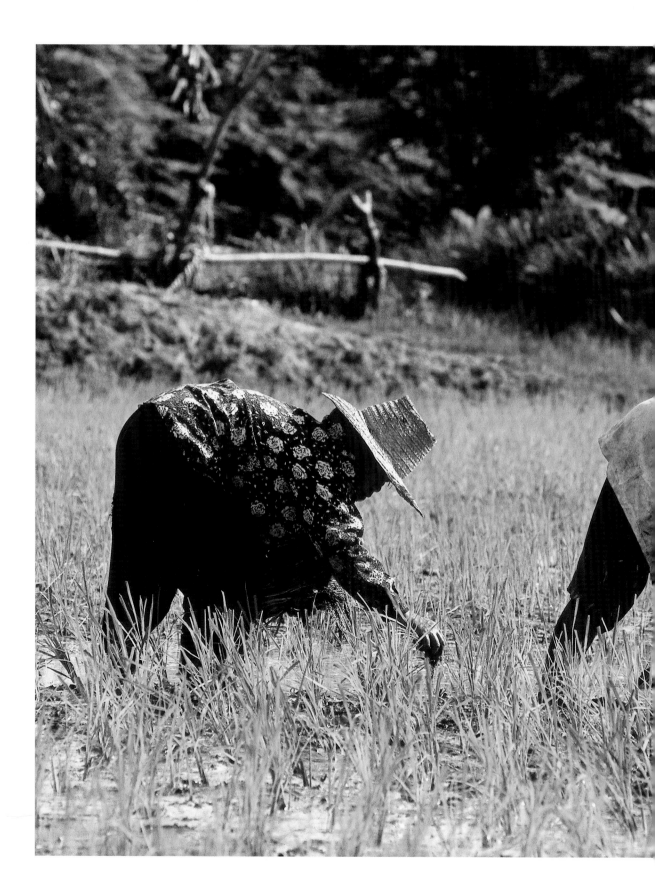

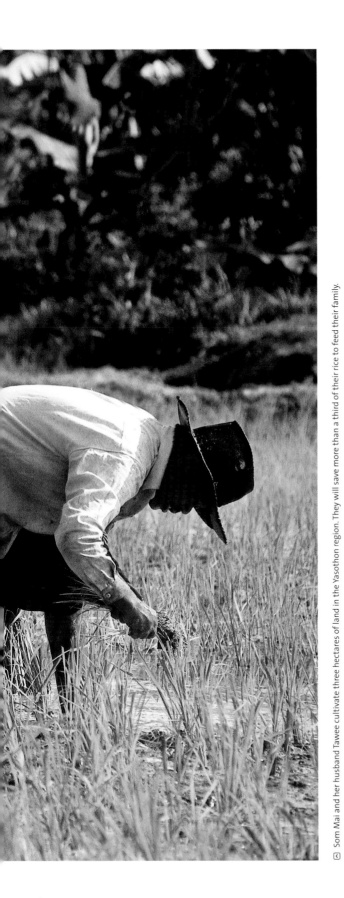

Som Mai and her husband Tawee cultivate three hectares of land in the Yasothon region. They will save more than a third of their rice to feed their family.

Chutima and her son Haleem.

||

With Chutima, the young technician from the Yasothon cooperative (Nature Preservation Club), founded at the beginning of the 1970s, I visit Ta Wee and Son Mai, typical small producers of the region. Their three hectares are a Garden of Eden. There are fruit trees, vegetables, fish ponds and even a frog hatchery – evidence of rich ecological and food diversity. In Thailand, organic rice farming uses a unique approach that encourages diversification. It's not uncommon for organizations that encourage organic farming to require small farmers to produce dozens of varieties of agricultural products on their land – a diversification of crops that promotes self-sufficiency.

"My father became a strong advocate of organic farming after having come very close to dying from cancer," says Chutima. Man Samsee, her father, a founding member of the Yasothon cooperative, had noticed that many farmers suffered from dizziness and head or stomach aches on crop-dusting days. When he was diagnosed with cancer, he quickly made the connection. His own disease was also his society's disease. By choosing organic farming, Man Samsee got involved in the battle to regain his own health and that of his environment. The lesson was well understood by Chutima. "Choosing organic is good for my health, my child's health and also the health of those who are going to eat the rice I grow."

WHEN INTERVIEWED BY A JOURNALIST who asked him how long he had been 'growing organic', an old French farmer replied without hesitation, "Forever. When I began to farm, there was no poisonous farming." If 'growing organic' means producing food without using any chemical pesticides, synthetic fertilizer or genetically modified organisms, we'd have to say that organic agriculture has been the norm for a very long time, ever since man began to sow.

The enrichment of soils using artificial additives began in the middle of the nineteenth century, when German chemist Justus von Liebig, the father of 'chemical agriculture', denied that humus had any nutritional role and proclaimed the salvation of agriculture using nitrogen (N), phosphorous (P) and potash or potassium carbonate (K). Von Liebig's prophecies delighted the owners of Germany's potash mines and chemical industries. Chemical agriculture became the norm. It took just a few decades for soils and foods to deteriorate sharply.

In 1924, philosopher Rudolf Steiner laid the groundwork for what he called biodynamic agriculture: "Agriculture that ensures the health of the soil and plants to provide healthy food for animals and people." Agriculture as promoted by Steiner takes into account the cycle of the seasons, the lunar cycle, and the planetary cycle, and uses powdered substances in compost and on plants to improve their yields. For its part, the International Federation of Organic Agriculture Movements (IFOAM), founded in 1972, bases its definition of organic agriculture on four main principles: health, ecology, fairness and care. According to IFOAM, "Organic agriculture is a production system that sustains the health of soil, ecosystems and people. It relies on ecological processes, biodiversity and cycles adapted to local conditions, rather than the use of inputs with adverse effects."

In its 2007 report, even the United Nations Food and Agricultural Organization (FAO) recognized that organic agriculture can meet worldwide food requirements without damaging the environment like modern agriculture does. With a reminder that in 2006 organic agriculture was "practised in 120 countries representing 31 million hectares and a market of 40 billion dollars", the FAO encouraged UN member countries to promote this type of farming.

Today selling products labelled 'organic' requires certification (AB, Ecocert, USDA, etc.). In addition, in several countries, certification is regulated by laws, which is not the case for the term 'fair trade'. Worldwide, nearly 50% of coffee, cocoa and rice certified fair trade are also certified organic. In Canada, 59% of fair trade sales involve products that are also organic. The remainder of fair trade production has to use agricultural practices that respect the environment and must limit the use of pesticides.

⊡ Organic agriculture encourages farmers to grow local varieties of rice. For Kankamkla Pilandi, this is a real passion; his land is an open-air laboratory where more than 75 varieties of rice are grown, including one he created himself.

⊡ Using organic methods, Phakphum Inpaen grows six kinds of beans, 12 varieties of fruit, 15 varieties of vegetables, and 20 kinds of edible herbs, as well as an abundance of rice. All this on a few hectares of land.

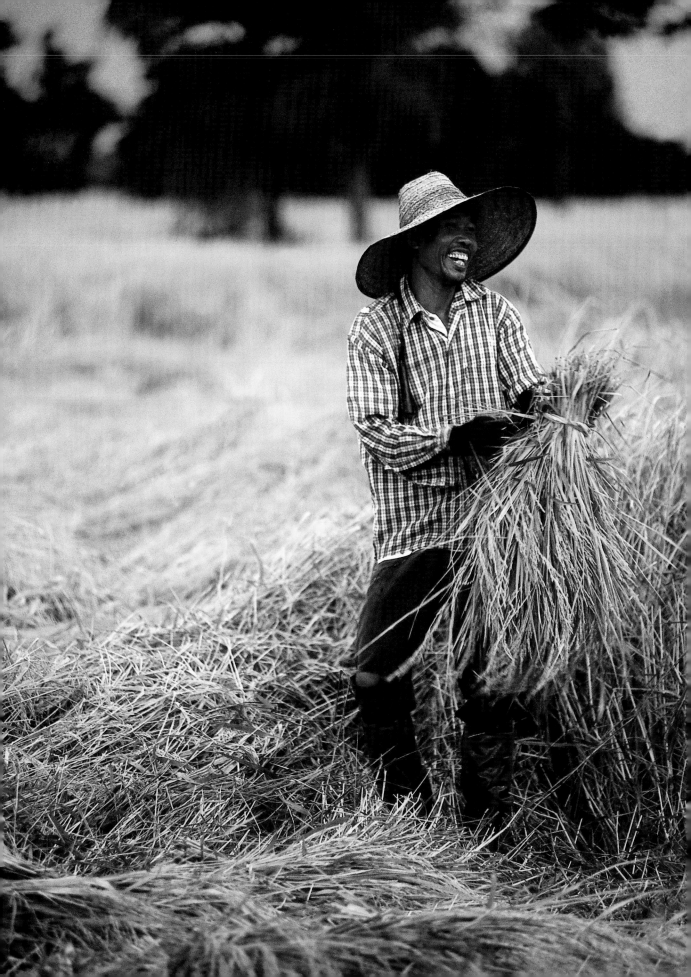

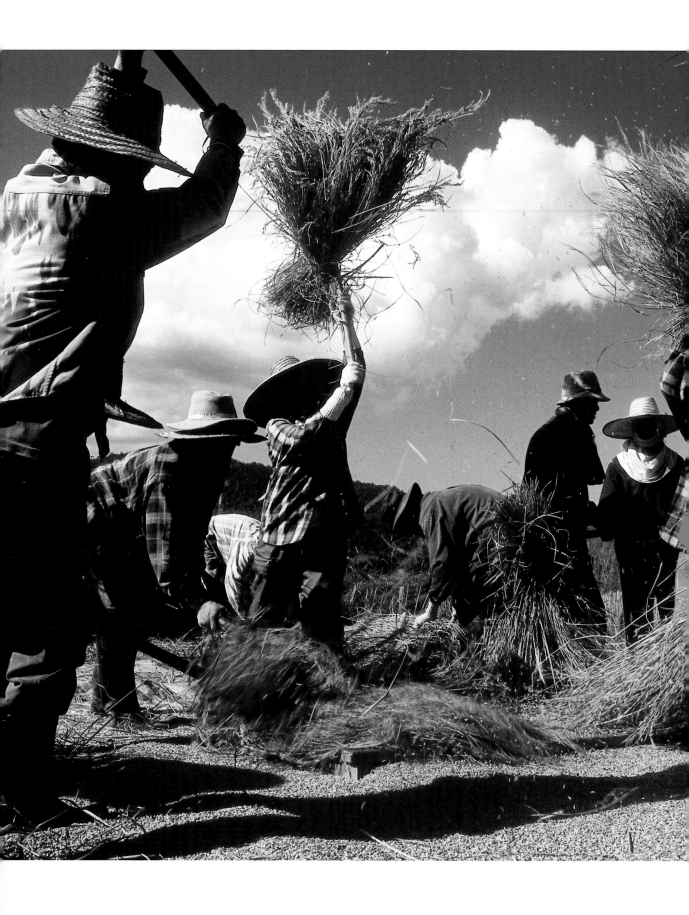

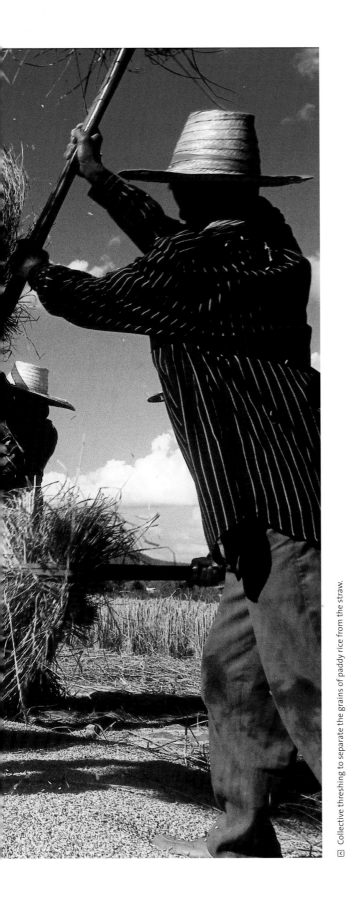

Collective threshing to separate the grains of paddy rice from the straw.

Sumanta Matkhao harvesting her rice.

||

Months have gone by and October has re-painted the dried up rice paddies with golden highlights. At Kampun's place, harvesting is at its peak. "We often work together to encourage each other," he says. After much hard work, it's time to eat. Everyone puts his contribution in the centre of a mat. On the menu: sticky rice, of course, but also herbs and vegetables along with a few local specialties, such as small quails, roasted grasshoppers and a lively fricassee of vigorously swarming red ants. Conversations revolve around the beneficial effects of organic products on the lives of producers and consumers. "Here we aren't afraid to eat our rice," says a neighbour. "In the centre of the country they have four harvests a year (whereas elsewhere there are only one or two), but the producers use so many chemical products that they prefer to buy rice from other parts of Thailand for their own consumption."

||

A few fields further along, Pa Yanchai and her husband carry sheaves into the centre of their patch of land for the rice threshing. The sheaves are then firmly held between two sticks tied together with a rope and beaten to separate the grains from the stalks. In a neighbouring field, Dang, Kam and Pan have exchanged their sticks for shovels and winnowing fans. They fan the grains to quickly remove impurities, before the paddy rice goes to the mill.

▽ After having threshed the rice in a big basket, Dang, armed with a wooden shovel, tosses the grains in the air, while Kam and Pan fan the grains to eliminate impurities in the paddy rice.

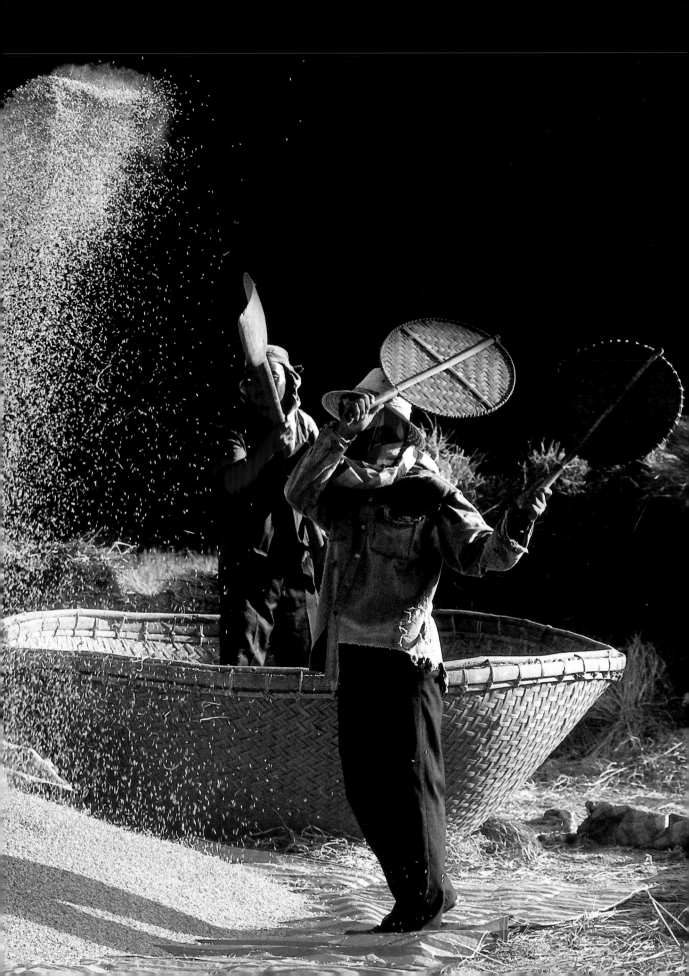

|||

At the Surin cooperative, in the northeast of the country, the rice mill is swarming with people coming and going. Here the paddy is husked to produce grains of brown or white rice. Women are busy selecting by hand the rice that will be vacuum-packed for export. Against the warehouse walls are stacked boxes for various clients: Claro in Switzerland, Alter Eco, in France, and Equita, Oxfam-Quebec's fair trade brand, in Canada. The mill also houses the offices of the Surin Rice Fund, the local cooperative. Today is meeting day for the board of directors, one of whom is Kanya Onsri.

Smiling and with a determined look on her face, this mother of two in her late thirties, the daughter of a *pram* (guardian of traditions), is the president of the 45-member producers' association in her village. She is also the founder of a day camp that aims to make agricultural labour more attractive and encourage the passing on of ancestral knowledge. This project is especially dear to her heart because of the participation of 25 of the village's 30 young people.

At the camp, after the fieldwork is done, Kyra, an American volunteer, gives English lessons to the village's young people. At the end of the lesson, when the children find out I speak French, they also indicate their wish to learn a few words. Kyra, who speaks Thai perfectly, takes the opportunity to ask for lessons in Khmer, the daily language in this region next to Cambodia. "The lesson will take place this evening at Kanya's place,"

Kyra tells them. At 7:30 in the evening, the whole gang plus a few parents gather. "*Bonjour*, good morning, *gin kao*"; their desire to learn seems boundless. When I ask them what sentence they would like to learn, Kyra translates their response, laughing, "Go take a bath!" "But...I had a shower!" I say, looking surprised. "You mustn't take it personally," she adds quickly. "Bathing at the end of the day is an essential habit here. For them, telling a stranger to take a bath is a way of welcoming him warmly." After Kyra's explanation, everyone has a good laugh.

Early the next morning, a van stops in front of Kanya's house. Women with baskets crowd inside. "Every Saturday, we go to the Green Market in the city of Surin to sell our surplus farm products," explains Kanya. Going from house to house, the van fills up with provisions, overflowing onto the roof. "This family doesn't even sell rice at the cooperative. It earns all its income from the Green Market," says Kanya.

At the market, clients are awaiting the van's arrival. Even before the stalls are set up, the prices are already being negotiated. Fruits, vegetables, fish, frogs, frosted peanuts, fresh rice cooked in bamboo, fried bananas – we are spoilt for choice. One client tells me unhesitatingly, "These bananas are better and cheaper than the ones in the other markets."

On the way home, everyone in the van is happy. Each calculates the day's total sales: $10, $25, $40. Kanya reminds me that some of them

⊡ Kanya Onsri with young people at her day camps. ⊡ Smeuan Rabeunam, Kanya's father and *pram*.

⌄ Selecting grains of brown rice by hand at the Surin cooperative's mill.

make as much as $100 on a Saturday, which is huge, given that a manual worker earns $4 a day. The Green Market has become an essential complement to export agriculture. She continues, "This allows us not only to increase our incomes, but also to have money coming in from week to week. The money from the sale of rice goes toward big purchases, to renovate our houses, etc.; money from the Green Market covers our weekly expenses." One of the women jumps out of the van outside the first farmhouse we come to, from which she quickly returns with a bottle of rice alcohol under her arm. The bottle doesn't make it around the group twice. In a racket of Khmer, laughter comes from all sides, showing gums blackened by betel nuts. Outside, the countryside is bathed in warm highlights. The peasants, with scythes on their shoulders, are returning from the fields. It's a moment to be savoured.

Fair trade has not just transformed the material circumstances of the lives of Kanya and other small-scale Thai producers. The democratic participation inherent in this small farmers' organization has been and remains an engine for social change. "Usually, in Thailand, women take care of household tasks, but in my home it's not like that. Men and women with ideas have to participate in meetings and get involved!" Kanya tells me. Carrying a tortoise shell, a long stalk of sugarcane and a few offerings, she and her father head slowly toward the granary where a portion of the annual harvest is stored. She explains the celebration to me. "This is one of the final ceremonies where we apologize to Mae Phosop for having taken her rice, and ask her to accompany this rice wherever it goes...even to Quebec!"

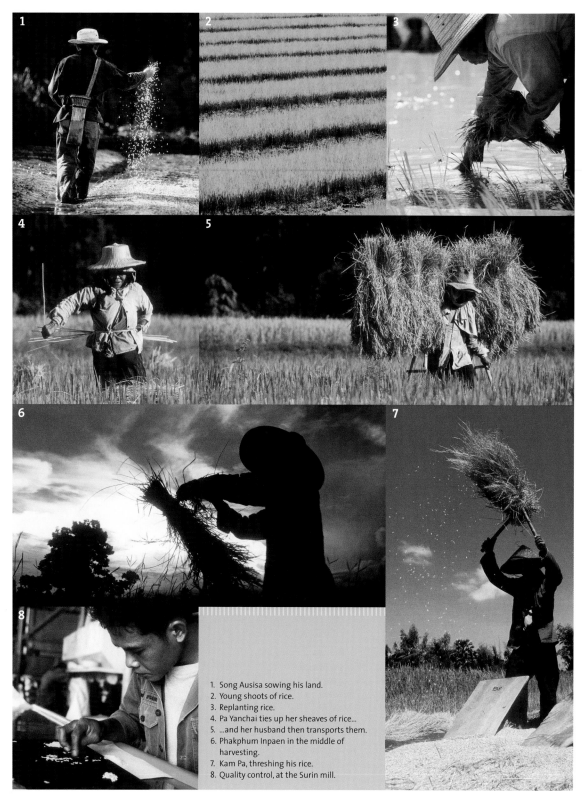

1. Song Ausisa sowing his land.
2. Young shoots of rice.
3. Replanting rice.
4. Pa Yanchai ties up her sheaves of rice...
5. ...and her husband then transports them.
6. Phakphum Inpaen in the middle of harvesting.
7. Kam Pa, threshing his rice.
8. Quality control, at the Surin mill.

▷ Top : Pa Yanchai takes a well-earned break.
▷ Bottom : This paddy rice will soon be sown to start another growing cycle...

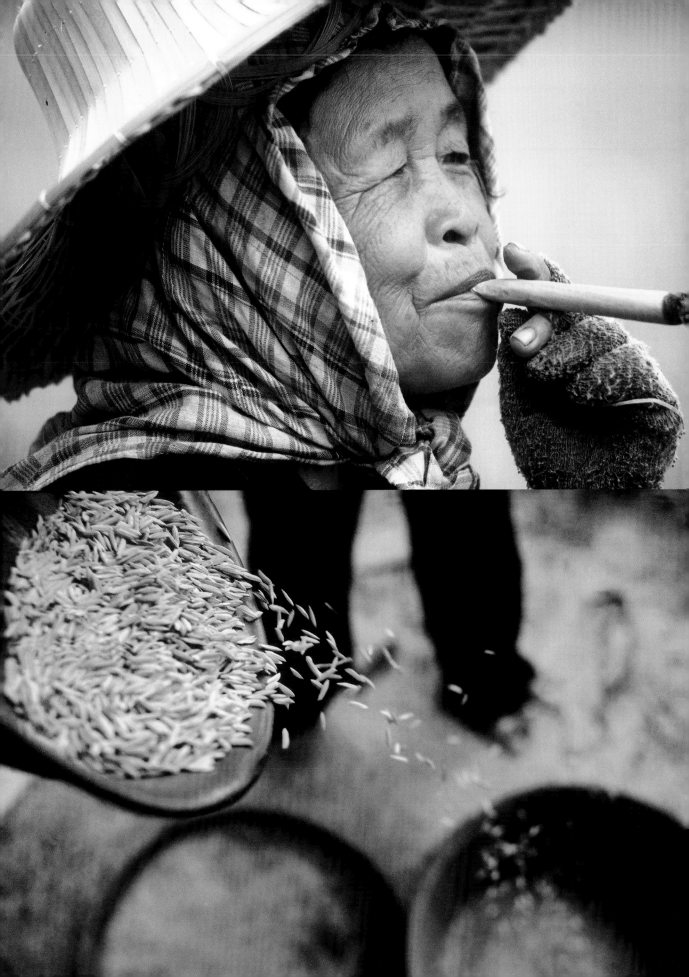

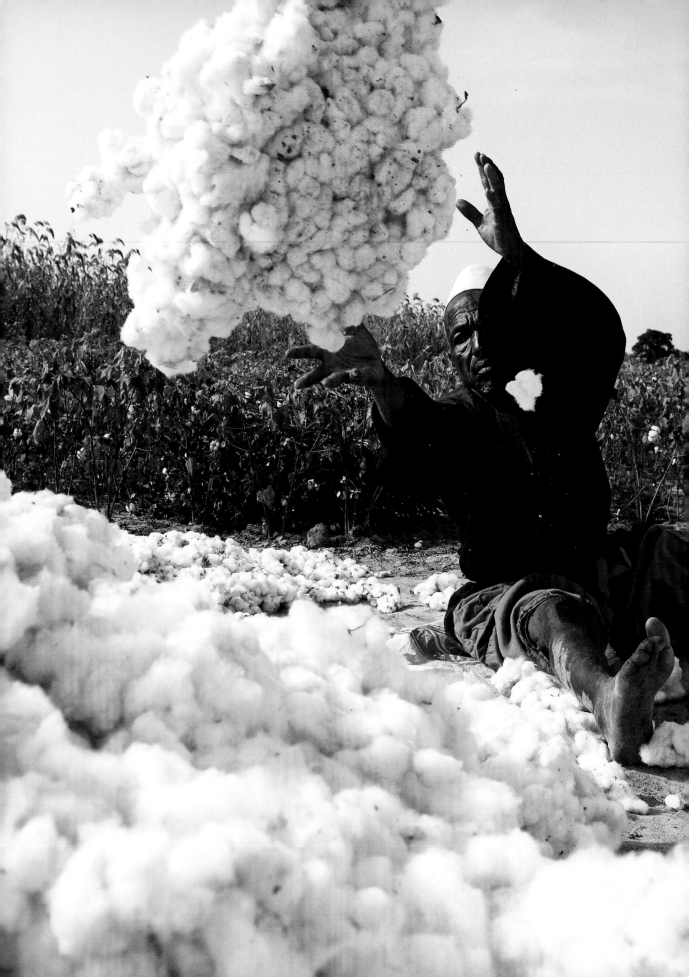

cotton

In the plant kingdom, cotton is the essence of gentleness. It spread across the globe even before human beings did, perhaps preparing for their arrival. The use of cotton for clothing purposes is without a doubt one of man's first achievements. While India was the cotton distribution centre for China and the Middle East, knowledge about and cultivation of the cotton plant go back to the dawn of various civilizations in different parts of the world, as shown by the discovery of fragments of cotton fabrics over 7000 years old in Mexico's Tehuacán Valley. In ancient Greece, Herodotus was surprised at the quality of clothing worn by Indians, made of a "wool that is more beautiful and softer than that of sheep." Could this softness be the reason behind our universal preference for this fibre whose origin is so mysterious? From India to Mesopotamia to the colonies of the New World, cotton became and remains to this day the world's main textile fibre.

There was cotton in Africa long before there were contacts with Arabs or Europeans, as evidenced among the Dogons and Soninkés. "In Dogon mythology, Nomo, a mythical ancestor, spits out cotton threads. These threads are separated by his teeth, with his lower and upper jaws forming a weaving loom. The fabric is the word, the word-fabric," says Boubacar Doumbia, a Malian artist belonging to the famous Kasobané group, which brought Bogolan art to the attention of the world by creating contemporary works inspired by the ancestral technique of using clay to dye cotton.

||

In the Kita region, a few hundred kilometres northwest of Bamako, the capital of Mali, the countryside is ochre-coloured and sandy, typical of the arid sub-Saharan regions. In Djidian, adobe houses and a few small shops line the hard earth road, and a large antenna looms over the village. "It was for cellular phones, but someone stole the solar panels," the mayor tells me. "Beside it are the buildings housing the generator, which gives us a few hours of electricity...usually every evening!" Mali ranks number 173 out of 177 countries on the human development index, but the country is nonetheless rich in traditions and culture.

In his fields, a few kilometres from the village, Téréna Keita is harvesting cotton with his children. The sun is like lead and the heat overwhelming. "I have two hectares of cotton, from which I harvest nearly two tonnes," he explains, picking the small white balls off the delicate shrubs one by one. "Last year, I sold 280,000 francs worth of cotton, but my fertilizer cost 225,000. I only had 55,000 francs ($125) left after the harvest." Cotton is often the only way these producers can afford fertilizers for all of their agricultural production. Téréna also grows corn, peanuts, sorghum and millet, mainly for subsistence.

All Malian cotton is sold through the Compagnie malienne pour le Développement du Textile – the Malian company for textile development, or CMDT. Founded in 1974, the CMDT, with 4,000 employees, claims to be represented in 6,345 villages and hamlets, with a population of 3,700,000 people, or 28% of the country's population. Cotton has been an economic force in Mali for a long time, but the fluctuations and especially the decline in world prices and the never-ending demands for privatization from the International Monetary Fund (IMF) have greatly weakened the state company. In 2003, Malian producers harvested 620,000 tonnes of cotton,

⊡ Téréna Keita's children, back from the cotton fields. ⊡ The day's harvest.

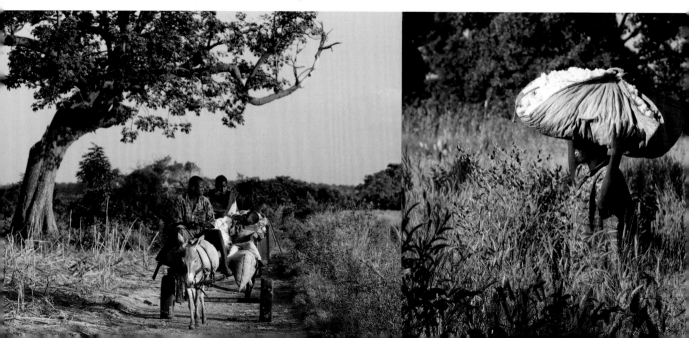

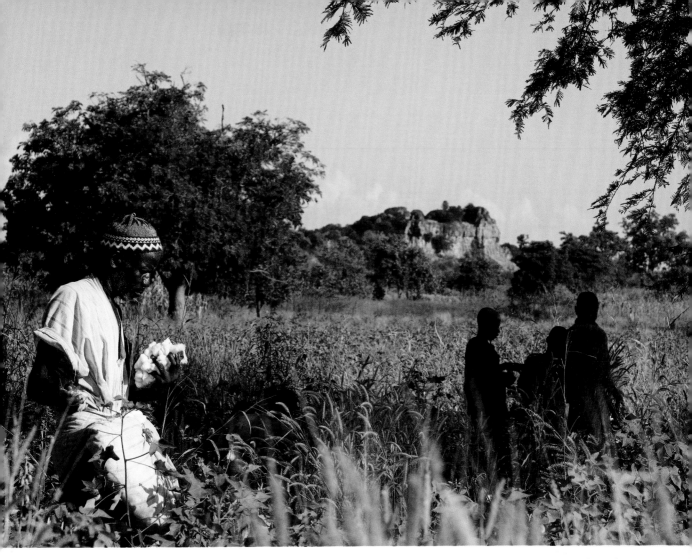

Téréna Keita harvests his cotton, in the Malian countryside.

whereas in 2006-2007, they harvested just 240,000. The Malian cotton sector is going through a major crisis.

Although the production costs for African cotton are lower than those for American cotton, the latter is a bigger player in the world market because of the subsidies given to producers in the United States, estimated at more than 4 billion dollars. These subsidies mean that American producers receive from 90 to 140% more than market prices for their cotton. Brazil made a complaint against these subsidies and won, but its victory was short-lived, because American dumping is still going on. The failure of negotiations at the World Trade Organization's Ministerial Conference (Doha round) in 2008, caused by wealthy countries' determination to maintain their subsidies, left farmers in the South in uncertainty.

With the cart filled up, it's time to head home, where Téréna's two wives are busy preparing the evening meal. Their earthen house consists of three adjacent rooms. Two granaries, structures seen everywhere on the Malian landscape, stand in the central courtyard and underneath one of them a goat nibbles on a few leaves. A small storehouse completes the picture. Two cows graze outside the walls that encircle the property. Cetou, his second wife, carries a bucket of water drawn from a communal well a few metres from the house and Kanimba, his first wife, carries the cornmeal dough and peanut sauce. For dessert, I'm offered hot milk and sugar that I share with Téréna's twelve children. His oldest daughter, Sayou, is nursing her baby, while her younger brothers build a magnificent vehicle out of a few pieces of wire. When the sun has set, the evening ends by lantern light. This evening, there is no sign of electricity.

The Kita region was the first in Mali to export fair trade cotton. In November 2003, an agreement between Max Havelaar France, Dagris and the CMDT made it possible to begin exporting fair trade cotton to Europe. In 2004, FLO made the certification of cotton, its first non-food sector, official. In France, more than 20 large brands started selling fair trade clothing, with much advertising fanfare.

The Malian fair trade sector grew quickly, going from four cooperatives in 2003 to 72 in 2007. The production of fair trade cotton has risen from 400 to 5,000 tonnes. "Fair trade premiums and the price differential increased producers' incomes by 450 million francs (1.1 million dollars) in 2005-2006," says Sékou Amadou Thiéro, manager of fair trade for the CMDT. "Because of these funds, we have been able to complete a number of social projects, including building wells, schools, dispensaries, warehouses, etc."

||

A few kilometres from Djidian, Dougourako-roba and Dougourakoroni are among the first villages to have taken a chance on fair trade. Classrooms built with fair trade premiums mean that the village children now avoid many hours of walking, morning and evening. "Our classrooms are now well built; the children no longer sit on earthen floors; we have more rooms and each grade has its own classroom," says Soulale Sékou Aba, the principal of Dougourakoroni school, which has 133 students, of whom 61 are girls.

||

In Batimakana, the producers are proud to show me around their warehouse, where they stock pesticides, fertilizers, farm produce, and cotton. Behind the store, a dispensary is being built. "We'd really like to finish it, but we're still waiting for the fair trade premiums from last year's harvest," explains the president of the Batimakana cooperative. It seems that even fair trade isn't immune from the Malian cotton crisis. At the CMDT, Sékou Amadou Thiéro doesn't hide his anxiety. "Unfortunately, after so many hopes were raised at the beginning, orders have levelled off quickly. As of now, we have still not sold a single kilo of last year's harvest. The cotton is still sitting in the port at Dakar and as long as it hasn't been exported, we are not paid in full. The 30 new certified cooperatives haven't yet seen any sign of fair trade premiums. The producers haven't lost hope, but they're worried." Cotton from the 2008 season will not be certified fair trade, for lack of demand.

☑ Kadiatou, an elementary school student in Dougourakoroba. ☑ A Dougourakoroni classroom, built with fair trade premiums. ☑ A classroom under construction in Batimakana.

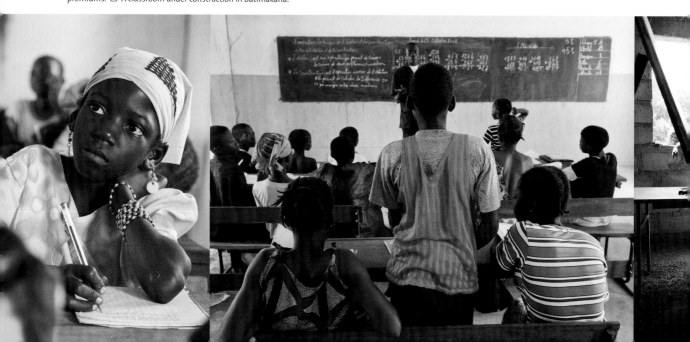

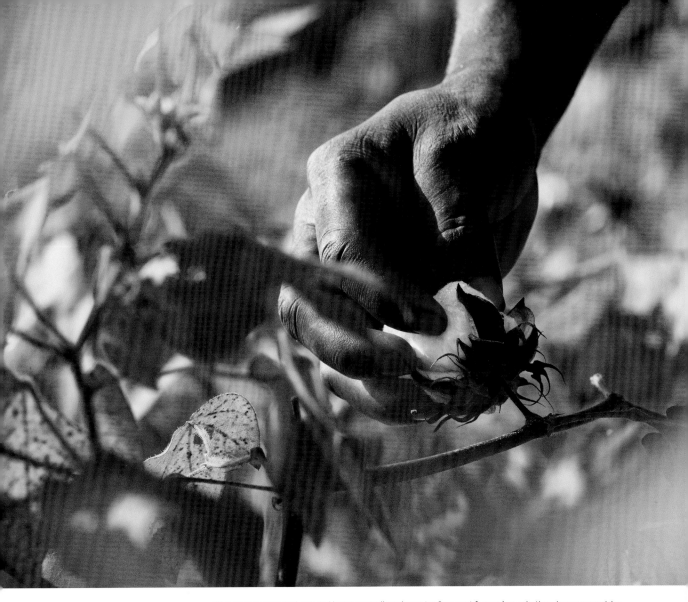

⌃ Fair trade cotton is harvested by many small producers in 28 peasant farmers' organizations, in seven countries.

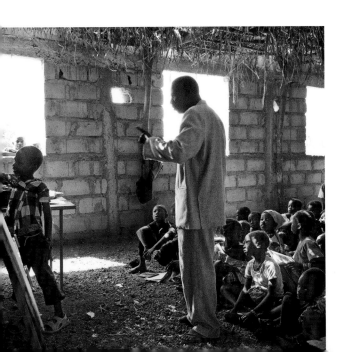

In the Batimakana school, it's the same thing: the brick walls have been built, but the temporary roof lets in sun and rainwater. "We've received many delegations here, but what we are waiting for now is our premium money," the cooperative's president reminds me, with an accusatory look. In Djidian, Téréna comes to the same conclusion. "The premiums have not been paid and, what's more, we didn't receive money for the cotton until June, when the harvest had already been over for several months. We went from 75 members in 2006-2007 to just 25 in 2007-2008."

COTTON IS A PLANT OF THE FAMILY MALVACEAE (mallow), of which the best known varieties are *Gossypium arboreum* and *Gossypium herbaceum*, found in India, *Gossypium badanense*, found in Peru and Egypt, and the most famous, *Gossypium hirsutum*, originating in South America, which accounts for more than 90% of production worldwide. The seeds make up 55 to 65% of the total weight of cotton harvested (seed cotton), depending on the variety. The fibre (cotton fibre) accounts for 85% of the market value of this same cotton. From the seeds, vegetable oil is extracted for cooking and food is produced for livestock.

Cotton cultivation is extremely polluting. Although it covers barely 2.4% of arable land, cotton uses up 11% of the pesticides and 25% of the insecticides produced globally. In India and the United States, 50% of agricultural pesticides are intended for cotton production. The gradually increasing resistance of pests to these substances has led to more frequent spraying, exposing human beings and the environment more and more to a multitude of dangers. Transgenic cotton, among which is the sadly famous 'Bt Cotton' produced by agri-food giant Monsanto, is taking over large production areas (66% of production in India and 93% in the United States), despite much criticism.

Around 100 million families earn their living from cotton, in 70 countries, but in terms of volume, world cotton production is controlled by three countries, China, India and the United States, which together account for 67%. China, while being the country that produces the most, is also a major importer and consumes 45% of the world's cotton.

In West Africa, production costs ($0.66/kg) are twice as low as those in the United States, but subsidies to American farmers still let them dump three quarters of their yield on international markets at lower prices, artificially causing a decline in world prices. Since 1990, cotton prices have dropped by 70%, resulting in serious crises in 2001-2002 and in 2008-2009 that have put many cotton industries in danger, including Mali's. Following its introduction in 2004, the fair trade cotton sector quickly met with success. In 2008, it was one of the fastest-growing sectors, with sales rising by 94% for a total of 27 million items: T-shirts, socks, sheets, towels and fair trade jeans, sold all over the world. Nearly three-quarters of these sales were in the United Kingdom, where the market went from just 500,000 items in 2006 to 9.3 million in 2007, and to an amazing 20 million items in 2008.

cotton in figures

CONVENTIONAL TRADE

Global production: 72,504,406 tonnes
Global trade: $11,329,000,000

MAIN PRODUCING COUNTRIES

China	31.6%
India	22.7%
United States	12.3%
Pakistan	8%
Brazil	5.4%
Mali (23rd)	0.4%

FAIR TRADE

Year of certification: 2004
Global imports: 27,600,000 items
Retail sales: $261,910,000
Growth (2007-2008) : 94%

CERTIFIED ORGANIZATIONS

28 small producers organizations in seven countries.

ORIGIN OF CERTIFIED ORGANIZATIONS

India	50%
Mali	14%
Senegal	14%

MAIN IMPORTING COUNTRIES

	Imports (items)	Growth (2007-2008)
United Kingdom	20,200,000	112%
France	4,000,000	33%
Switzerland	900,000	-13%
Germany	800,000	not known
Finland	500,000	not known

PRICES AND PREMIUMS

Fair trade price: $0.54 to $0.76/kg
Fair trade premium: $0.07/ kg
Organic premium: $0.10 to $0.15/kg
Proportion of organic cotton: 8%

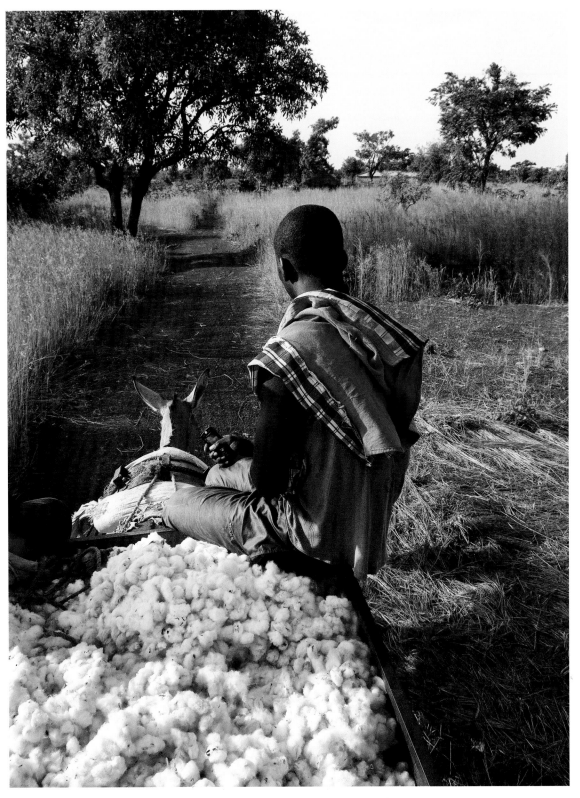

The harvest was good for Yvette Sessé's family. The seed cotton, consisting of fibres and cotton seeds, will be taken to the factory, where the seeds will be removed and turned into vegetable oil and animal feed.

In the office of the Malian organic movement (MOBIOM) in Bougouni, in the southern region, the sale of cotton is also the current challenge. In the first phase of the project in 2002 there were 174 producers; there are now 11,000 producing 2,000 tonnes of fair trade organic cotton. MOBIOM's director describes the situation thus: "At the beginning, we had to fight to prove we could make cotton without chemicals, but with fertilizer costs rising and productivity dropping, organic has become a good alternative to conventional production."

In Sibirila, the harvesting of rice, corn, cotton, peanuts and sesame is underway in the fields. The region is known for its rich agricultural land. In the small village, several men and a few women have gathered to meet with a European specialist come to evaluate Malian cotton's organic sector. Among them, only one represents conventional cotton producers. "There used to be 140 conventional producers but now there are only 21 of us," he states. "The cost of fertilizers ranges from 100,000 to 150,000 francs per hectare. In the old days, some farmers harvested two tonnes of cotton per hectare, but now, we have trouble even getting a tonne. The CMDT provides seedlings, and the variety chosen for conventional cotton has fewer seeds, so we are the losers. At 160 francs a kilo or even 200 francs, the 2008 price, it isn't profitable."

According to the most talkative of the organic producers, Nahoum Samaké, there was a time when conventional cotton meant prosperity. "I could once cultivate nine hectares of cotton and harvest 12 tonnes! I had even bought a motorcycle worth one million francs ($2500) back then, but times have changed. By my last year, I had cut my cotton fields back to three hectares and I still lost 200,000 francs ($500). I had to sell an ox and a cow to pay back my debts. The next year, I started growing organically." In 2007-2008, organic fair trade cotton was worth 326 francs, plus 34 francs of fair trade premium per kilo, twice the conventional price. "Now I'm making a profit," says Nahoum, "and I've been able to marry a fourth wife...She's my organic fair trade wife," he says laughing along with his fellow producers. "It would have been better to look after the other three," Barakali Jara, a female producer who is also a member of MOBIOM, retorts tartly.

"In the past, women didn't grow cotton because of the chemicals, but now with organic cotton, some of us have begun to do so. We started with just a quarter of a hectare per person, or in groups of ten working on half a hectare. Very small yields," Barakali tells me. Yvette Sessé, treasurer of the MOBIOM board of directors, now cultivates a hectare and a half of cotton in Yanfolina, from which she was able to harvest 875 kilos last year. As she explains, "Cotton is a cash crop. There aren't many economic options for women here, aside from shea butter. In Yan-

☑ The literacy room at the Yanfolina cooperative. ☑ Nahoom Samaké with his four wives and 21 children. ☑ Yvette Sessé in Yanfolina.

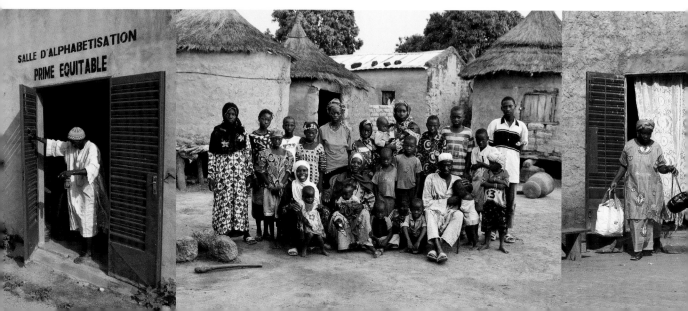

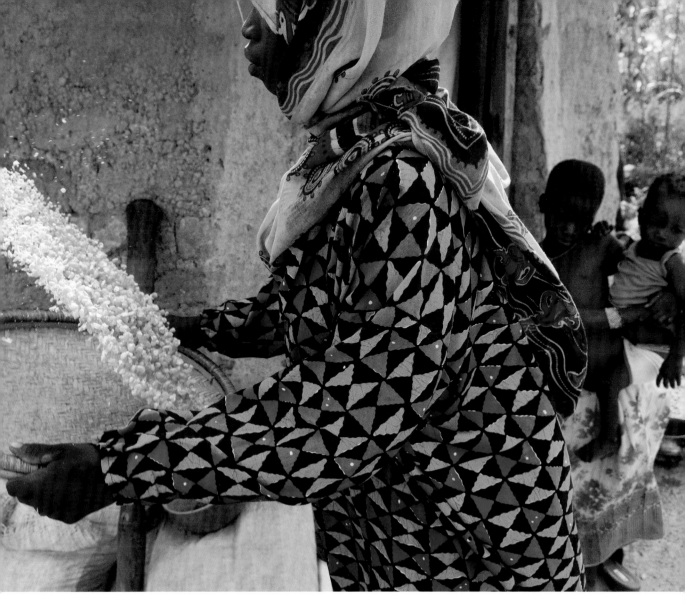

In addition to cotton, Malian peasant farmers harvest rice, millet, peanuts and maize, which Maimouna Jara is winnowing for the evening meal.

folina, there are almost as many women producers as men, and in the region, four women are presidents of their local cooperatives."

In the MOBIOM offices, it's the board of directors' meeting day. Yvette is sitting among her fellow Malian producers, MOBIOM's managers, volunteers from abroad and other experts who have come to advise the association. The director of MOBIOM, back from a European trade fair, presents a few disturbing facts. "Indian organic fair trade cotton is much cheaper right now than Malian cotton; we will have to be more competi-

tive. Today, MOBIOM's immediate responsibility only extends as far as the ginning factory. The exclusive right to sell cotton has always belonged to the CMDT, but with privatization this will change; we will have more flexibility, but also more responsibility for exporting our cotton." "We have to diversify and that also means beginning to process more of our cotton locally." MOBIOM, making the most of its members' production, now offers sesame, peanuts and shea butter, all organic and fair trade.

I N SÉGOU, THE FACTORY BELONGING to the Compagnie Malienne des Textiles – the Malian textile company, or COMATEX –, with 1,400 employees, has been partly owned (80%) by Chinese interests since 1993. In spite of this, in 2009 it had to ask for support from the Malian government, a 20% shareholder, to counter "a lack of competitiveness with Chinese products". Zhang Ouyi, the managing director, greets me in impeccable French and explains that only 10% of Malian cotton is processed inside the country. As for fair trade cotton, "We've tried spinning it," he tells me, "but there was only enough to 'spin it out' for a few hours!"

⌃ Industrial spinning at Comatex in Mali.

"In Africa, I can't order fair trade cotton thread directly. I have to go through European middlemen," explains Marc-Henri Faure from the FibrEthik cooperative, which imports its fair trade cotton from India, the largest producer worldwide, where the image of Mahatma Ghandi at his spinning wheel left an indelible impression. "In India, I can buy cotton raw, as thread, as fabric or made up into polo shirts," he explains. "I work mainly with Agrocel in Gujarat and Chetna Organics in Andhra Pradesh, one of the states most affected by suicides." The high number of suicides among Indian peasants unable to pay their debts, in some cases as a result of purchasing seeds, fertilizers and pesticides to produce Monsanto's Bt Cotton, has been called "the GMO cotton epidemic". The scandal caused a stir in the media and even Prince Charles has denounced "the failure of many GMO varieties". According to Marc-Henri, "The yield from organic cotton is slightly lower, but its export price is much more attractive and therefore more profitable for producers."

"Our clothing is produced by a small family business in Calcutta, Raj Laksmi, but formal FLO certification is limited to producers' organizations," Marc-Henri tells us. Begun by Max Havelaar France in 2004, fair trade cotton certification has given rise to some debate. Already, other solidarity initiatives were taking action against 'sweatshops'. Max Havelaar/FLO, on the other hand, really only certifies small-scale raw materials producers working within democratic organizations. Others involved in processing (ginning, spinning, weaving, clothing production) are only 'accredited' by FLO and must abide by the standards of the International Labor Organization.

India accounts for half of the 28 cotton producers' organizations certified by FLO in 2008. What's more, the number of accredited Indian processing companies is five times higher than the number of producers. In Mali, there are only four certified producers' organizations and COMATEX is the only accredited company.

> Begun by Max Havelaar France in 2004, fair trade cotton certification has given rise to some debate. Already, other solidarity initiatives were taking action against 'sweatshops'.

▷ Bintou Traoré spinning cotton fibre in Ségou.

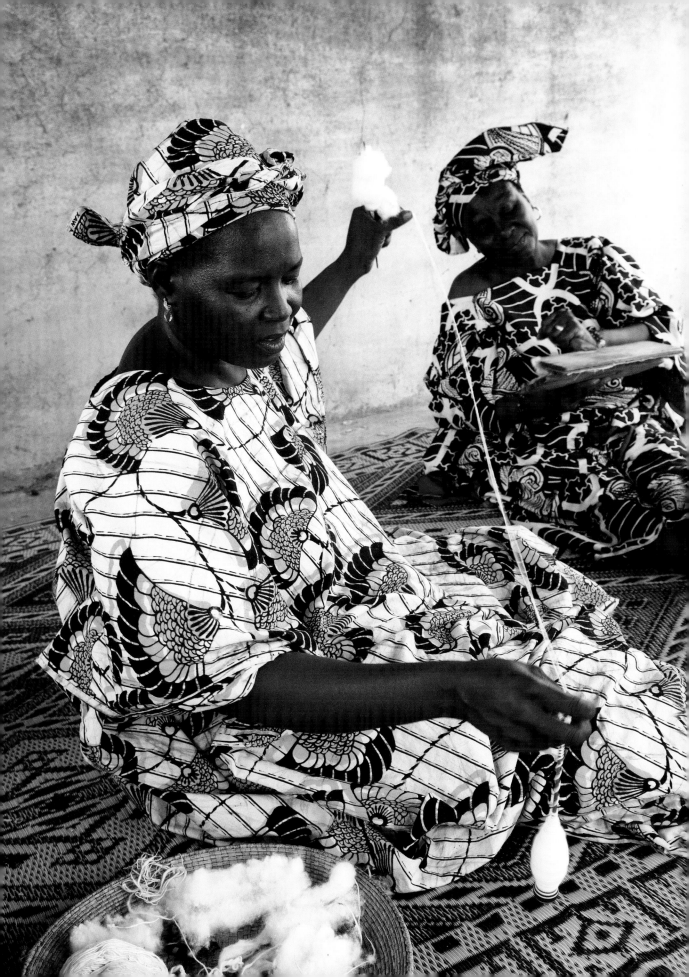

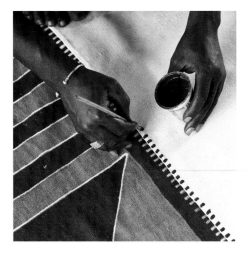

Back in Ségou, Boubacar Doumbia methodically paints large lengths of cotton fabric. His studio, N'domo, is located in a building constructed in a traditional architectural style, whose mud walls are reminiscent of the famous Djenné mosque. "This cotton is spun by women from Ségou and woven in small workshops in the area," Boubacar tells me, as if it were obvious. According to many experts, Malian Bogolan is one of the country's most distinctive arts. The universal language of art has taken this cotton around the world. Unfortunately, those who practise this art, however splendid it may be, cannot use up all the cotton produced in the country's rural areas. Malian cotton, despite being organic and fair trade, seems to always be the victim of global competition.

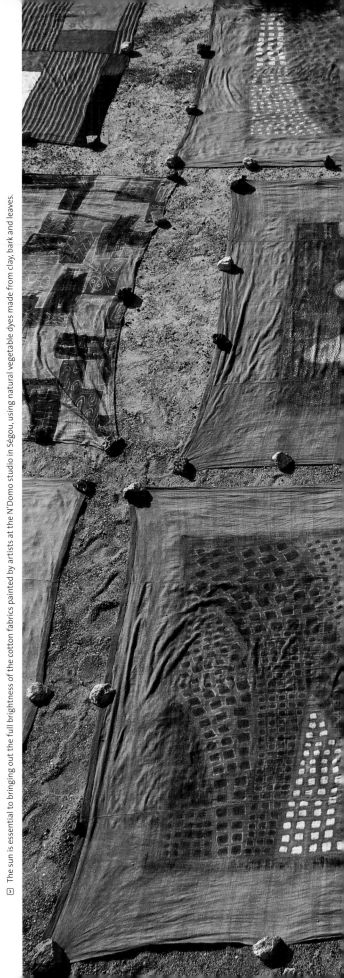

⊡ The sun is essential to bringing out the full brightness of the cotton fabrics painted by artists at the N'Domo studio in Ségou, using natural vegetable dyes made from clay, bark and leaves.

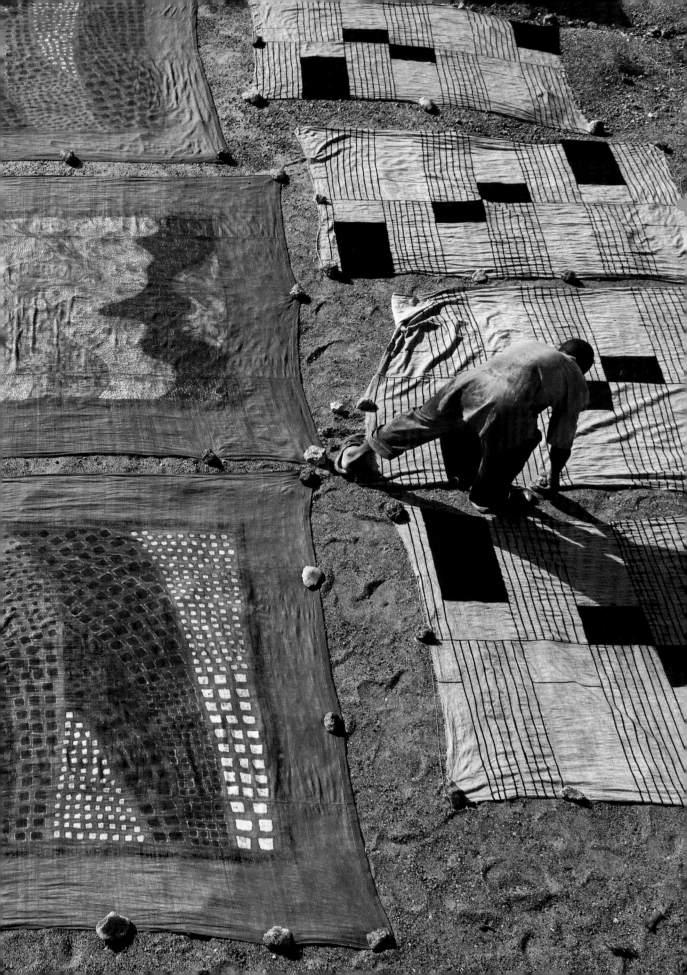

1. A cotton boll.
2. Yvette Sessé, in the middle of harvesting.
3. A cart full of cotton.
4. Rows of threaded bobbins lined up in a Ségou workshop.
5. A weaving loom, in a small workshop in Ségou.
6. Cotton fibre from Comatex.
7. Printed fabric from Comatex.

▷ Top: Awa Samake winnows rice in Sibirila.
▷ Bottom: The cotton boll and its famous filaments account for nearly half of the world's textile fibre production.

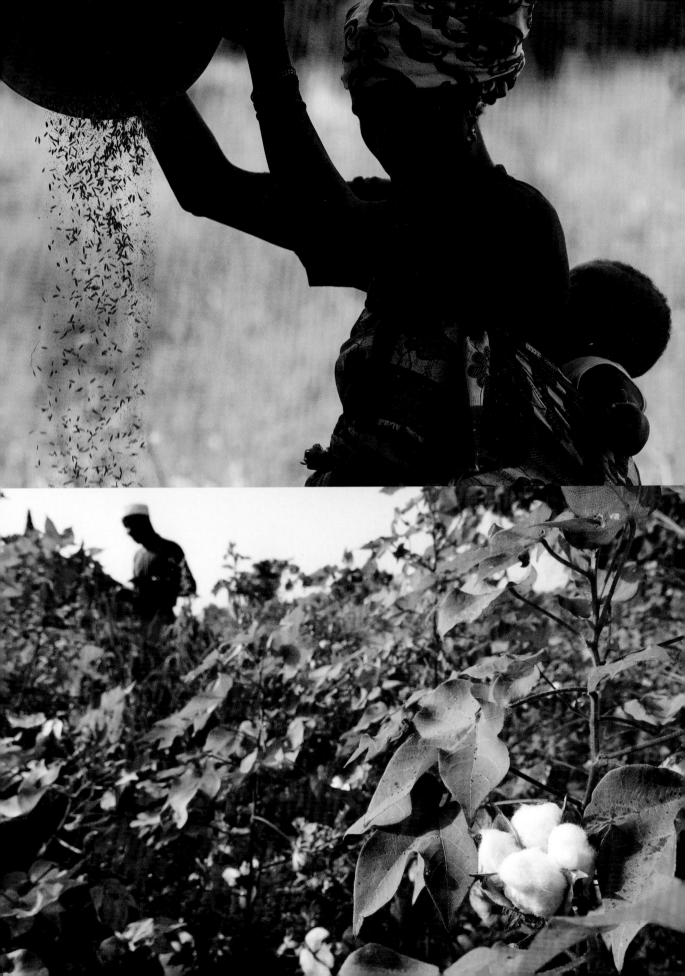

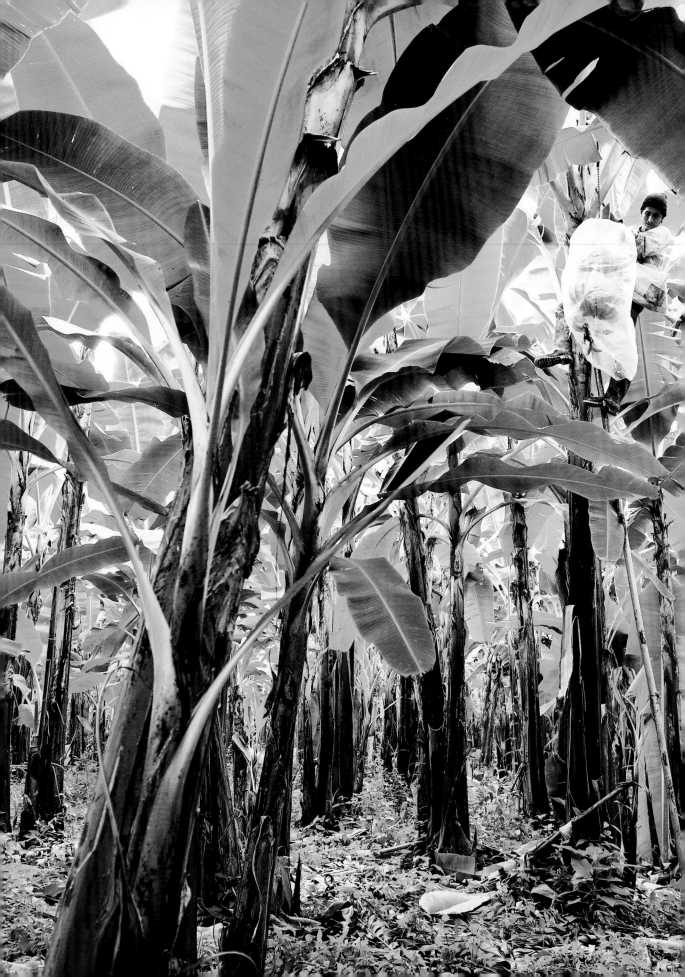

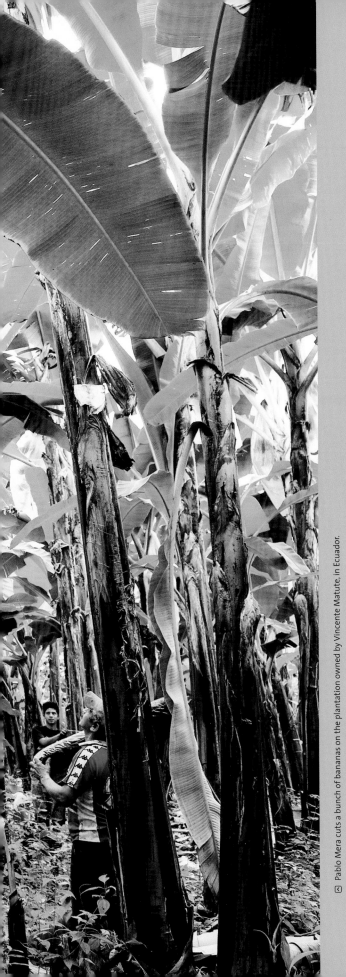

© Pablo Mera cuts a bunch of bananas on the plantation owned by Vincente Matute, in Ecuador.

bananas

I n *El papa verde*, one of the novels in the *Trilogía de la república de la banana*, Guatamalan author Miguel Ángel Asturias, Nobel laureate for literature in 1967, describes a harsh world where small farmers are dispossessed by a monopoly that stops at nothing and is deterred by no one from setting itself up as absolute ruler. This economic power has a political side and commits its share of attacks and massacres. In the history of large fruit monopolies, flavours and settings may change depending on the era and companies may change their names by means of mergers and publicity campaigns, but for small farmers and labourers the injustice remains the same. Outside the novels of Miguel Ángel Asturias lies the dismal reality that, in 2007, an international brand name in the

banana trade paid paramilitaries to hunt down unionized workers! But so what? The company was ordered by its own government to pay a 'heavy' fine – 25 million dollars. In return, the justice system of this great state decided not to investigate the crimes against humanity committed by the multinational company.

||

It's barely 6 a.m. in El Guabo, the banana capital located in southern Ecuador, and already hundreds of workers wait at the intersection of the main roads for trucks to take them to the plantations. I am in one of the fiefdoms belonging to Noboa, a private group involved in transportation, mining, banking, and insurance, and which manages 35% of the country's banana exports. Noboa is one of five banana oligopolies, along with Dole, Chiquita and Del Monte in the United States and Fyffes in Europe, that together control 85% of worldwide exports, a market worth nearly six billion dollars. Ecuador is the world's biggest exporter of this fruit, with almost a third of the market (more than 194,000 hectares here are dedicated to growing bananas). Note that only 4% of the proceeds from the sale of conventional bananas remain in the producing countries.

Hardly have I left the city when banana plantations take over the countryside. The unavoidable Cavendish variety is everywhere. It has cornered 99% of world trade – in spite of the thousand varieties of bananas –, even though many scientists have sounded the alarm about the major risks of an epidemic in a monoculture of this kind. The near eradication of the Gros Michel variety by a fungus in the 1960s seems to have been completely forgotten.

After an hour's drive, I arrive at Vincente Matute's small plantation. He is one of 450 members of the El Guabo Asociación de Pequenos Produtores Bananero – the El Guabo Association of Small Banana Producers. A few workers are gluing boxes together, while others are preparing soap in the washbasins. Fabian, Vincente's son, is adjusting the chains on the tracks for transporting bunches of bananas. Vincente keeps an eye on everything without giving any advice – everyone knows what he has to do. "This plantation is the work of a lifetime," he says, having taken care of this land for 30 years. "I'm happy with my four hectares. What's the use of having ten if you can't look after them," he philosophizes, as we walk through the setting of green, yellow and red. These fruit trees, which can reach ten metres in height, are not really trying to fool us: the banana tree is not a tree per se, as it contains no woody matter, but it is one of the tallest grasses in the world. "A banana tree is 90% water," Vincente tells me, pointing at the water spurting from the all-important irrigation system, which sprays water in a 360-degree arc.

☑ The bunches are cut into clusters of four to seven bananas, which are then put into washbasins. ☑ Vincente Matute, a founding member of El Guabo.

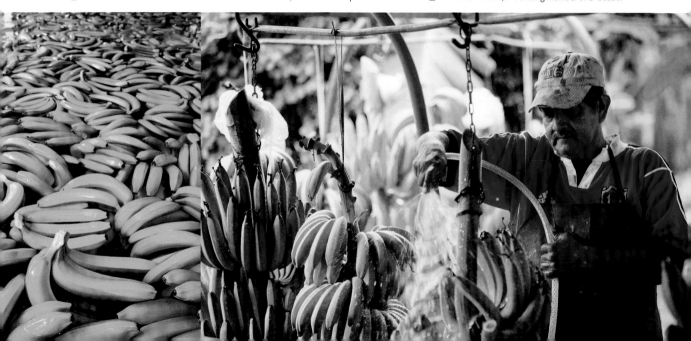

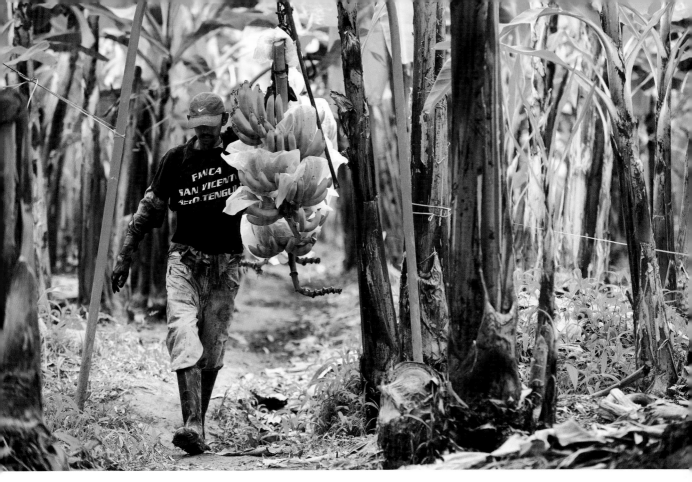

Fabian Matute wants to follow in his father's footsteps and work on the four-hectare plantation where 350 boxes of bananas per week are produced in the high season.

Pablo Mera arrives at a brisk pace with a shoulder bag and a ladder, which he carefully leans next to a large bunch of bananas covered with a plastic bag. He climbs up, takes a chain out of his bag, attaches it to the bunch, cuts the bunch and lets it down gently. Below him, another worker supports the fruit on a large cushion he wears on his shoulder. Pablo then quickly cuts off all the leaves. "You don't cut down the mother plant," Vincente says; "It plays a role in the growth of the daughters, which grow around it permanently." These bananas are seedless and are propagated by underground rhizomes. It takes six or seven months to produce flowers and another three or four months for the fruits to ripen.

"We don't use any herbicides and nematicides here, the Association's agronomists don't urge us to use products we don't need," Vincent explains. "In the low season, I fill 120 boxes, but in the high season, I fill more than 350 boxes per week. Large banana plantations use 30 kilos of pesticides annually per hectare, ten times more than the intensive agriculture of northern industrialized coun-

tries. In fact, health problems linked to widespread use of pesticides have led 24,000 former workers in the Latin American banana industry to file legal proceedings against Dole, Chiquita and several petrochemical companies; the lawsuit involves the nematicide Nemagon (DBCP), which can cause sterility, birth defects, and kidney and liver problems. Banned by the Environmental Protection Agency in the US since 1977, this product is still used on some plantations.

Vicente continues, "At current prices, we don't get rich, but we have enough to get by on." In 30 years, Vincente has seen more than one crisis. "The local middlemen who bought our bananas before we had the association were not exporters. They were exploiters! I remember very well our association's first meeting with the representatives of a European organization. We sat under a tree. We laughed and cried. In the end, they offered us ten times more than the local price," Vincent recalls. "Some people didn't believe in it, but I decided to and so we formed the first small-scale producers' association in the region.

POPULAR LANGUAGE MAY VERY WELL compare apples and oranges, but it is another fruit that really steals the limelight. The indescribable banana, 85 million tonnes of which are produced annually, is the most popular fruit in the world and the most important staple food next to the three basic cereal grains (rice, wheat and corn). Some horticulturalists even speculate that this smile-shaped gift, a grass of the genus *Musa*, may have been the first fruit in the plant kingdom.

The origins of its cultivation by humans, dating back 10,000 years, seem to lie somewhere in Indonesia's string of large islands. After having been considered a forbidden fruit during the Middle Ages, by Christians and Moslems both, the banana appears to have accompanied human migration to Africa – where it got its name, which means 'Arab finger' in the Bantu language – and thence to the New World.

Technological advances in transportation (such as the railway and refrigerated maritime freight) enabled many more people to enjoy its nutritional qualities, including its high carbohydrate and potassium levels and its lack of fat. Unfortunately, the price to pay for increased availability worldwide was high for those at the bottom of the ladder. By taking control of marketing and part of the production process, a few large western monopolies have historically walked off with the profits of the banana trade, while imposing on labourers working conditions that gave rise to the unsavoury reputations of 'banana republics'. Even today, stories about the exploitation of children, catastrophic environmental management or even violent intimidation of unions still surround the fruit; when we turn it upside down, it no longer makes us smile.

The 1990s saw the emergence of a healthy discontent, as a number of regional governments woke up, producing countries joined forces, agricultural lands were given back to workers and export taxes were imposed – a series of changes that set the scene for a true banana war between producers and oligarchs. A world conference in 1998, organized by the International Union of Food Workers, urged the various parties to find common ground. The result was the *International Banana Charter*, produced just a year after the fair trade and organic banana sector was launched. This happened at precisely the right time. Today, by weight, bananas are the largest fair trade sector product, with 300,000 tonnes sold in 2008.

bananas in figures

CONVENTIONAL TRADE

Global production: 85,855,856 tonnes
Global trade: $5,799,000,000

MAIN PRODUCING COUNTRIES

India	26%
China	9%
Philippines	9%
Brazil	8,5%
Ecuador	7,5%

FAIR TRADE

Year of certification: 1999
Global imports: 299,205 tonnes
Retail sales: $660,720,000
Growth (2007-2008): 28%

CERTIFIED ORGANIZATIONS

28 small producers' organizations and 35 organizations with hired labour, in nine countries.

ORIGIN OF CERTIFIED ORGANIZATIONS

Dominican Republic	36%
Colombia	30%
Ecuador	11%

MAIN IMPORTING COUNTRIES

	Imports (t)	Growth (2007-2008)
United Kingdom	189,413	32%
Switzerland	28,019	-1%
Germany	12,432	-9%
United States	11,292	244%
Austria	10,572	51%

PRICES AND PREMIUMS

Fair trade price: $6.75 to
$9.25 per box of 18.14 kg
Fair trade premium: $1/box
Organic premium: $1.50 to $2.30/box
Proportion of organic bananas: 30%

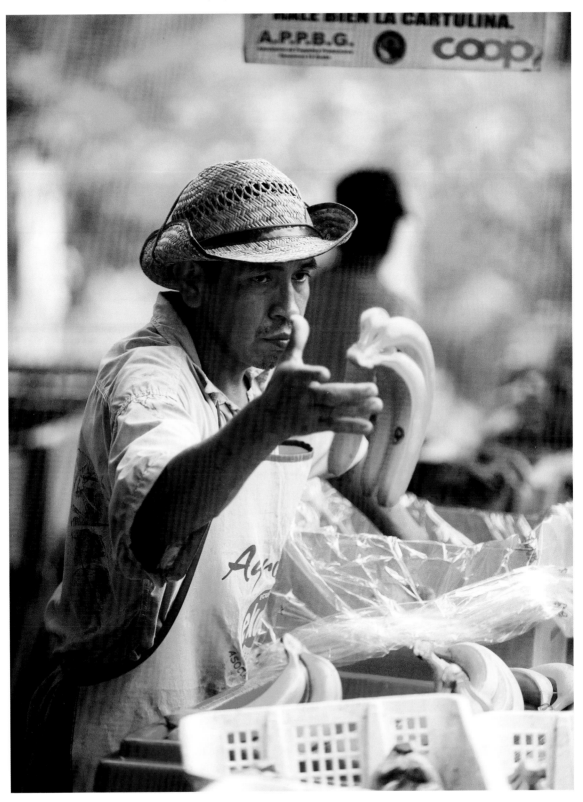

Thelmo Japon packs his organic fair trade bananas into boxes at the Muyuyacu association's small collective facilities. The association is one of El Guabo's 15 peasant farmers' associations.

The first steps were hard, but on November 27, 1997, the El Guabo Association of Small Banana Producers was officially recognized. They had to learn the ins and outs of world trade and meet the quality standards of northern markets, all the while competing with giants. Then along came another obstacle: the El Niño phenomenon. This climatic disturbance, which affected more than 25,000 hectares of banana plantations throughout the country in 1997 (13% of the total surface area under banana cultivation) meant that El Guabo's exports actually had to be suspended.

In cooperation with the Dutch organizations Stichting Nederlandse Vrijwilligers (SNV) – the Netherlands' development organization – and Solidaridad, El Guabo began exporting to Europe again in October 1998. "It was a trial by fire," says Wilson Navarrete, a producer and leader of El Guabo. The trial was successful, for by the beginning of 1999, El Guabo was shipping one container a week and, six months later, had tripled its exports. However, transportation, controlled by the large banana monopolies, remained a challenge. In 2000, El Guabo found a reliable and affordable transporter, but it required that El Guabo provide 20,000 boxes of bananas per shipment, five times more than its fair trade market. The low prices on the conventional market then forced El Guabo to use its fair trade market to subsidize its exports and led producers to develop a new alternative: organic agriculture. By 2003, they had met the challenge. El Guabo exported 10,000 boxes of fair trade bananas, 8,000 boxes of organic bananas and only 3,000 of conventional bananas.

"Today, we export more than 40,000 crates per week, nearly 100% of which are certified fair trade," says Lianne Zoeteweij, El Guabo's general manager, during my visit to the Puerto Bolivar port, one of the largest in the country. Even during this period of reduced production, four million crates of bananas are exported each week. Day and night, ships load up here and begin their one- to three-week voyage to Russia, western Europe, the Middle East or the United States.

"The United States will soon be our second-largest market, once the partnership with Dole is established. There remain a few details to sort out, but in a few weeks our fair trade bananas imported by Dole will be for sale in Sam's Clubs (a subsidiary of Walmart) in the western United

◉ In the Puerto Bolivar port, it's loading day for El Guabo's bananas; they will leave the coast of Ecuador behind as they begin a one- to three-week voyage to Europe, the United States and other fair trade markets.

States," Lianne says. When I ask whether she is comfortable working with companies like these, she replies, "If we are treated fairly and if the rules of fair trade certification are respected, it's good for our members. We need this new market."

IN El Guabo's offices in Ecuador, I ran into representatives from Dole, in Ethiopia several from Nestlé, and in Argentina I was able to witness 50,000 bottles of fair trade wine being shipped to Sam's Club, in the United States. Giants among giants, of whom several question the connection to fair trade. "In North America, a number of multinationals were urged by consumers and activist organizations to offer fair trade products," recalls Rob Clarke, the general manager of Transfair Canada, the organization responsible for fair trade certification in Canada.

⊡ Boxes of El Guabo bananas, warehoused before loading.

On the ground, all the producers' organizations I met said the same thing. "In their dealings with us, these companies fully abide by fair trade criteria." According to Rob Clarke, "Multinationals have not changed FLO standards in the least. All companies importing fair trade products have to respect the same rules. Our job is not to certify companies, but products." This is a big distinction. If, for a particular product, a company follows fair trade certification rules, it can use the FLO label on the product's packaging – a label that guarantees the 'fairness' of the product, but does not take a stance on the social history or the 'fairness' of all the company's practices.

"Our role is to give producers in the South better access to markets in the North," adds Rob Clarke. Market access is often the sinew of war and multinationals have the means to move huge volumes. In the case of coffee, 50% of the volume produced by FLO-certified organizations is exported under the fair trade label; for flowers this is slightly more than 25%, for tea, just 15%, and for sports balls, a meagre 3.7% of items produced. So there is a lot of room for expanding fair trade, both among multinationals and among distributers of 100% fair trade products. "When a conventional company starts out with just a small percentage of certified products compared with its entire supply, we ask it to continually increase its fair trade imports. Fair trade has to be a long-term commitment," says Rob Clarke. The choice therefore remains, for many fair trade stakeholders, whether to create an alternative to the conventional market or reform the system from within!

"In North America, a number of multinationals were urged by consumers and activist organizations to offer fair trade products."

||

Fridays are harvest days for the members of the Asociación de La Florida, located in an agro-forestal region in Ecuador where there is no monoculture. In sloping fields, large native trees overshadow scattered banana trees, grown without irrigation. Several producers also grow cocoa trees. Horses laden with boxes of bananas make their way slowly along the paths and across small rivers. "You won't see production any more traditional than this," says Edgar, one of El Guabo's technicians.

In the collective facilities of La Florida's 23 members, Luis Heras deftly cuts small bananas off large bunches attached to bamboo poles. The La Florida region has several varieties of banana trees. As Luis explains, "With a bunch of Cavendish, you can fill an 18-kilo box; with small varieties, you need four bunches and the boxes only weigh 12 kilos." These fair trade organic bananas are worth $7.25 for the large size, and $8.40 for the small. The same boxes sell for between $0.80 and $3 in local markets. "Before El Guabo, there were no buyers for our bananas. I worked as a labourer for $60 a week. Now I earn at least $150 per week from my bananas," Luis says.

In 2008, El Guabo's sales figures exceeded 20 million dollars, three times those of 2003. For the sale of bananas, the average income of $29,000 per member is by far the highest I've seen in my fair trade travels, but for the smallest producers things are still difficult.

Luis Gamboa and his son Denny look after 8,000 banana plants and cocoa trees on 12 hectares of land. "Quarterly fertilization with manure compost costs $500," Luis notes. "When we sell 50 boxes a week, there's very little left over." Victor Samaniego, a neighbour, has ten hectares of cocoa and banana plants. "In the peak season, I can produce 75 to 80 boxes of bananas, but right now, I can only produce 25. An organic box brings in $7.25, but $2.20 is deducted for the cost of the box and labels, and I have to pay $15 to have my boxes transported. What's left?" Victor asks himself. "My two sons work with me, but if I only sell 25 boxes, I can't pay them the $60 per week a labourer earns. They have to work somewhere else," he adds.

"We have to do more for some of our members so as to increase their yields and reduce costs," says Lianne, in the Association's offices. "For those who produce fewer than 50 boxes a week, it's hard to make a profit growing bananas," she adds. "But with the help of fair trade premiums we're going to set up programs to assist these members in their work." The fair trade premium for each box of bananas is $1. For El Guabo, which exports 2.2 million boxes annually, the amounts in question are enormous. "Twenty per-

⊡ Miguel Merchan transports his boxes of bananas to his organization's collective facilities. ⊡ Luis Gamboa and his son Denny. ⊡ Small organic fair trade bananas heading for the European market.

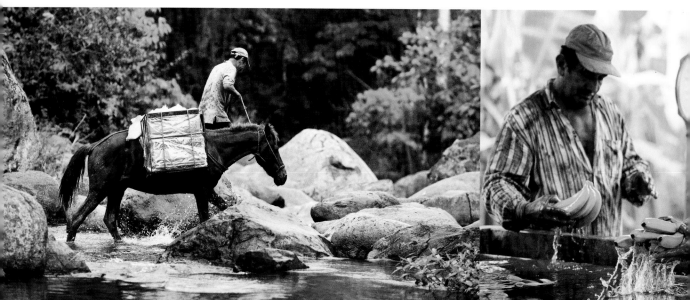

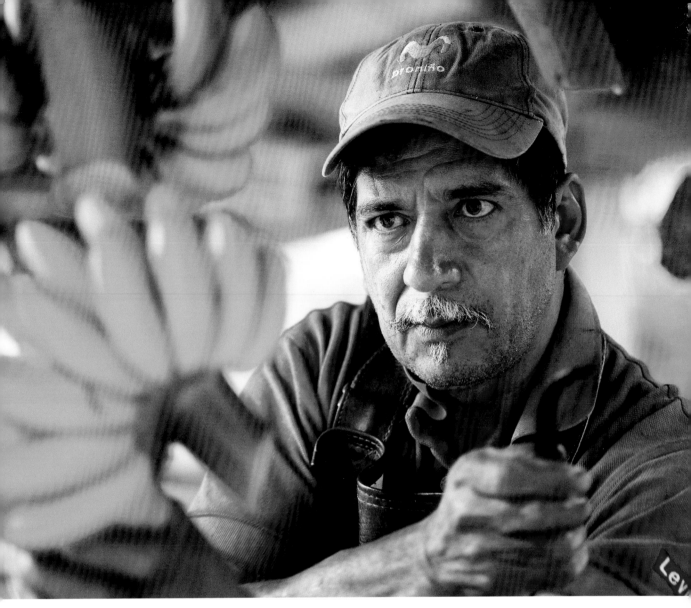

⌂ Luis Heras, a new producer in the Asociación de La Florida.

cent of the premium goes to 15 local associations. We have a clinic with a doctor and a nurse (who did 5,000 consultations last year), and we pay the salaries of 17 teachers in schools in the area," Lianne tells me. What's more, El Guabo pays health insurance premiums for all its members and contributes to workers' organizations. "Every worker on our members' plantations also gets a box of basic foodstuffs every month," the director concludes.

▷ A *rana* sits on a banana leaf, on the organic plantation belonging to Guillermo Limones, an El Guabo member.

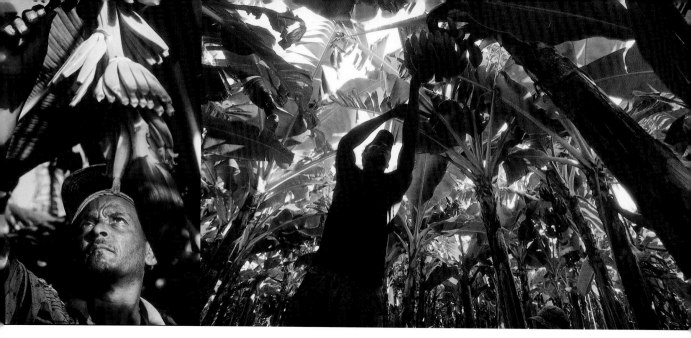

◸ Rosendo Pujol removes a few flowers from the tips of his fruit. ◹ Doni Varga, in the middle of harvesting. ◿ Cutting clusters of bananas. ◿ Getting ready to pack them into boxes for export. ◿ Finca 6's enormous banana plantation, which covers 700 hectares, is subdivided into 250 plots, one for each of the families belonging to this fair trade cooperative in the Dominican Republic.

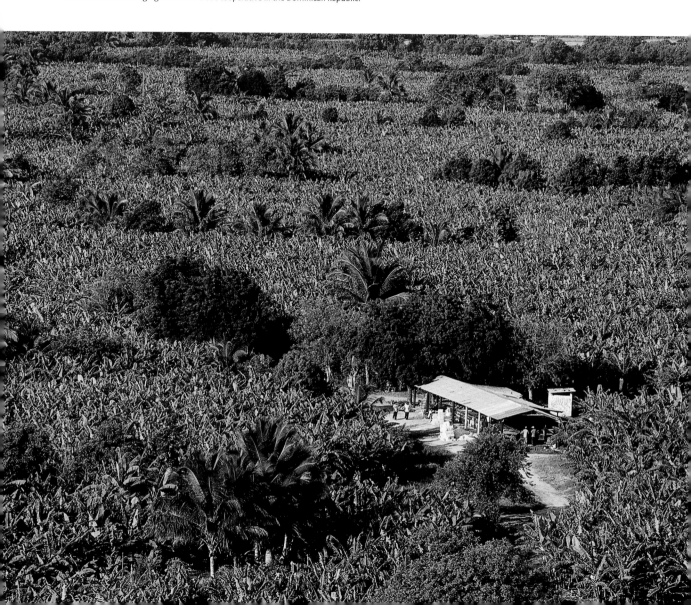

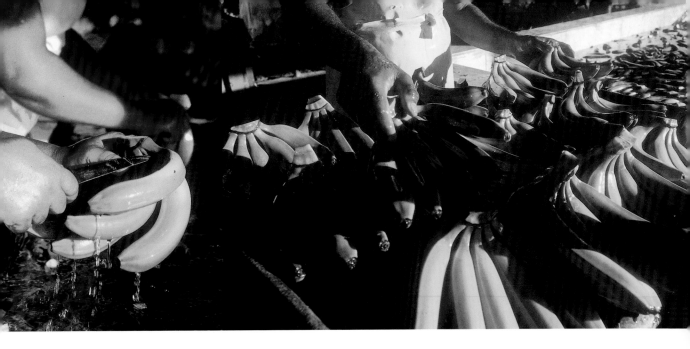

In the Dominican Republic, the Finca 6 organization is not nearly as large as El Guabo, but its history is fascinating. In the early 1990s, 250 families lived in conditions of extreme poverty in the Loma del Curro mountains, not far from the border with Haiti. They practised slash and burn agriculture and were turning the forests of a future national park into charcoal. "We didn't really want to do this but we didn't have the choice," says Angel Custodio, one of the founding members of the organization. Then an abandoned 700-hectare plantation, near the city of Azua, changed the situation. A struggle with the government ensued. "We occupied the land to convince the government to listen to us," says Elia, the president of the organization. Each family was given a two-hectare patch of land. Roads, a school, a church, a small medical clinic and a modest house for each family were built. In 1996, a business opportunity encouraged them to focus on growing bananas – organic and fair trade, what's more. In 1998, Finca 6 was certified and now, each week, six containers of organic fair trade bananas leave the organization's facilities, heading for the Atlantic Ocean.

There is no doubt that sweet, nutritious and cheerful-looking bananas, picture perfect on Carmen Miranda's head on stage in the 1940s and still so today, deserve to play a happy part in the lives of their growers. Consumers in importing countries have the choice between a healthy fruit grown with a concern for fairness and a conventional product bearing chemical residues that will linger in their fatty tissues forever. In our global marketplace, every item carries within it not just the residues of the fertilizers used to produce it, but also the traces of the production relationships that underlie it.

Let's hope that consumers will be able to appreciate, in addition to the sweetness of the fruit they eat, the incomparable taste of solidarity and justice.

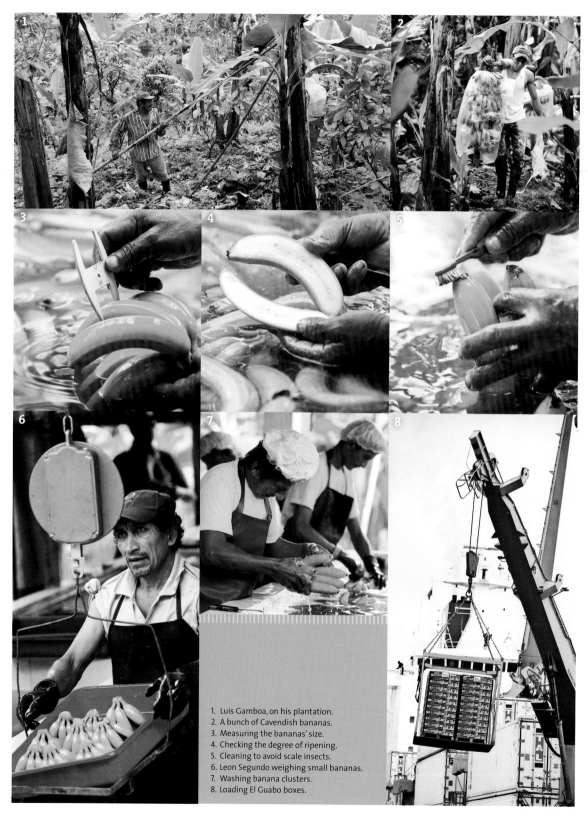

1. Luis Gamboa, on his plantation.
2. A bunch of Cavendish bananas.
3. Measuring the bananas' size.
4. Checking the degree of ripening.
5. Cleaning to avoid scale insects.
6. Leon Segundo weighing small bananas.
7. Washing banana clusters.
8. Loading El Guabo boxes.

▷ Laura Ines and Luis Coyago Sagbay, El Guabo members.

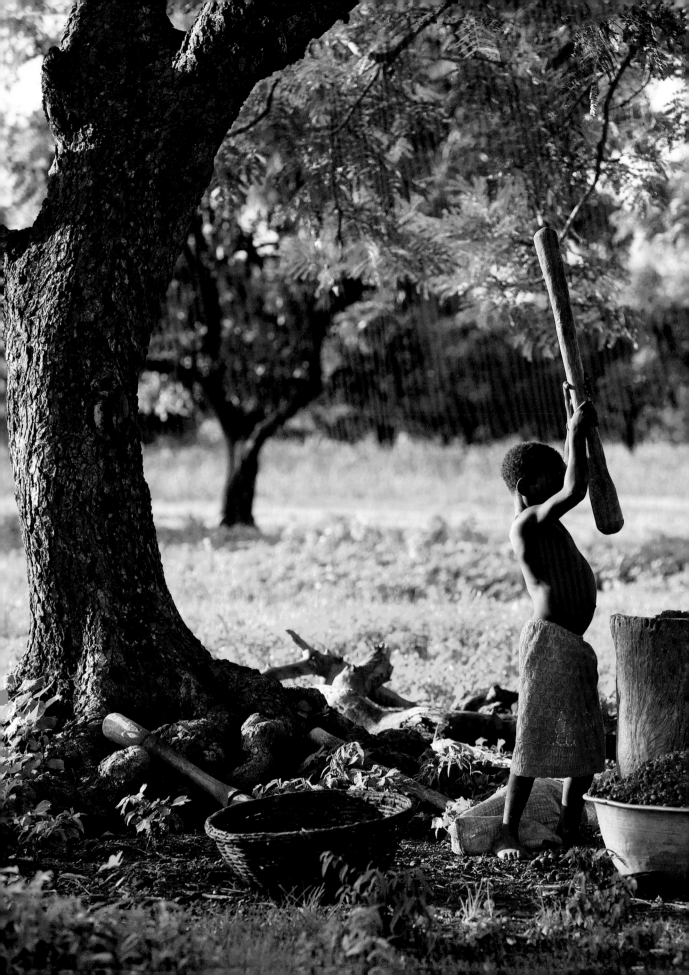

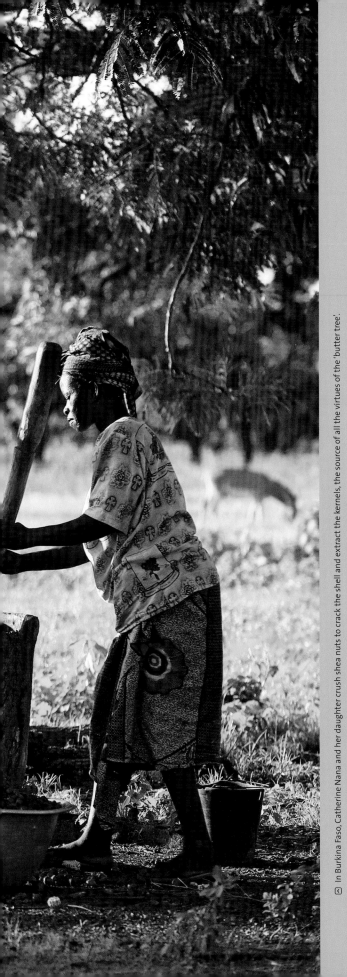

◁ In Burkina Faso, Catherine Nana and her daughter crush shea nuts to crack the shell and extract the kernels, the source of all the virtues of the 'butter tree'.

shea

W e name what we love and Africans understand this well. In Mandingo, the word 'shea' simply means 'life'. In Wolof, the shea tree is called the 'butter tree'. The logic of experience was responsible for naming this tree, which has nourished and beautified generations of human beings over the centuries. According to the Yorubas, the shea tree can even help the gods cheat death. When Shango, their god of lightning and thunder, tired of his failures and his people's lack of understanding, decided to leave this world, he sat down beneath a shea tree to wait for the elements he controlled to come and shake the Earth so it would swallow him up. Was it this tree of youth that enabled Shango to reappear in other cultures, beyond the seas and in another cosmos, to comfort his children living in misery in the fields of Brazil or Cuba?

What's in a name? If we exercised our naming rights, we might call the shea tree 'the tree of time and patience', for it takes at least 15 to 25 years for it to produce its first fruits. It takes 50 years to reach its energetic youth, which continues until it turns a hundred. It then lives another two hundred years, during which it could be called 'the tree of wisdom and knowledge', since the twenty kilos of fruit it produces annually require human labour and traditional knowledge to accomplish all of their good works. This amount of fruit yields just six kilos of kernels, which in the end provide just two and a half kilos of the precious 'shea butter'. If we continued this hypothetical and affectionate naming exercise, we could then call it 'the tree that is all around us', for it is in the womb that human offspring first come into contact with the shea tree. Pregnant women use shea butter on their bodies to soften their skin and firm up their abdominal muscles, the walls of our pre-birth home. Shea, a powerful disinfectant, is then used to heal the umbilical cord. It nourishes the body as a food, pampers it as a lotion, and washes it as soap. It is also found in homes in the form of objects of great significance. One such is the bandiagara, or large eating bowl, of the Dogons, sculpted slowly with a chisel, pyrographed by amazingly skilled blacksmiths, and engraved with disturbing creation myths. And if we are lucky enough to reach old age, it will be there to soothe the weary muscles and joints that are the unavoidable reminder that we are not eternal.

Do we own what we name? No. Scottish explorer Mungo Park did not 'discover' the shea tree during his adventures at the end of the eighteenth century. The homage paid him by naming the shea tree *Butyrospermum parkii* was undeserved and it was later renamed *Vitellaria paradoxa*. Like learned Europeans of the Renaissance, who took from the Greeks what they in turn had learned from their Arab predecessors, Park had no doubt heard about the shea tree through the writings of geographers and travellers such as Al-Umari and Ibn Battuta, four centuries before his pre-colonial explorations. Nor were these great Arab scholars the 'discoverers' of the shea tree. Perhaps the 'discovery' belongs to Oya, Shango's sister-wife. No one can ask her to find out the truth, but what is absolutely certain is that the shea tree was discovered by a woman.

‖‖‖

She was gentle and beautiful like Alice, smiling like Zénabou, strong like Sara and wise like Kayon, the women I see walking quickly through the fields in 'the land of honest people'. It's a pleasant Burkina Faso morning in August, with people preparing for winter and doing field work. Alongside the dirt road are fields of corn, millet and cotton. Here and there I notice a few

⊡ Gathering nuts at the foot of a tall shea tree. ⊡ Zénabou, Sara and Kayon, back from the harvest.

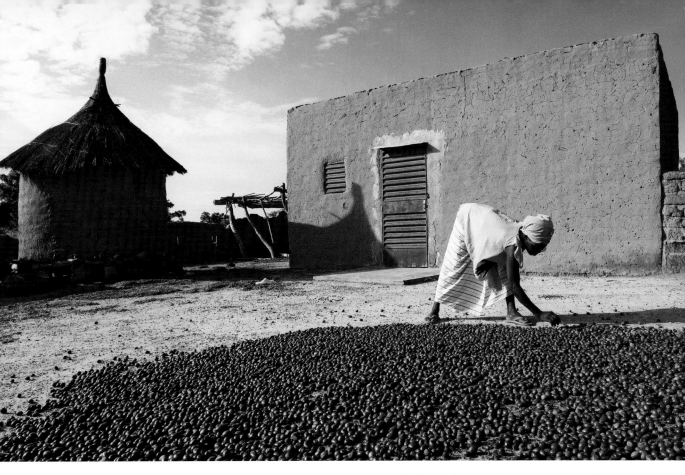

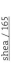

After harvesting, shea nuts are spread out to dry in the sun.

baobabs, some néré trees, and especially shea trees, proudly holding court right in the middle of the fields. "We have always learned that we have to protect the shea tree. It would be unthinkable to cut one down to cultivate the land or to burn it for cooking," says Jamal, one of the coordinators of the Union des Groupements de Productrices de Produits de Karité (UGPPK) – a union of groups of women producers of shea products – in the provinces of Sissili and Ziro, known more prosaically as the Union de Léo – the Léo union –, named after the city in southern Burkina Faso where its offices are located. The Union de Léo consists of 3000 producers in 67 associations.

The harvest season, underway since April, is drawing to a close. "To harvest shea for the Union, which is certified organic, we have to go into the bush. The trees near the fields are exposed to chemicals," Jamal explains. The temperature rises as they walk, but the women do not slow down. Kayon's boubou bears the slogan of the Union's 2009 walk: "Let's protect the shea tree, women's gold". From Guinea-Bissau to Ethiopia, wherever the shea tree is found, the harvesting and local processing of its fruit, also called shea,

is women's work. Traditions and essential needs coincide. For women, shea butter is often the only income they have to support their families.

We have covered the first five kilometres of the day. Alice and Sara lead us into the forest, where they continue on at the same speed. We confidently follow the mistresses of this place and arrive at a large tree covered with small green fruits the size of crab apples. "Only fruits on the ground will be gathered. We never climb the tree so as not to damage it," explains Alice. She picks up a very green fruit and gives it to me to taste. The sweet pulp is extremely delicious. There have been some attempts to make it into jam, but the value of the shea fruit really lies in its kernels and the butter made from them for its cosmetic, medicinal and culinary qualities. The fruits on the ground are gathered and roughly depulped on the spot. After an hour of harvesting, the containers are full and we head back to the village of Tabou with our foursome, who are now balancing several kilos of nuts on their heads.

That same day, Alice blanches her shea nuts to keep them from fermenting. She then spreads them out in the sun. In the evening, the nuts are gathered up and are then spread out again the

following morning. This process is repeated for eight to twelve days, until the nuts are sufficiently dried. Here and there, all over the village, women are crushing dried nuts with a pestle. Underneath a shea tree, Catherine and her daughter beat time, speeding up the rhythm to crush the last nuts. The mortar is tilted to loosen the kernels and their shells. They then kneel down to pick out the kernels. As with rice and millet, Catherine will then winnow the kernels, letting them fall from a height so the wind can remove dust and other residues.

The next day, I meet up again with Alice, who is sitting in the shade of her clay dwelling grinding previously washed shea kernels. Although the shea harvest is seasonal, processing takes place throughout the year, slowly, like a small hourglass that doesn't want to see its last grain of sand fall through. After an hour with the pestle, Alice goes inside and returns with a few

embers to begin roasting her shea kernels. Stirring constantly, she takes only a few seconds to wipe the sweat off her face. After 45 minutes, the kernels are nice and brown. Once cooled, they will be taken to the village mill to be turned into a smooth paste that looks just like melted chocolate.

The next day, a dozen women from Tabou gather at Kayon's, where they've arranged to meet to do the kneading. Alice arrives with her big bowl of paste, along with Zénabou, who is carrying a large terra cotta bowl. They settle in under the shade of a tree. Zénabou removes a few bracelets and begins gently to stir the paste to make it smooth. Six women soon take turns vigorously beating the sticky substance, while the others encourage them, sing and beat time. More than 30 minutes go by and the women are sweating before they tell me that the paste is now ready for the first washing. It takes just a simple bowl of water and, as if by magic, the brown paste loses all its colour. The white emulsion is transferred into a new vessel six times and each time the brownish water is thrown away. In the end, an immaculately white ball is placed in a steel pot to be cooked.

Embers and a few pieces of wood are placed under the pot and the emulsion melts into a brassy-yellow oil, like olive or cottonseed oil. Black residues floating on the surface are removed, while other heavier particles accumulate on the bottom. We have to wait a day for the oil to be decanted, filtered and made into butter. The next day, in a vat of cool water, Alice gently stirs the oil with a small paddle to make it solidify. One of the women then takes a spoonful and puts it into cool water so it will congeal. "This is the measurement used for the balls sold in the market," she says. It's the final stage of a marathon begun three days before. In all, there are twenty stages to go through, beginning with the harvesting, to obtain butter. On average, and adding in each step, a single kilo of butter requires more than six hours of work per woman, not including selling at the market.

Alice Nignan grinding shea kernels.

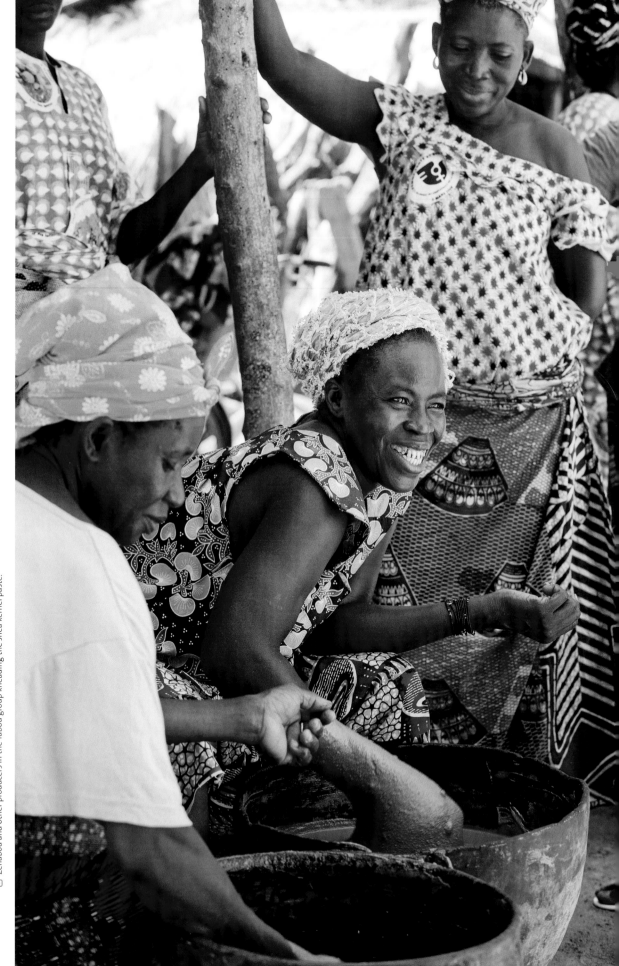

▷ Zénabou and other producers in the Tabou group kneading the shea kernel paste.

ON THE EDGE OF THE SUB-SAHARAN REGION, a wide swath of the African continent depends on the generosity of a tall sturdy tree. Both a defence against the encroaching desert and a resource for rural populations from Guinea-Bissau to Ethiopia, the shea tree has something of the sacred about it. Legend has it that cutting it down with malicious intent will bring misfortune on the person responsible. If the wise *Vitellaria paradoxa* could speak, it would be able to tell us about the passage of centuries, since it reaches maturity at around 50 years of age and has a lifespan of 300 years! It is only after 15 to 25 years of slow growth that it produces its first fruits, with pulp like that of figs or dates, and whose nut conceals a fatty substance with innumerable uses.

Used both for cooking food, in Africa, and for body care, the butter extracted from the shea kernel is a balm with a thousand uses: skin moisturizer, sun screen, hair conditioner, topical antibiotic, decongestant, muscle anti-inflammatory, etc. Nine-tenths of world production is used locally. Nigeria, the source of more than half of this production, is not even on the list of principal exporting countries; Burkina Faso is at the top, with 26% of world exports. The chocolate industry has discovered another of its qualities to be of considerable value in commercial terms; at a very advantageous price, it is a perfect substitute for cocoa butter – a market that accounts for 95% of exports. Residual shea is used in pharmacology and cosmetology.

Growth in commercial demand for shea butter and the protection of this resource are facing several problems: in spite of repeated attempts, the tree does not appear to adapt readily to enclosed cultivation. In addition, destitute populations covet it for its wood and it can fall victim to bush fires, especially those caused by human beings.

While still in its early stages, the fair trade sector likely offers the most sensible solution to these problems. Paying African women directly, since they are the ones who have traditionally been responsible for caring for the trees and processing shea, ensures a better quality product (processing elsewhere involves the use of chemical solvents, which cause the medicinal qualities of the butter to deteriorate); furthermore, contributing to the economic wellbeing of communities means they are more likely to protect the resource over the long term.

shea in figures

CONVENTIONAL TRADE

Global trade (nuts): 784,676 tonnes

MAIN PRODUCING COUNTRIES

Nigeria	53%
Mali	23%
Burkina Faso	9%
Ghana	8%
Côte d'Ivoire	4%

FAIR TRADE

Year of certification: 2006
Global imports (butter): 18 tonnes

CERTIFIED ORGANIZATION

One small producers' organization.

ORIGIN OF CERTIFIED ORGANIZATION

Burkina Faso

MAIN IMPORTING COUNTRIES

	Imports (t)
Canada	9
France	9

PRICES AND PREMIUMS

Fair trade price: $3929/t
Fair trade premium: $275/t

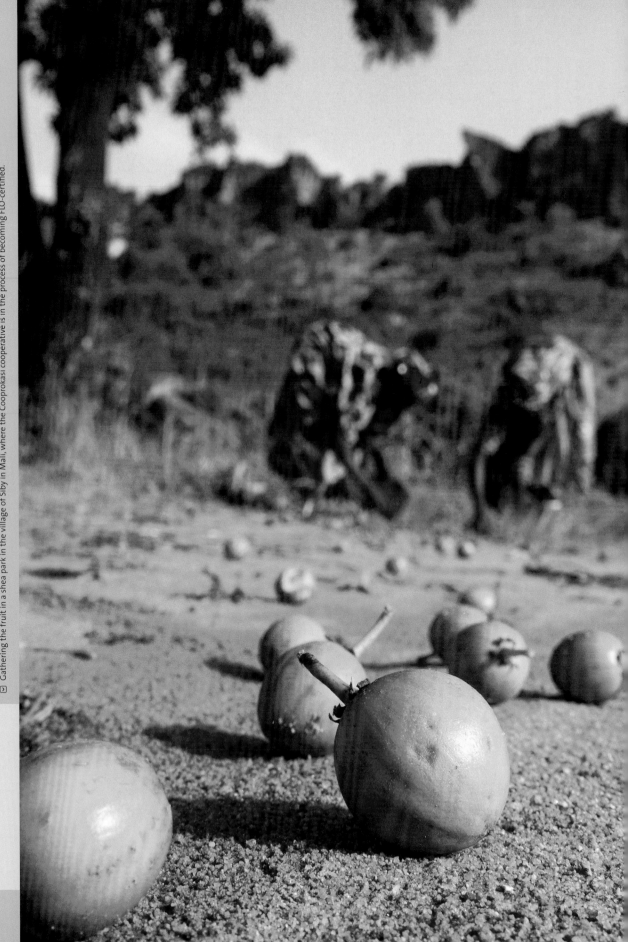

Gathering the fruit in a shea park in the village of Siby in Mali, where the Cooprokasi cooperative is in the process of becoming FLO-certified.

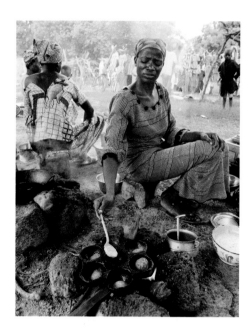

⌂ At the Lon market, Adjara Diasso fries millet fritters in shea oil.

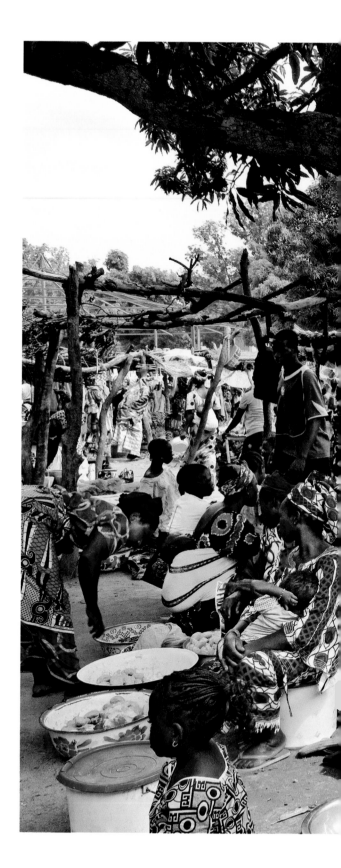

||

Friday afternoon in the village of Lon, ten kilometres from Tabou, everybody gathers at the market. The women have tiny stalls where they offer, on large well-filled platters, manioc tubers, okra, or soumbalas, néré beans blackened by fermentation. These ingredients are essential for the preparation of sauces to go with tô, a porridge made of millet flour, which is the basic food for families in the region. Peuls, who live outside the village with their flocks, sell fresh or clotted milk. Small shopkeepers sell combs, batteries, flashlights, mirrors, and other minor indulgences brought from the city, while others bargain for a multitude of contraband pills from Ghana, said to cure all ills.

Some of the village women also sell millet fritters fried in shea oil, while others sell their balls of shea for 25 francs. They have to sell 20 balls at the market, the equivalent of a kilo of butter, to earn 500 francs ($1). "On good days, some manage to sell 500 francs' worth, but often they earn barely 100 francs ($.20), never making any real profit," Safoura, the treasurer of the the local association of women shea producers in the village of Lon, tells me. "Often, in April or May, our grain reserves are very low," Safoura continues. "Shea butter and néré beans are then the only currency they have to feed their families. When they have to buy millet, they come to the market to sell shea kernels to the small shopkeepers,

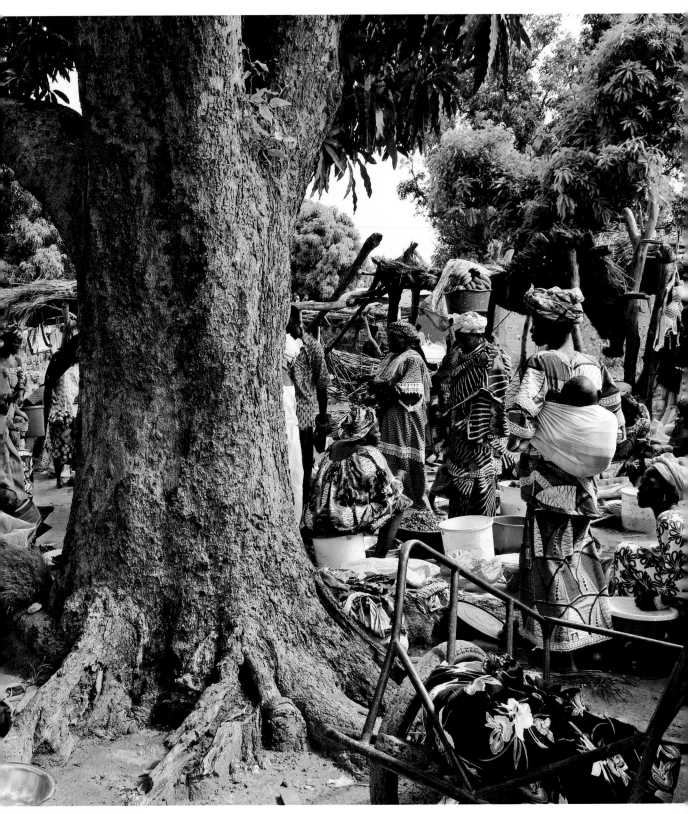
⌂ African markets are crossroads of trade and culture full of colours and aromas.

who then sell them over again to merchants heading for Ouagadougou."

They earn 200 francs for a bowl of more than 2.5 kilos of kernels, an amount which yields about a kilo of butter when processed. At the Union, the same bowlful is worth 500 francs, more than twice as much. In the case of shea butter, the price goes up to 1,200 francs, again more than twice the market price.

"Women who belong to the union get a much better price and they can sell their shea all at once, which means they can see the profits," Safoura explains. Of course, a modest income, even doubled or tripled, is still modest. The sale of their shea to the Union earns these women an annual income of about $100. "A few years ago, we had hopes of reaching an annual average of $150, but more members have joined and orders haven't come in yet," says Abou, the Union's friendly manager.

||

At the Union offices, in Léo's small processing plant in the south of the country, not a day goes by that Nana, the president, and Abibata, the person responsible for quality control, don't come by to greet the employees and producers as they work. "The Union grew out of gatherings of female agricultural producers who began to organize in the early 1990s," Abibata tells me, smiling and dressed in a magnificent boubou. "In 1997, people working for CECI, the Centre d'étude et de coopération internationale (centre for International Studies and Cooperation), a Canadian organization involved in international development, undertook to support female shea producers in the region. Their first priority was to help us make better quality butter by improving our processing techniques. Then they helped us with organizational development. Our union was officially recognized in 2001," she adds.

"Before we had the Union, we couldn't make large quantities of butter. It was too much work," explains Abibata. Today, in Léo, processing kernels into butter is done collectively. In the facility, there is a mill to crush the nuts, there are ovens for roasting and, best of all, vats for kneading, where dozens of women are at work. During the visit, I notice in one of the buildings something that seems to me to be totally out of place in this part of the Sahel. "Yes, yes, it really is a maple syrup press!" Abou confirms. Praxède Lévesque, the owner of the Delapointe company, which im-

ports and distributes the Union's shea butter in Canada, and who is also a maple sugar producer, sent them the press. "The machine's filtration system has enabled us to improve the quality of our butter," says Abou. "By working collectively and with a little infrastructure, not only have we improved its quality, we have also reduced the average processing time per kilo to an hour and a half," he adds. By the end of 2009, 18 local processing centres will be fully functional in the Union as a whole.

"Working collectively means I can produce 400 or even 500 kilos of butter each year," Abibata announces proudly. "Before, I couldn't buy school supplies for my children or even clothe them. Now, that's not a problem anymore, and I can even buy nice clothes for myself. Shea butter is truly a husband for widows and a father for orphans," says this mother of five, whose husband died in 2003. Still and forever, the shea tree is appropriately named 'women's gold', and is there when it is most needed.

☑ The Union de Léo's small facilities, including roasting ovens, reduce shea butter processing time.
▷ Abibata Ido, a shea butter producer, responsible for quality control on the Union de Léo's board of directors.

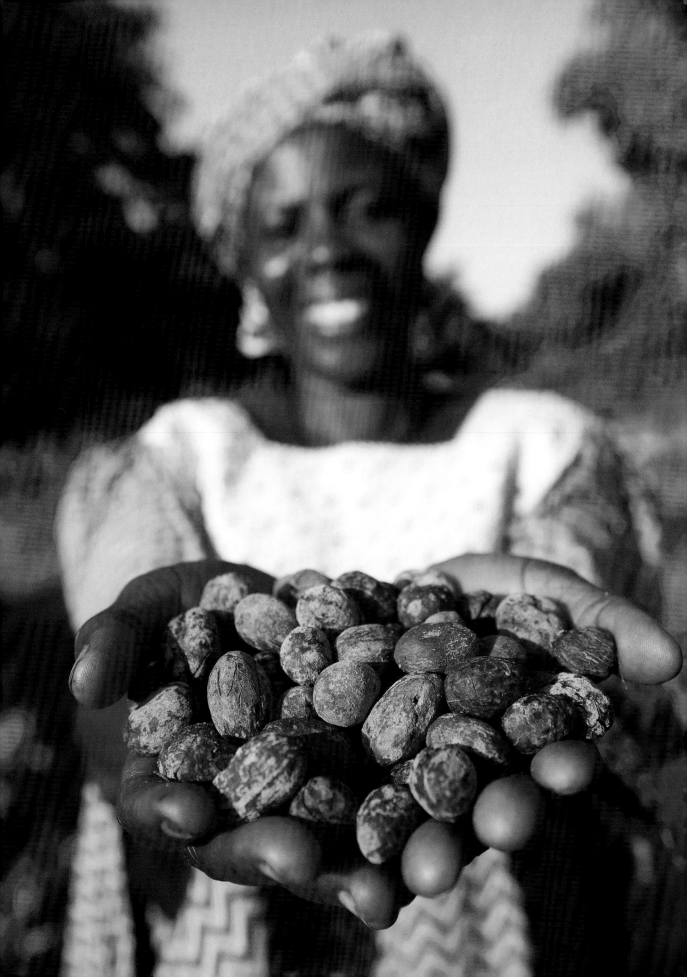

"OUR UNION'S STRENGTH LIES IN OUR MEMBERS' SIMILARITY; they are all peasant women. Our president doesn't drive around in an air-conditioned 4x4; she rides a bike and kneads her butter like everyone else," explains Abou, the manager of the Union de Léo. "We currently have 3,000 women producers and more than 1,000 more are waiting to join the Union."

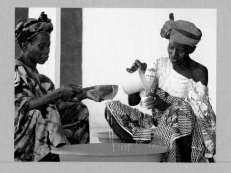

◹ Geke Konata and Adama Kamara, members of Cooprokasi, package shea butter for export overseas.

"Solidarity with African women has a direct impact on the living standards of the whole family," explains Roch Harvey of CECI, which has been working in the Burkina Faso shea sector since 1997. "We've expanded our program to Mali (in 2001), Niger (in 2004), and Guinea (in 2005) and soon we will be in Ghana." The CECI programs are involved in strengthening organizations, producing and improving the quality of the butter, and marketing and resource management.

In Siby, in Mali, CECI supports the Cooprokasi cooperative, which is made up of 800 women producers from 21 villages. Among its goals is the protection of shea tree stocks, an initiative the World Environment Fund (WEF) considers to be a 'model of success'. Furthermore, 14 of Siby's producers ran as candidates in community council elections in April 2009. "Increasing women's incomes has enhanced their image, status and position in the family and in the entire community."

"It's for the sake of the women producers that I've decided to carry on with this project," says Praxède Lévesque, the owner of Karité Delapointe, which distributes the Union de Léo's shea butter in Canada. In 2000 and 2001, Daniel La Pointe, her husband, then working in Burkina Faso for CECI, was tasked with promoting the sale of shea butter produced by organizations in Burkina Faso to international clients. He canvassed many buyers, but the large supply of shea butter and the needs of the producers motivated him and his wife to begin distributing it in Canada themselves. "We imported half a tonne in 2002. In 2007, when Daniel died (in a car accident), we were importing a tonne. I decided to continue in spite of the tragedy, because we had built up so much hope that I couldn't abandon these women." In 2008, imports totalled 9 tonnes, and then 18 tonnes in 2009. Karité Delapointe supplies ointments, body milks, exfoliants, lip balms and other soaps, as well as raw butter for other cosmetic brands.

At thousands of retail outlets, Karité Delapointe products or those of the French company L'Occitane, the Union's main client, reach female consumers in the North, completing an entirely female chain of solidarity that begins in the countryside of Burkina Faso, Mali or Nigeria. "Good for you, good for them" is CECI's shea butter campaign slogan. Women producers gain dignity while women consumers enjoy a unique product with many fine qualities.

"Good for you, good for them" is CECI's shea butter campaign slogan.

⌃ Siton Koné, the vice-president of Cooprokasi cooperative, and two other producers.

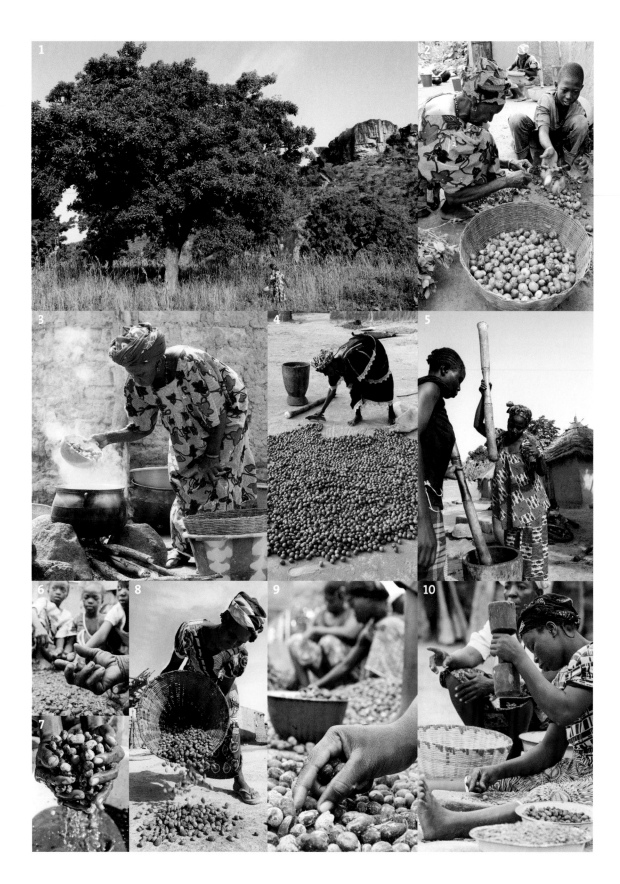

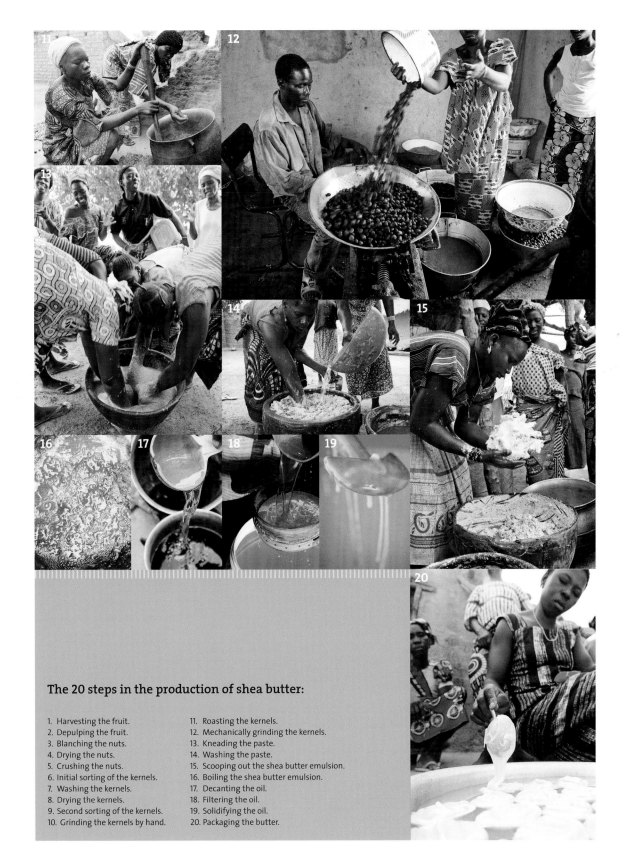

The 20 steps in the production of shea butter:

1. Harvesting the fruit.
2. Depulping the fruit.
3. Blanching the nuts.
4. Drying the nuts.
5. Crushing the nuts.
6. Initial sorting of the kernels.
7. Washing the kernels.
8. Drying the kernels.
9. Second sorting of the kernels.
10. Grinding the kernels by hand.
11. Roasting the kernels.
12. Mechanically grinding the kernels.
13. Kneading the paste.
14. Washing the paste.
15. Scooping out the shea butter emulsion.
16. Boiling the shea butter emulsion.
17. Decanting the oil.
18. Filtering the oil.
19. Solidifying the oil.
20. Packaging the butter.

▷ In the village of Siby, Nantene Konaté gathers her shea nuts before dew falls. Well dried, they will keep for several months.

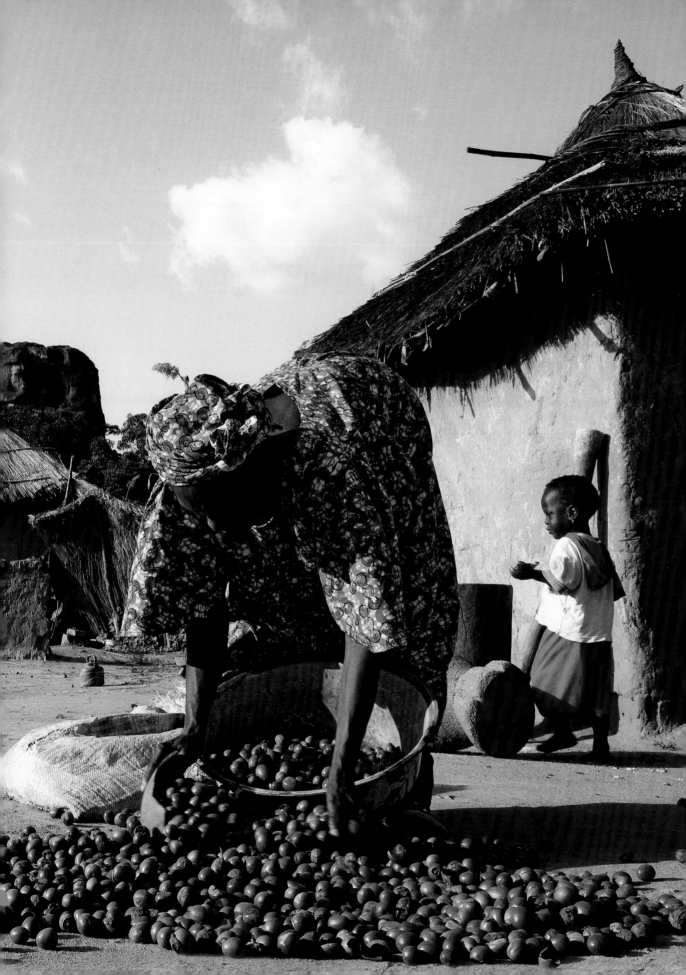

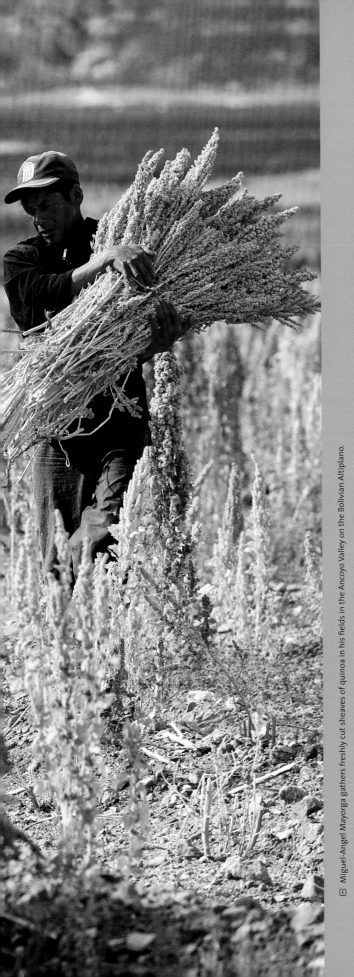

© Miguel-Angel Mayorga gathers freshly cut sheaves of quinoa in his fields in the Ancoyo Valley on the Bolivian Altiplano.

quinoa

E ach year, the Supreme Inca of Tawantin-suyo himself was the first to plant quinoa, using a golden hoe. Thus began a festival lasting several days throughout the entire Inca Empire. The Incas, reigning over more than 100 million people at the peak of their civiliza-tion, had gained control less by military force than because of food security and the glory they offered to those agreeing to worship Inti, the sun god. It was Inti who had sent the first emperor, Manco Capac – who emerged from Lake Titicaca – to teach agriculture to the survivors of the Great Flood. At the end of the harvest season, it was to this same god, Inti, that quinoa seeds were of-fered, in a huge fountain made of solid gold.

From overhead, the Bolivian Altiplano, once part of the territory of the Incas, looks very much like a desert surrounded by the white summits of the Andean Cordillera. In the southern part of

this vast plateau, the yellow plains turn into large pure white lakes: these are the Coipasa and Uyuni *salars* or salt flats. At 3,550 metres above sea level, these expanses of salt are a magnificent reminder of the forces of Mother Nature, which pushed these oceanic beds from another age up toward the skies. The lands bordering the salt lakes are the natural home of royal quinoa, the most prized variety.

The 'mother of all grains' for the Incas, and the pillar of their civilization, quinoa was revered and incorporated into numerous rituals. This cultural importance explains in part why it was banned by the Spanish colonizers, who went so far as to forbid its cultivation. Quinoa was thus limited to the high plateaus, a fact that no doubt contributed to a loss of genetic diversity. Called 'Indian food' by the Christian masters of the New World, quinoa would be replaced by other foods and would eventually be no more than a cultural relic.

From the hilltops bordering Salinas can be seen on the horizon the Uyuni salt flats and the majestic summit of the Thunupa volcano, standing tall at 5,000 metres. This small city on the Bolivian Altiplano is known as the quinoa capital of the world. All around, on the slopes of the volcanic hills, the quinoa fields are divided by low stone walls, making an irregular mosaic. According to Max Uhle, the dean of archaeologists specializing in the Americas, these quinoa lands have been cultivated by the Andean people for more than 5,000 years. Back then, indigenous families had put in place a traditional system of agricultural production. This involved rational soil management with fallow periods of 4 to 8 years in between crops and natural pest control. Quinoa was not a monoculture. By the sweat of their brow, the peasants prepared a hectare of land or even less to grow it on. On the cultivated mountain terraces local potato varieties and other high altitude crops were grown. Herds of llamas provided, in addition to meat, the manure needed to fertilize the soil.

Celebrating the Festival of the Sea in Salinas, the quinoa capital of the world. The mechanization of agriculture, in the village of Ancoyo.

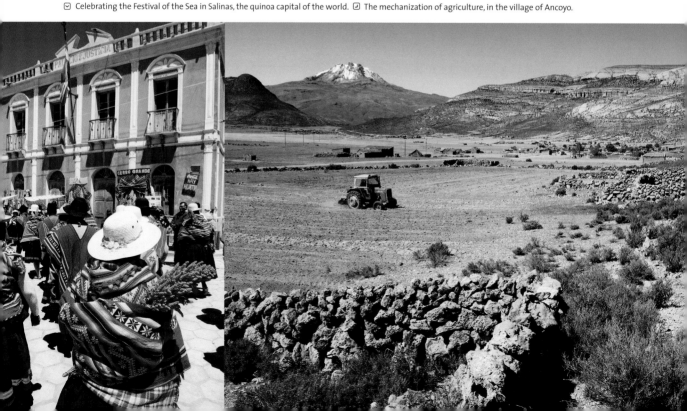

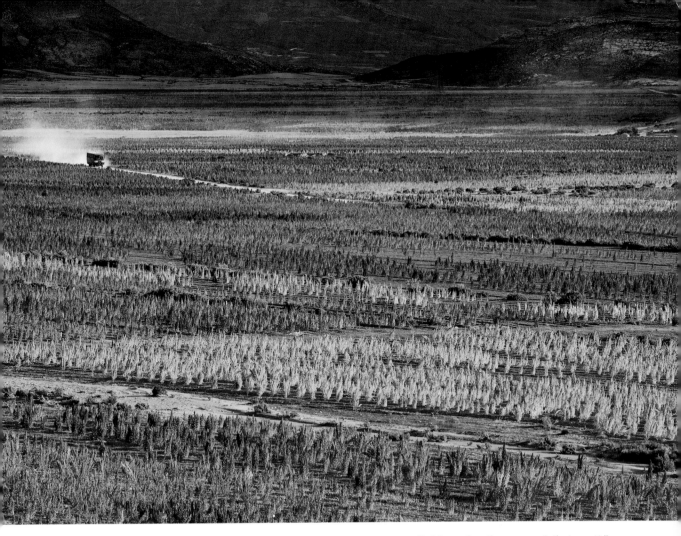

Quinoa as far as the eye can see, in the Ancoyo Valley.

Not far from Salinas, the Ancoyo Valley is coloured in red, orange-yellow and ochre. In the upper valley, Fisher García Mollo, a future agronomist, describes to me the recent changes in quinoa cultivation. "These lands began to be cultivated when tractors arrived. Before that, they were mainly used as grazing lands for llamas, alpacas and vicunas. Now, quinoa takes up so much room that we've had to limit the amount of land used for growing crops so that the animals have enough to graze on."

In Bolivia, quinoa's return to favour began with the 'green revolution'. First came the official realization that the Bolivian diet had become dangerously deficient. Research institutions then threw themselves into studying quinoa; its genetic heritage was mapped and its production encouraged. Other markets discovered quinoa and its agricultural borders were extended to respond to growing demand in the United States and Europe. Along with the good intention of improving the daily diet of Bolivians, the so-called 'green revolution' brought its own share of 'solutions' – fertilizers, chemicals and mechanization. More intensive agriculture on the plains, now ploughed by tractors, contributed to the erosion of soil that was already not very fertile. One of the objectives attached to agricultural modernization in the 1960s was an increase in productivity. However, whereas in the 1940s a family could hope to harvest 1,500 to 2,000 kilos of quinoa per hectare, several decades after the 'green revolution' quinoa production is now barely 650 kilos per hectare, on average.

Q UINOA (*CHENOPODIUM QUINOA*) IS NOT TECHNICALLY A CEREAL, because it is not part of the Graminaceous (grass) family. Instead, it is a close relative of beets and spinach. Unusually adaptable, it has spread to various climates, withstands frost and droughts and grows abundantly in saline soil. In the nineteenth century, Alexander von Humboldt, a German naturalist, noted that quinoa could be found from the savannas of Bogota to the south of Chile.

Quinoa is rich in proteins and mineral salts and contains no gluten. Its most singular characteristic is that it contains all the amino acids essential for human nutrition. It is the food that most resembles mother's milk. According to Dr. Duane Johnson of the University of Colorado, if human beings were forced to eat only one food, quinoa would be the one to choose.

Dr. Johnson and his colleague, Sarah Ward, patented the young male sterile plant of the traditional variety of Bolivian quinoa, *apelawa*. This caused a major commotion among Bolivian producers, whose protests were heard as far away as the United Nations. Four years later, the controversial patent was withdrawn.

The global production of quinoa, nearly 60,000 tonnes, is exclusive to two countries, Bolivia and Peru, which together harvest more than 95%. Between 2003 and 2006, Bolivian exports more than tripled. The nutritional properties of quinoa have contributed to its recent popularity in the West. The increase in quinoa production, including that destined for fair trade markets, has caused major disruption in the areas where it is grown — a challenge for advocates of a social movement concerned with justice, self-sufficiency in food production and respect for the environment.

quinoa in figures

CONVENTIONAL TRADE

Global production: 59,115 tonnes
Global trade: $9,296,000

MAIN PRODUCING COUNTRIES

Peru	53%
Bolivia	44%
Ecuador	1%

FAIR TRADE

Year of certification: 2004
Global imports: 552 tonnes
Retail sales: $4,320,000

CERTIFIED ORGANIZATIONS

Four small producers' organizations in two countries.

ORIGIN OF CERTIFIED ORGANIZATIONS

Bolivia	75%
Ecuador	25%

MAIN IMPORTING COUNTRIES

	Imports (t)
France	370
United Kingdom	135
Australia/New Zealand	7
Switzerland	7
Canada	6

PRICES AND PREMIUMS

Fair trade price: $711/t
Fair trade premium: $85/t
Organic premium: $150/t
Proportion of organic quinoa: 82%

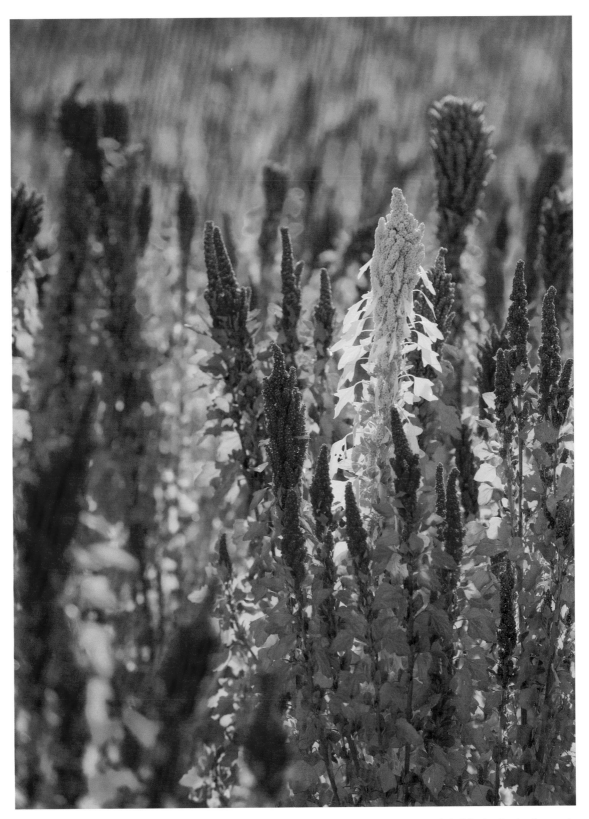

⊡ Contrary to popular belief, quinoa is not really a cereal...

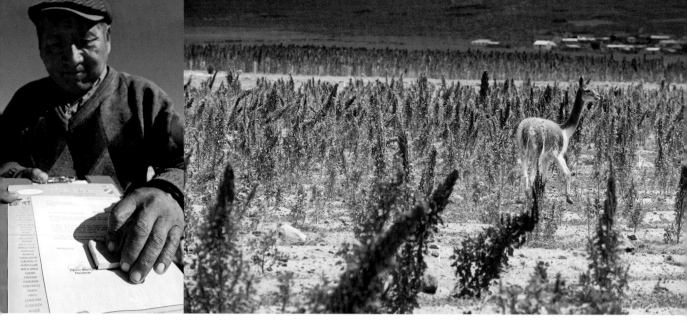

◩ Ciprian Beliz Mayorga, the president of Acroproquirc. ◪ A vicuña in a quinoa field, near the village of Irpani. ◪ A young llama and its mother. ◪ Valério Silvestre and his llamas, at the foot of the Thunupa volcano.

In the village of Irpani, located at the foot of the Thunupa volcano, the change in growing patterns is noticeable. Here and there, a few fields are scattered across the slopes of the volcano, but it is in the valley's lowlands that you see fields in all the colours of rainbow. "This year we've cultivated the south side of the valley and ploughed the lands on the north side for next year's sowing," Valério Silvestre explains while attempting to catch one of his ewes. In this area, lands do not very often lie fallow for more than a year. Ploughing, between January and March, allows the soil to absorb a little moisture before the seeds are sown in September. However, this ploughing also makes the soil more vulnerable to water and wind erosion.

Valério heads slowly toward a second stone enclosure, where he keeps 60 llamas. He adds, "I had more, but because of the lack of pasture land I was forced to reduce my flock. There is a lot less rain in the winter and the llamas have only twigs to eat." Valério's 60 llamas and 120 sheep seem to be the total population in Irpani. "People will shortly arrive. The harvest will soon start!" he tells me. Droughts, floods, an underemployed workforce, meagre agricultural incomes, the difficulty in accessing education, land fragmentation, soil erosion, the attraction of life in the cities – there are many factors causing the exodus of rural populations. The phenomenon is endemic.

According to Ciprian Beliz Mayorga, the president of Acroproquirc, it is the poor quality of life that has caused people to leave the region. In his village of Ancoyo, out of 36 families only eight live there year round. At Sebingal, only a few kilometres from Salinas, the situation is even more depressing: only two families live in the village. Even electricity didn't make it here. The church, traditional houses, and the little field of quinoa present a bucolic picture, but when you look more closely you notice that several thatched roofs are collapsing and even the adobe walls have begun to crumble here and there. All evidence would indicate that it's been a long time since the school's basketball court last saw a ball or a child!

"I lived in La Paz for 20 years, where I was a taxi driver, but today my quinoa is much more profitable," Ciprian informs me. At first the secretary, then vice-president and now president of Acroproquirc, he believes that future prospects for quinoa are good and that it could revitalize the region. "Currently, our main social project is to improve soil fertility with manure from llamas and sheep. After one application of manure we can see the results in the next three harvests. We have to continue working on this and find partners to launch other pilot projects."

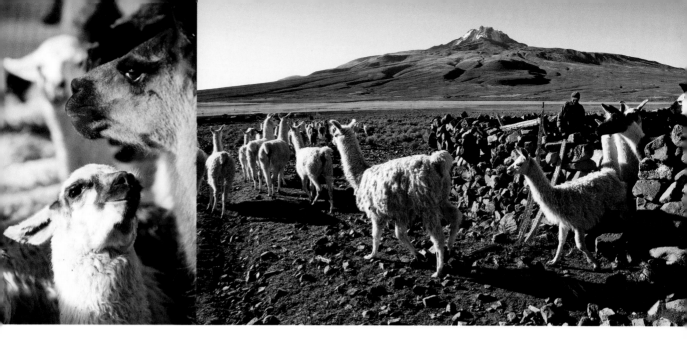

The village of Sebingal, with its small colonial-inspired church.

⌃ Quinoa packaging, for the Canadian brand GoGo Quinoa. ⌄ The ANAPQUI factory, in Challapata.

Acroproquirc is one of eight member organizations in the Asociación Nacional de Productores de Quinua (ANAPQUI) – the National Association of Quinoa Producers. "Before ANAPQUI existed, producers would trade their quinoa for staples. They were totally dependent on merchants," Miguel Choque explains to me in ANAPQUI's offices in La Paz. "In the beginning, all producers of quinoa in the country were considered members of ANAPQUI, but in the mid-90s we began to put in place a membership system and the numbers dropped sharply. Today, we represent 1,500 producers, all from the southern Altiplano." The great majority of ANAPQUI's exports are destined for solidarity markets. The organization received its organic certification in 1992 and its fair-trade certification in 2005. "We have more than a dozen clients in Europe and North America. In 2008, we exported 1,800 tonnes of quinoa, about 25% of the country's total exports."

A small proportion of the quinoa sold by ANAPQUI is turned into flour, flakes or even puffed quinoa, but the vast majority (70%) is exported in the form of grains. "In 1997, we built our own quinoa-packaging factory," Miguel recalls. Located in Challapata, ANAPQUI's factory performs an important step in processing the quinoa for sale – 'desaponization'. The quinoa grain is coated with saponin, a mildly toxic and bitter glycoside. In the factory, the grains' husks are mechanically removed. Next, the grains are soaked to remove the saponin. Then, the grains are dried again and sorted before packaging.

On weekends, Challapata turns into a big outdoor market. At the fair, fruits, grains, animals, coca leaves, agricultural tools and even tractors can be found. The latter are for the most part second-hand, shipped by boat from European and American farms. The Challapata fair is also where market prices for quinoa are decided. The price of unpackaged quinoa sold directly by producers is set here. In 2008, from April onward, at the start of the harvesting season, prices had already gone up by 50%, and by the end of the harvesting season, they were 190% higher than in 2007. With prices three times higher, even though the 2008 harvest was 40% lower than in previous years, producers earned a higher income. "In 2007, the export price was $1,200 per tonne; it's now $3,200," Miguel informs me. "Our members earn $110 per quintal (46 kilos), higher than the minimum guaranteed fair trade price set at $40."

I n 2003, it was Acoproquirc's turn to build its own packaging factory in Irpani. Ciprian Beliz Mayorga, the president, has been one of major forces in making this factory a reality. "Selling washed quinoa (ready for consumption) earns more and we create local employment and keep our people from leaving the region", he says. "This year, we completed the probationary period for organic certification and we have 15 new members. We are ready for a good season. Now that quinoa sells for a good price, people are coming back to reclaim their lands! Five families have come back this year. They sowed in September and should shortly return for the harvest."

B ack in the Ancoyo Valley, Fisher takes me on a visit to his royal quinoa fields, accompanied by two students of agronomy from the University of Oruro. Very big scarlet-red shoots are a head taller than he is. "These fields are new and their yield is very very high," he says proudly. Going from plant to plant, he carefully examines the grains to make sure they are ripening as they should and especially that there are no harmfull fungi or larvae. "All my fields are cultivated organically," he says. "It takes more work but the results are worth it. You should see us at night during the month of November, with our lanterns, catching butterflies before they can lay

☑ Fisher Garcia Mollo in his organic quinoa fields.

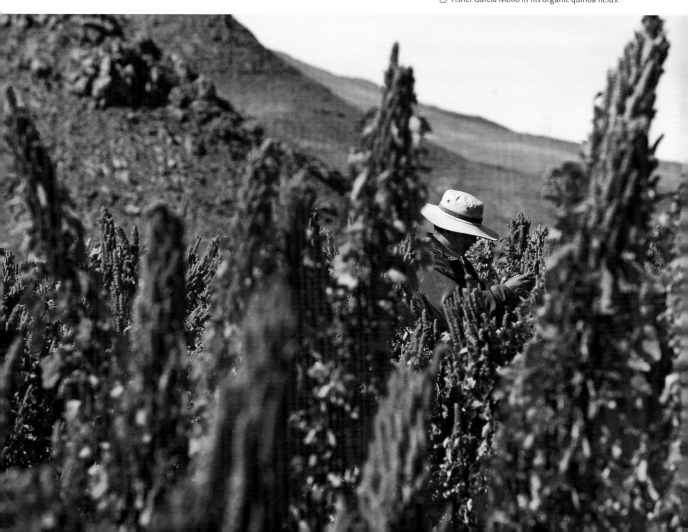

Quinoa remains mostly unknown outside the Andean countries that have been producing it for millennia. The fact that it is now enjoying a certain celebrity status is due to the organic and fair trade market (82% of fair trade quinoa is also organic). In 1997, when I first began speaking publicly about the situation of the UCIRI coffee growers and the fair trade alternative, no fair trade quinoa, spices, or wine were available in Quebec. In fact, there was just one product, coffee, available at just a few points of sale. Today, there are points of sale and products by the thousands and fair trade has even become the norm in certain countries (in Switzerland, 50% of flowers and bananas sold are fair trade).

In 1997, there were also several fair trade handicraft initiatives, including of course an extraordinary variety of woven baskets, pottery, embroidery and other textiles, sculptures, jewellery, and leather products. Today, in Canada, fifty Ten Thousand Villages shops alone offer 2,000 different products.

In 2008, FLO certified more than 6,000 products distributed by 2,700 companies licensed to use its label. While coffee, tea, cocoa or even bananas get top billing, millet and quinoa are more unusual. In total, FLO has determined prices and premiums for close to 100 products in 18 mainly food sectors, with the exception of sports balls, cotton and flowers.

Some of these products are of course marketed for economic reasons. Others, however, have been launched primarily for political reasons or to show solidarity with fragile states, like Haiti, or non-recognized states, like Palestine, which exports several brands of fair trade olive oil such as Zeitouna, sold in Canada by Medical Aid for Palestinians. The cultivation of olive trees goes back 3000 years in the region and is the main source of income for 25% of the population of the West Bank.

In the years to come, FLO hopes to continue to diversify and grow, so that certified organizations can increase their exports and that fair trade will reach more producers' groups, more kinds of products and more countries. The creation of a WFTO label for handicrafts will substantially boost their availability for consumers supportive of fair trade.

FLO-CERTIFIED PRODUCT SECTORS IN 2008

Product	Small producers' associations	Salaried workers' organizations	Total	Imports (t/* 1000 Items)	Growth (2007-2008)	Total Sales
Coffee	291	0	291	65,808	14%	$ 1,784,230,000
Bananas	28	35	63	299,205	28 %	$ 660,720,000
Tea	31	43	74	11,467	112 %	$ 294,640,000
Cocoa	30	0	30	10,299	unknown	$ 275,300,000
Cotton	28	0	28	*27,573	94%	$ 261,910,000
Cane Sugar	15	0	15	56,990	unknown	$ 257,440,000
Flowers	0	46	46	*311,000	31%	$ 255,950,000
Fruit Juice	14	1	15	28,219	11 %	$ 101,190,000
Fresh Fruits/Vegetables	25	53	78	26,424	1 %	$ 98,210,000
Wine	4	23	27	*8982	57 %	$ 71,430,000
Honey	19	0	19	2055	22%	$ 29,760,000
Rice	15	0	15	4685	11%	$ 28,270,000
Shea (nuts and oil)	16	0	16	775	unknown	$ 20,830,000
Dried Fruits	6	0	6	712	unknown	$ 17,860,000
Spices	14	0	14	197	unknown	$ 6,100,000
Sports Balls	0	4	4	*141	2%	$ 4,320,000
Quinoa	4	0	4	552	unknown	$ 4,320,000
Other	1	0	1	unknown	unknown	$ 135,420,000
Total	541	205	746			$ 4,308,050,000

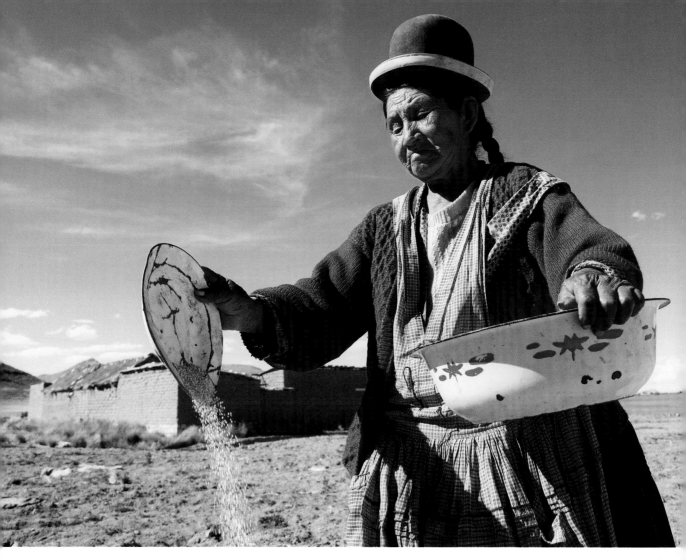

Carmen Mollo makes good use of the Altiplano breeze to remove quinoa husks before preparing a traditional soup.

their eggs." Further on, his colleagues have an experimental patch of land growing different varieties of quinoa, among which is *pisankalla*, one of the most studied varieties.

Back at the house, Carmen, Fisher's mother, standing in her boots in a large mortar, is crushing quinoa grains to remove the hulls, which are high in saponin. Next, she scoops up the grains and lets them fall gently so that the wind can blow away the dust from the husks. Tonight, we will have quinoa soup with our meal.

Quinoa's outstanding nutritional qualities are largely behind the increasing interest it has aroused in the North. According to the American Academy of Sciences, quinoa is one of the best plant foods human beings can eat. In fact, recent scientific research findings indicate that quinoa possesses all of the amino acids in adequate proportions for absorption by the human body, making it unique among all plant foods. In addition, quinoa is rich in minerals such as phosphorus, magnesium, potassium and calcium. NASA has even included quinoa in the foods taken on long space voyages.

The Incas, who worshipped the sun, looked to the stars when planning their agricultural calendars. Through their knowledge of astronomy they were able to predict eclipses and the passage of comets. One of the 13 Incan rulers, in a moment of extreme clairvoyance, no doubt saw that one day the sacred quinoa grain would head into space in the luggage of the astronauts of today, all the better to contemplate from on high Inti in all his glory.

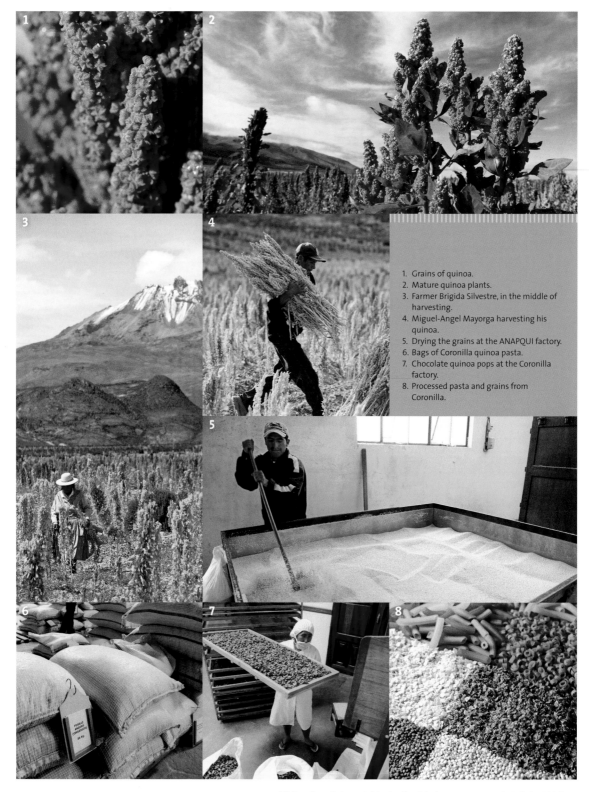

1. Grains of quinoa.
2. Mature quinoa plants.
3. Farmer Brigida Silvestre, in the middle of harvesting.
4. Miguel-Angel Mayorga harvesting his quinoa.
5. Drying the grains at the ANAPQUI factory.
6. Bags of Coronilla quinoa pasta.
7. Chocolate quinoa pops at the Coronilla factory.
8. Processed pasta and grains from Coronilla.

▷ Top: Eugenia Apaza taking her family's sheep to graze on the Bolivian Altiplano.
▷ Bottom: Benita Calane Ayabide in Salinas during the Festival of the Sea, which commemorates the loss of Atacama province to Chile in 1879, depriving Bolivians of their only access to the sea.

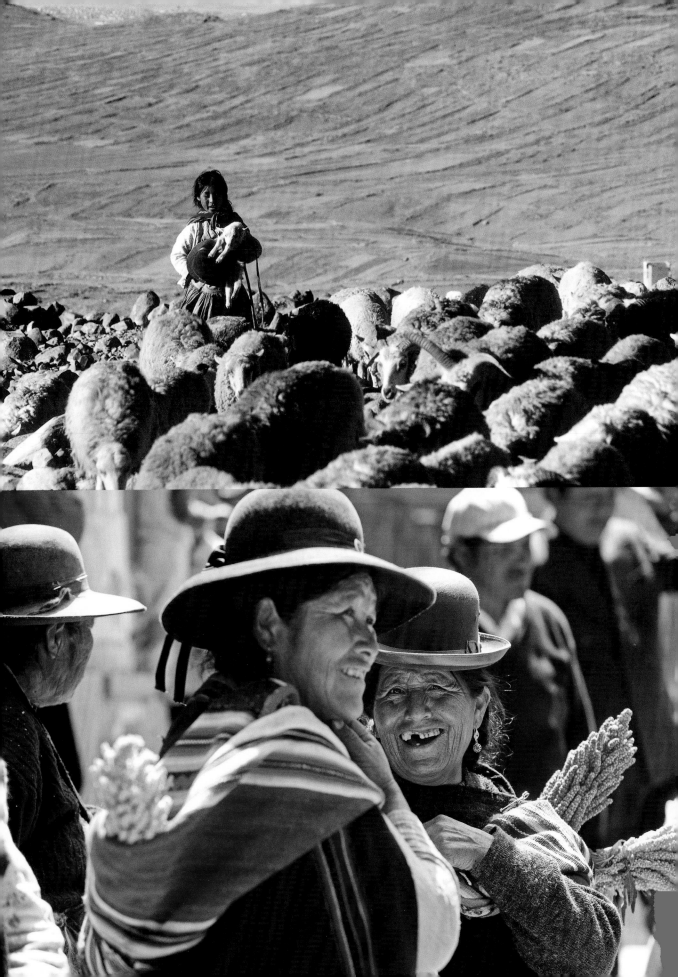

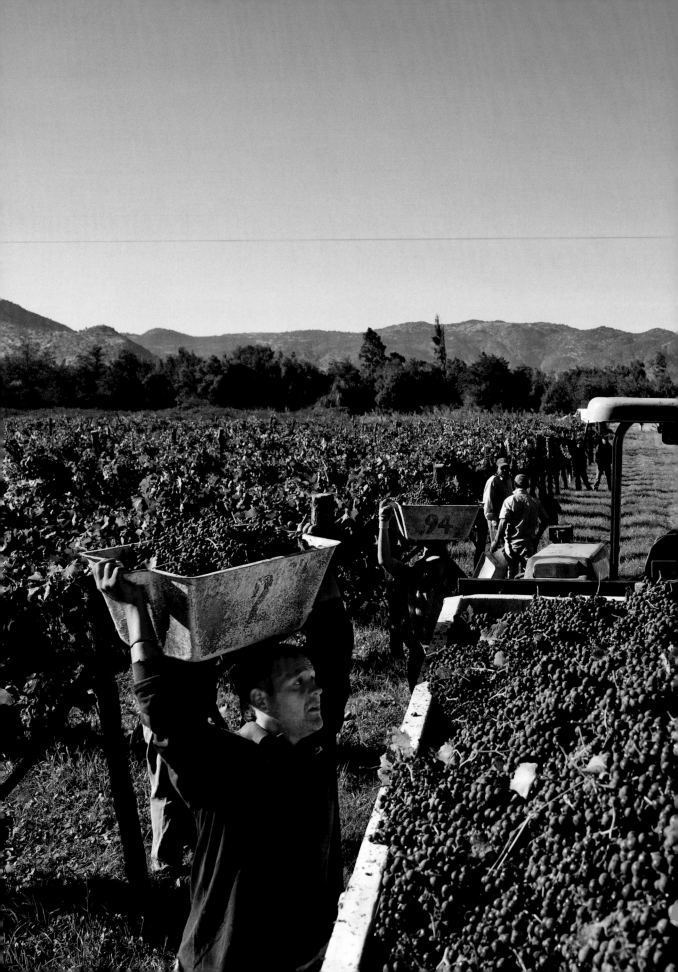

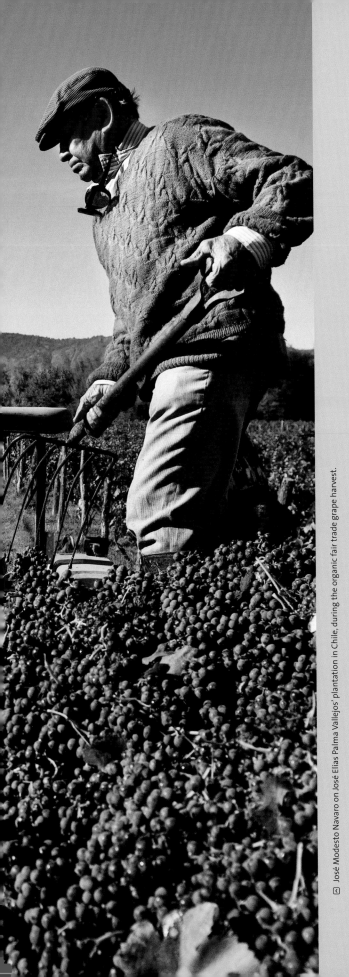

wine

Vine leaves fossilized for nearly 60 million years have been found in Champagne, France, evidence that the spirit of wine waited a very long time for man's arrival. The purpose of this land, the source of sublime intoxication, appears therefore to be rooted in the Palaeocene era! Grape seeds have certainly been found in prehistoric caves, but fermenting the fruit to make wine appears to have begun 7,000 years ago, shortly after the discovery of agriculture. Naturally, wine was deemed divine. In Mesopotamia, it was reserved for priests and kings. The Egyptians associated it with Osiris, the Greeks with Dionysus, and the Romans with Bacchus. The Persians, according to one of their legends, attributed it to a princess abandoned by a king, who wanted to poison herself by drinking the dregs in a container of fermented grapes. Instead of death, she found renewed love in her sovereign's arms, for he repaid her discovery of this wonderful substance with sensual delights.

Always associated with Faith and the Passions, wine cares little about Justice, but it is nonetheless easy to find it in the search for Harmony. According to Herodotus, the Persians got drunk on wine to make important decisions, but the morning after the night before these important men checked to be sure their decisions were right.

Wine makes us happy, but it can also lead men astray and into anger. The Roman Empire collapsed under the weight of its excesses, but wine-growing survived, assisted as it was by monasteries. Christianity, more than any other religion, sanctified wine. Vineyards were placed under the protection of St. Vincent. Veneration of this saint inevitably crossed the seas, for the Spanish conquerors took up the lance in the name of God and their new subjects henceforth had to eat the body of Christ and drink his blood in the form of bread and wine. Vines followed Spanish colonization as it advanced, perpetuating the Christian faith. In 1543, the first Argentinian vines were planted in Salta, but it was in Santiago del Estero in 1557 that the Jesuits began making as much wine as they needed. In 1561, vines from Chile began to grow in Argentinian soil in Mendoza, then in Misiones and Santa Fé. These names say it all: wine and Faith were interconnected and there would be no empty chalices to endanger the salvation of souls.

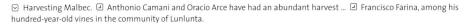

O n the outskirts of Mendoza, in northern Argentina, the sun rises over Francisco Farina's hundred-year-old vines. It's a cool autumn morning; April is just beginning, but in the vineyards it's the end of a year of work. "In two days, 12 months of work go into the cellars," Francisco sighs. The green is still intense, but a few leaves are turning yellow or red, in the shade of the olive trees. In the distance, the Andes are majestic. The small hamlet of Lunlunta is known for the quality of its grapes. "Our favourable climate, with its wide daily temperature range, is perfect for grapes! Our wines have a unique slightly spicy taste," explains Francisco in the middle of his five hectares of Malbec, the iconic grape variety of Argentina's wine-growing regions.

The introduction of Malbec into Argentina took a winding path. In 1849, Louis Bonaparte's revolution of 18 Brumaire forced French republican agronomist Michel Aimé Pouget into exile. He went first to Chile, where he introduced agricultural techniques and new plant species; then, in 1852, Sarmiento, the future president of Argentina, asked him to create an immense botanical garden in Mendoza. In 1853, Pouget settled there with various varieties of grape, young plants and cuttings...and the first Italian bee colonies. The man who was to become Miguel Amado Pouget will be forever associated with the history of Argentinian Malbec. It was in Argentina that this

⊡ Harvesting Malbec. ⊡ Anthonio Camani and Oracio Arce have had an abundant harvest ... ⊡ Francisco Farina, among his hundred-year-old vines in the community of Lunlunta.

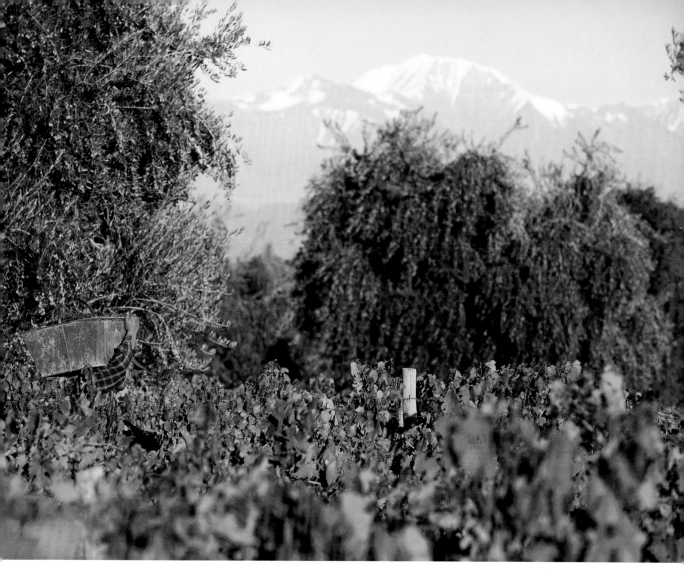
⌃ Harvesting grapes at the foot of the Andes in Argentina.

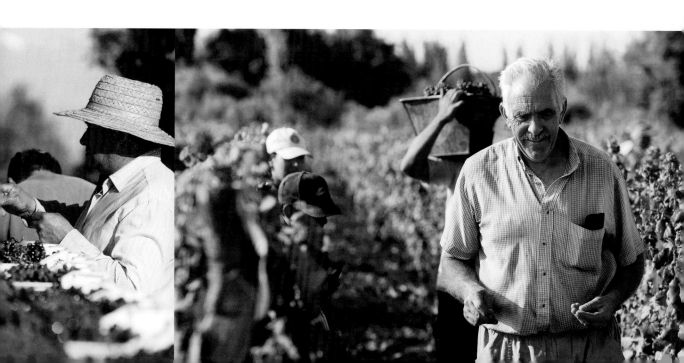

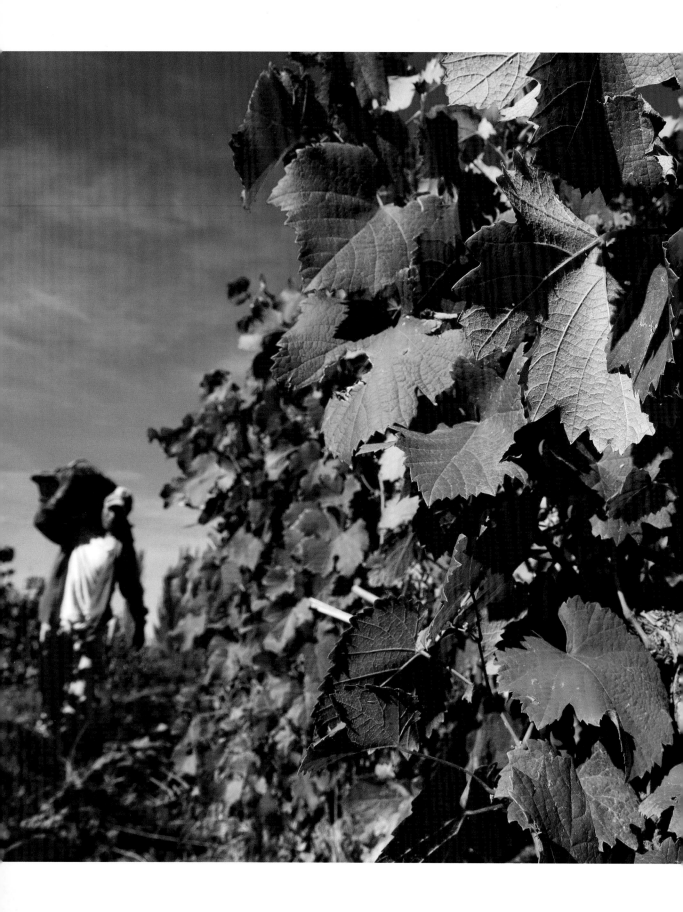

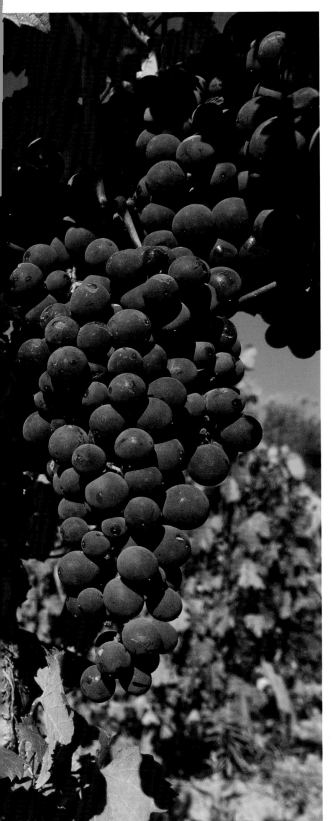

grape variety was able to show off its best qualities. Today more than half of the land growing Malbec grapes is in Argentina!

"Don't leave a single grape on the vines or any leaves in your baskets. These grapes are for our 'reserve' wines," Francisco tells the pickers. Francisco is a member of Viña de la Solidaridad (Viñasol), a producers' organization founded in 2005 that has 19 members. "Several producers were asked to join, but few wanted to participate owing to the bad reputation that cooperatives have here," explains Francisco. Yet small Argentinian producers had every reason to work together. Between 1990 and 2000, two-thirds of the country's small vineyards disappeared; they were bought up, merged, and transformed. Eduardo Bertona, the president of Viñasol, says of that time, "I cut down 40% of my vines for lack of a market; I even made white wine out of my Malbec for the national market. If in January I didn't have any buyers for my grapes, I worried. When Viñasol was founded, the promise of a minimum guaranteed price was inconceivable to me, but this year, for my fair trade grapes, I got twice the region's current price!"

Viñasol is unusual in the fair trade sector in having both owner-producers and *contratistas*, or workers with a special status. The *contratista* has a long history in Argentina; he is the manager permanently responsible for the maintenance of the owner's vines. He's a sort of tenant farmer who receives a small monthly allowance for his work, but whose main income comes from the grape harvest, from which he receives 15 to 18% of the earnings. The production costs, on the other hand, are paid for by the owners.

Between them, Antonio and Oswaldo, Eduardo's *contratistas*, have 80 years of experience! "Vines are a year-round thing," says Oswaldo, the senior of the two. At 221 workdays per hectare, vines require more labour than any other crop. "They have to be pruned, tied, watered, fertilized, taken care of and pruned again...one man by himself cannot take care of ten hectares!" Eduardo's two *contratistas* each look after six hectares. "All three of us are members of Viñasol," Eduardo adds. "For the moment, not all of our grapes can be sold as fair trade, for lack of a market, but the *contratistas* are first in line to receive higher prices and the social premium. This year, Antonio's children will be supported by Viñasol. As for Oswaldo...his grandchildren will benefit!

The fair trade grapes produced by Viñasol's members are bought by Bodega Furlotti, accredited as an exporter by FLO. Gabriela Furlotti, one of the owners, receives me in her ancestral home, now a country inn. The place exudes tradition and everything to do with wine. "This was my grandfather's vineyard. My family came here from Italy at the beginning of the last century. My ancestors were initially *contratistas* before becoming owners of their vineyard, and later their own cellar," she explains. A private wine-growing business, Bodega Furlotti was founded to make wines from fair trade grapes. Gabriela continues, "In the beginning, fair trade was just a business opportunity, but now the social aspect is more and more significant. It took a major education campaign. Nobody wanted anything to do with a cooperative. Viñasol is therefore a non-profit organization. We pay the members directly for the grapes we buy, which accounts for 20 to 25% of their harvest. We can tell that the fair trade premium is making the association stronger. As well, since Viñasol is a producers' organization, its members have been able to get government assistance of $3,000 per hectare this year to increase their yields."

According to Maria Laura, the agronomist responsible for Viñasol's production and also the FLO representative for Argentina and Chile, "Without fair trade, small-scale producers would disappear." The dynamic agronomist rushes from one vineyard to another and always has time to answer members' questions. "Look at this vineyard. It's only one hectare, but it's pampered as if it were a garden," she says as we visit the vineyard belonging to Miguel and Marta, wine-growers and members of Viñasol, where the harvest is in full swing. "I'd like to have dozens of members like them. They're the reason fair trade exists", she says, as Miguel beams with pride.

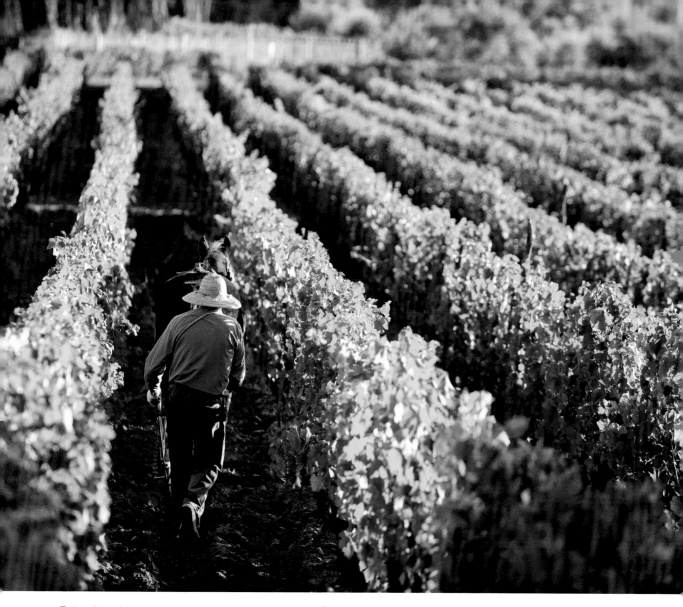

⌃ Gerardo Gauthier, a *contratista*, looking after Francisco Farina's vines. ⌟ Osvaldo, Antonio and Eduardo. ⌞ Agronomist Maria-Laura Bardotti and Miguel Borderon, owner of a vineyard with one hectare of malbec. ⌝ Gabriela Furlotti, one of the owners of Bodega Furlotti, where Viñasol members' wine is made.

L IKE SO MANY OTHER FOODS THAT HAVE ACCOMPANIED man over time, the point where wine began to be made from the fruits of the vine (*Vitus vinifera*) is lost in the maze of history. There is evidence that wine existed among the Persians, 7,000 years ago; it was later traded by the Phoenicians and wine-making know-how developed further in Latin Europe. Over time, a veritable world of cultivars (varieties of grape, in oenological terms) has spread across the planet, modified by the kind of soil, climatic features specific to each place and the instinct of the geneticist-artisans we call wine-growers. Much more than their red, white or pink skins, it is the subtleties in aroma and flavour of the various grape varieties – Cabernet Sauvignon, Pinot, Chardonnay, Riesling, Malbec, Shiraz, Sangiovese, Muscat, to name just a few – that have made wine the most sophisticated of beverages. More than any other food, wine by its very diversity defines 'the art of living'.

While this image of nobility and exclusivity belonged for a long time to just a few producing regions, the second half of the twentieth century saw the true globalization of wine. This was seen not only at the business level, but also in consumption patterns; on one side, there was the 'establishment' in countries with an ancestral tradition – with France and Italy in the forefront; on the other, the emerging nations of the New World, such as the United states, Australia, Argentina, Chile, and many others. All over the world – even in a country like China, where wine was for a long time just a western curiosity – there are attempts being made to produce wine not just for local consumption, but of a sufficiently high quality for export.

Wines can easily be compared on the basis of their taste qualities, but it is harder to do so based on the socioeconomic conditions in which they are produced. The public has trouble imagining that poverty and exploitation could be problems in this sector. Sadly, in many countries in the South, where there is no social safety net, wine is often produced on the backs of small-scale producers and a labour force that is easily taken advantage of.

While fair trade is still in its early stages (it accounts for about 0.02% of the wine market), it is succeeding in reducing economic injustices, notably in Argentina, Chile, and particularly in South Africa, where paying salaries with wine has always wrought terrible devastation. With the help of non-governmental organizations and by targeting markets where there is no competition from local production, encouraging breakthroughs have been achieved, notably in the United Kingdom and in Belgium (with a global 57% increase in sales in 2008).

wine in figures

CONVENTIONAL TRADE

Global production: 26,444,731,000 litres
Global trade: $22,422,000,000

MAIN PRODUCING COUNTRIES

Italy	18%
France	14%
United States	9%
Argentina	6%
China	5%
Chile (8th)	3%

FAIR TRADE

Year of certification: 2003
Global imports: 8,980,000 litres
Retail sales: $71,430,000
Growth (2007-2008) : 57%

CERTIFIED ORGANIZATIONS

Four certified small producer's organizations, and 23 organizations with hired labour.

ORIGIN OF CERTIFIED ORGANIZATIONS

South Africa	44%
Argentina	30%
Chile	26%

MAIN IMPORTING COUNTRIES

	Imports (t)	Growth (2007-2008)
United Kingdom	4,411,000	25%
Sweden	1,766,000	87%
Netherlands	689,000	56%
Belgium	565,000	423%
Germany	557,000	72%

PRICES AND PREMIUMS (grapes)

Fair trade price: $0.22 à $0.37/kg
Fair trade premium: $0.07/kg
Organic premium: $0.07/kg
Proportion of organic grapes: 35%

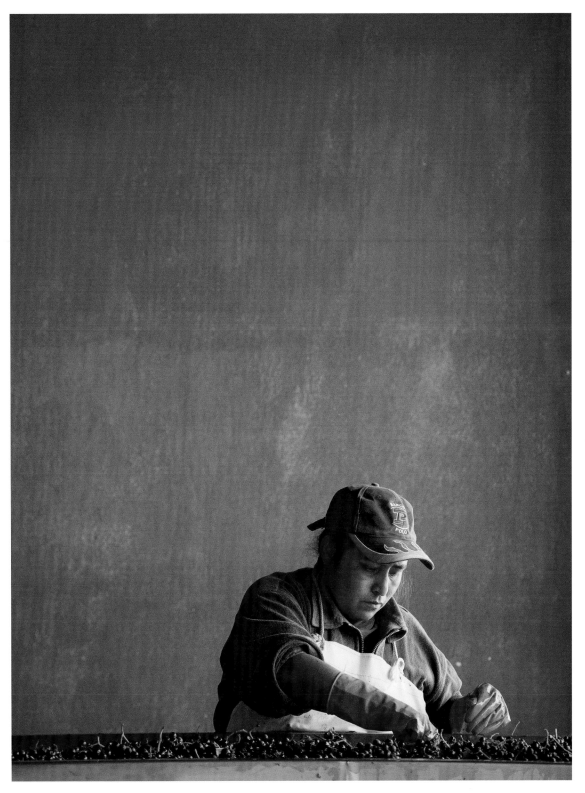

At Bodega Furlotti in Argentina, Luisa Delgado sorts the Viñasol members' fair trade grapes. Viñasol and Sagrada Familia, in Chile, are two of the four small producers' organizations for fair trade wine that are FLO-certified. The 23 other FLO-certified wine-producing organizations are private vineyards with a hired labour workforce.

In Chile, the early stages of the Vitivinícola Sagrada Familia company are reminiscent of Viñasol's. The 16 founding members of the association have fewer than 100 hectares among them and, as in Argentina, there are bitter memories of cooperatives in the region. "The members wanted nothing to do with a cooperative, but if you look at our statutes, it's all there except the name," says Raul Navarette, the company manager. Founded in 1997, this private company has 16 equal owners, all of whom are small-scale grape producers. Raul and Rafael Espinoza Inostroza, the president of the board of directors, welcome me to the small town of Curicó, in the heart of the Lontué Valley, a fertile fruit-growing region in Chile.

"In the early days of the organization, we could barely answer yes and no when we had visitors," he laughingly confides. "You have to remember where we came from!" Raphael began working as a labourer when he was nine. At 11, he went away to work. He adds, "When agricultural reform took place, my father got this small patch of a few hectares of land. He wanted to leave something to his children so they wouldn't be dependent on a boss. Some people complain because we don't earn very much, but we have something else that is priceless: freedom."

We drive off in his van to visit some of the organization's members: Manuel Jesus, Domingo and Luis. They recall, "Back then, we didn't even have shoes to put on our feet and we worked from Monday...to Monday!" It's only a few steps from Manuel Jesus's house to his vineyard, with its rows of white and red grapes: Sauvignon Blanc, Merlot, Cabernet Sauvignon, Carmenere... He continues, "I've been tilling this land for 30 years. I've always worked with my father. Before the association was founded, we had to sell our grapes for $0.05 a kilo. It was a disaster! The night before the harvest, we didn't sleep. Now, we know where to sell our grapes. Thanks to the association, we don't have to worry. What's more, the social fund is a huge relief. My mother is diabetic, but I know that if she needs care, she'll get it." The fair trade premiums are increased by bonuses from Oxfam-Wereldwinkles, the organization's main client, which adds 1.5 euros per box of wine. These funds enable Sagrada Familia to cover all the members' health costs and also to offer scholarships. "I was only able to finish fourth grade, but today our children go to university, some are engineers and we even have a doctor," says Manuel Jesus. Raphael adds, "My two oldest are doing graduate studies, which would have been impossible on our personal savings alone." In 2008, 30 students received support from the Sagrada Familia social fund.

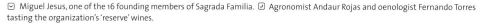

⊡ Miguel Jesus, one of the 16 founding members of Sagrada Familia. ⊡ Agronomist Andaur Rojas and oenologist Fernando Torres tasting the organization's 'reserve' wines.

Harvesting organic fair trade Cabernet-Sauvignon in vineyards belonging to José Elias Palma Vallejos, a member of Sagrada Familia.

During the grape harvest, agronomist Andaur Rojas and oenologist Fernando Torres go from vineyard to vineyard to make sure the grapes are ripening as they should. As soon as they arrive at the vineyard, they say, "Be ready tomorrow, Manuel. We will be coming to harvest your Merlot." This will be Manuel Campo's official entry into the organization. He is one of six new members joining Sagrada Familia for the 2009 harvest. "I'll have the assurance I can sell my grapes for a good price," says Manuel with delight. According to Manuel Jesus, the organization's evolution is phenomenal. "At the beginning, we only sold grapes. Then we made some of them into wine. Today, we even have to integrate new members!"

The company rents a cellar where the grapes are crushed as soon as they arrive and then are poured into large vats. Then come the various stages of the wine-making process: maceration, pressing, fermentation, clarification, filtration, bottling and sometimes, for 'reserve' wines, aging in traditional wooden barrels. "These barrels belong to us," Andaur says proudly.

When we return to the company offices, Raphael and Raul, the manager are receiving fellow Chileans with four large vats to sell. "Buying vats is another step towards fulfilling our dream of having our own cellar," says Raphael. "In 2008, we grew by 76%! Today, we make 1,300,000 litres of wine every year. We'll soon be producing enough to make the investment worthwhile," adds Raul. "Without fair trade, we never could have done this. And now we want other groups of small-scale producers to benefit from this model."

In April 2009, Sagrada Familia welcomed delegations from several Chilean organizations and representatives from importing countries. "There were more than 90 of us at those meetings," adds Léo Ghysel, a Belgian working for Oxfam-Wereldwinkels, which has a long history of development work with Chile. He continues, "When the Pinochet regime ended, we began to work with Chile; it was a gesture of welcome for democracy. This country has a number of products that can be exported through the fair trade network. We recently made juice from a concentrate of Chilean apples blended with fresh Belgian juice. It's very promising! With an FLO representative in the region, the outlook is even better. The people of Sagrada Familia are excellent ambassadors for fair trade; with them there is no window dressing, just basic fair trade values."

The village of Sagrada Familia is located on the Mataquito River, where the Mapuche resistance fighter Lautaro was killed. Sold into slavery at age 12, he was the groom of Pedro de Valdivia, a Spanish conquistador. Through contact with the Spanish, Lautaro learned the techniques of war. After having witnessed the murders and mutilations that Valdivia's men inflicted on his Mapuche brothers, Lautaro fled, rejoined his people and taught them that horses were not half-centaurs. He also taught them combat strategies and created the first indigenous cavalry. Lautaro took his revenge on Pedro de Valdivia at the Battle of Tucapel in 1553. Four years later, Lautaro's troops, tired out after a ritual drinking binge during a celebration, were taken in an ambush. Lautaro died under attack by his executioner, Francisco de Villagra, but his resistance was not in vain and his example inspired Chileans' later battles for freedom. The spirit of solidarity that inspired yesterday's Mapuche fighters, causing them to work together to resist and keep on going has survived. The Sagrada Familia producers are themselves resistance fighters in the Chilean wine market where just a few groups rule supreme. The fact their wines bear the name of the legendary Lautaro is not only a rightful homage but a courageous and creative statement.

☑ Sagrada Familia wine bearing the Lautaro label, named after the legendary Mapuche resistance fighter. ☑ The vine has been associated with man since the dawn of time.

"ACTING TOGETHER ACCOMPLISHES MORE THAN THE SUM OF OUR INDIVIDUAL ACTIONS," could be FLO's official motto. This thought, so common among women and men who work in fair trade, is of course rooted in the realization that networking is part of solidarity.

FLO certifies 750 producers' organizations and the WFTO has 350 member organizations, two-thirds of which are in the southern hemisphere. In 2008, more than 450 new organizations requested FLO certification. To help them integrate, FLO currently has 35 liaison officers working permanently in the southern hemisphere. In their early stages, producers' organizations have also often enjoyed the support of non-governmental organizations connected with international development, such as that given by the Belgian Oxfam-Wereldwinkles to the Chilean Sagrada Familia.

Whether they are cooperatives or other democratic organizations, small-scale producers' organizations may represent a few hundred artisans or more than 10,000 small farmers, like CoopeAgri in Costa Rica. A number of these organizations have also established unions or national federations. In coffee's birthplace in Ethiopia, the Oromia Coffee Farmers Cooperative Union (OFCU) stands behind 230,000 families. In Peru, COCLA consists of 23 coffee producers' cooperatives and has 'building alliances' among its main objectives .

From local cooperatives to national unions, the fair trade world now has three international producers' networks. In Latin America, the Coordinadora Lationoamericana y del Caribe de Pequeños Productores de Comercio Justo (CLAC) – The Latin American and Caribbean Network of Small Fair Trade Producers – unites more than 300 groups, representing more than 100,000 families; in Africa, African Fairtrade network, which is growing rapidly, brings together more than 200 producers' organizations in 24 countries; and in Asia, the stated mission of the Network of Asian Producers (NAP) is to include more Asian producers in fair trade.

These networks hold three permanent seats on FLO's board of directors. The organization's new global strategy for fair trade proposes that in the coming years these networks take their place as fundamental players in the system, instead of being just the beneficiaries of fair trade. This is a healthy decentralization process for fair trade, confirming its commitment to self-sufficiency and the decision-making power of producers, two founding objectives of the movement.

"Acting together accomplishes more than the sum of our individual actions," could be FLO's official motto. This thought, so common among women and men who work in fair trade, is of course rooted in the realization that networking is part of solidarity.

1. Cabernet Sauvignon.
2. Richard, a grape harvester, during the harvest in Francisco Farina's vineyard.
3. Argentinian Malbec.
4. Sorting by hand at Bodega Furlotti.
5. Swiss oenologist Marc Weis, tasting his 'reserve' wines.
6. Loading wines at Bodega Furlotti.
7. Bodega Furlotti's organic wine, made from viñasol grapes.

At Bodega Furlotti, Marc Weis is responsible for making wine from Malbec grapes produced by the members of Viñasol.

guarana

"Before there was time, there was the Noçoquém, a sacred forest where three divinities lived: the goddess Onhiamuaçabê and her brothers. Her brothers did not want her to marry, but all the animals dreamed of Onhiamuaçabê. One day, the snake rubbed against one of her legs and she immediately became pregnant. The child was born beautiful and healthy. His uncles were jealous and ordered the monkey to kill the child. Onhiamuaçabê picked up her child's body and planted his right eye in the ground. Out of this grew guarana. The child came back to life shortly thereafter. While she washed his body, all caked in dirt, his mother said to him, 'Your uncles ordered your death out of jealousy. They wanted you to have nothing, but you will be the greatest of all. You will be worshipped by everyone and people will come from far and wide just to sing your praises.' This child

was the first Satéré-Mawé," says *Juruena* Perpétua, a wise woman and the cook on the expedition taking me into the Amazon region. The *Juruena* sailed from the port in Parintins, Brazil, headed for the Satéré-Mawé demarcated territory, where over 10,000 people live in 100 or so villages spread over 788,000 hectares of forests and rivers. The boat sails calmly onward through vast expanses of green. In one tributary after another, I see strings of islands destined to disappear in the next floods, multicoloured birds, and other boats, from which passengers, obeying required Amazonian etiquette, wave at us and smile, without exception. From time to time, botos – freshwater dolphins – appear on the surface of the water, as if to invite us into their mysterious universe.

This is the first trip to buy guarana from the 2008 harvest. Obadias Garcia, a leader of the Satéré-Mawé and main organizer of the fair trade guarana project, gathers the entire crew together. A bowl of *çapó*, the sacred Satéré-Mawé beverage begins to make the rounds. An untiring teacher, Obadias knows he has to keep repeating the principles and objectives of what he calls Project Guarana: "Fair trade is not just about higher prices. It's about social justice, health, education, culture, control of the food supply and ecology. Fair trade is an integrated policy."

For centuries, guarana was the most important product in the Satéré-Mawé economy, used in trading with the pre-Columbian peoples of the Americas. "There are records indicating that Satéré-Mawé ancestors were selling guarana in Mexico as early as 1550!" says Obadias. In recent decades, constant growth in demand for soft drinks containing guarana (in 2008, nearly three billion litres of guarana-based drinks were consumed in Brazil) has given rise to the development of intensive agriculture in other parts of the country and resulted in guarana's steady decline in value. "There was a time when all of my people produced large quantities of guarana. Today, 70% of the fields have been abandoned", says Obadias. For the Satéré-Mawé, who call themselves 'sons of guarana', this process will have major sociocultural impacts, far beyond the economic repercussions.

Almost 15 years ago, a meeting with Italian socio-economist Maurizio Fraboni gave Obadias the opportunity to put a stop to a process of decline that threatened the very existence of his people. The two men got in touch with CTM Altromercato, Italy's largest fair trade organization. "Our first shipment was only 20 kilos," Obadias recalls. In France, Guayapi Tropical, an organic products marketing company, took up the cause for fair trade as soon as it heard about Project Guarana. Activist by nature, Guayapi Tropical committed its 1,600 points of sale in France to promoting Project Guarana and began to re-export Satéré-Mawé guarana to 20 countries.

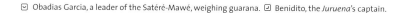

☑ Obadias Garcia, a leader of the Satéré-Mawé, weighing guarana. ☑ Benidito, the *Juruena*'s captain.

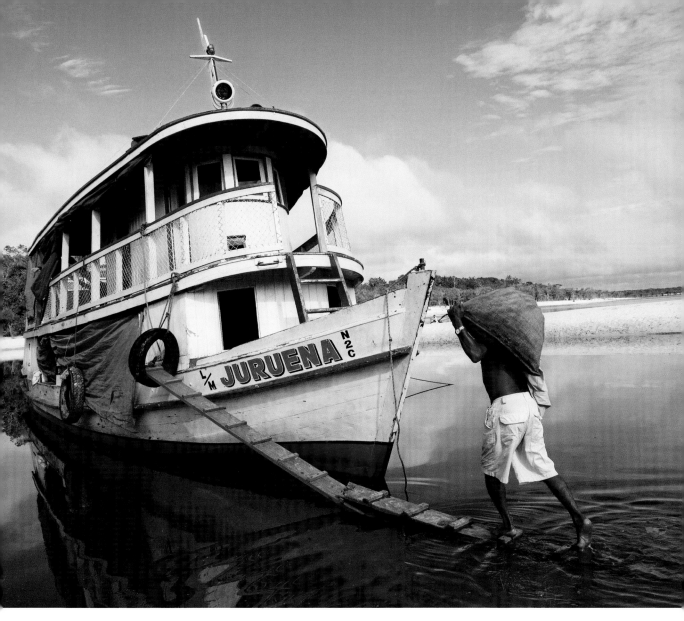

⌃ The *Juruena*, anchored in Guaranatuba in Amazonia, welcomes Satéré-Mawé who have come to sell their guarana.

Today, CTM Altromercato and Guayapi Tropical buy the entire tribal guarana crop, roughly seven tonnes a year. As a way of becoming better organized, the village chiefs established the Conselho Geral da Tribo Satéré-Mawé (CGTSM) – the General Council of the Satéré-Mawé Tribe. Organic certification of their agriculture and social and ecological projects undertaken as a result of fair trade have greatly contributed to improving the tribe's living conditions. In particular, they have reinforced tribal culture and once again made the Satéré-Mawé aware of their role on the planet, as protectors of the forest and of life. "Holy fair trade!" exclaims Obadias. "It's exactly like the Indian economy; in both cases, it's a question of protecting man and the environment!"

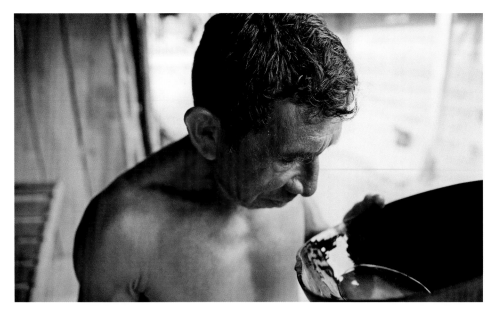

⊡ Paulo da Costa drinking a bowl of *çapó*, the sacred drink of the Satéré-Mawé.

‖‖‖

It is already dark when we arrive in Guaranatuba, the first Satéré-Mawé village in the Andirá River region. Before hanging up our hammocks, we greet the good *tuxaua** Delcides and his mother, Dona Iraci, who is both the oldest woman and the wise woman in Guaranatuba. Sitting on her stool, Dona Iraci prepares the *çapô*, grating a stick of guarana with a stone over a calabash full of water. *Çapô* is much more than a nourishing and medicinal energy drink; for these Indians it is a sacred beverage which, like the Eucharist, celebrates the union of God and man. The muddy-looking water harks back to the contents of the mythical calabash where Onhiamuaçabê bathed her reborn child. *Warana*** is 'the source of all knowledge'.

At dawn the next day, the producers arrive by boat carrying on their backs jute sacks full of guarana seeds. "At 40 reals ($20) per kilo, the Satéré-Mawé are the best paid guarana growers in the world," Obadias reminds us proudly. This is nearly ten times the price for a kilo of coffee. Along with his payment, each producer receives a written invitation to the founding meeting of the Satéré-Mawé Guarana Growers' Consortium, scheduled to take place soon, and a speech by Obadias on the importance of strengthening their independent organizations.

‖‖‖‖‖‖‖‖‖‖‖‖‖‖‖‖‖‖‖‖

* Among the Satéré-Mawé, the *tuxaua* is the village chief.
** Guarana, in the Satéré-Mawé language.

By offering better prices for Satéré-Mawé organic fair trade guarana, Project Guarana triggered a process of agricultural price inflation throughout the region. In less than five years, guarana produced by the Caboclos, people of mixed ancestry descended from white Europeans and indigenous peoples, who grow guarana on the outskirts of Satéré-Mawé territory, saw a nearly 600% increase in price, which upset some commercial stakeholders and made people greedy. Project Guarana was the object of defamatory attacks in some of the scandal-seeking media, and was even subjected to unfounded lawsuits, sowing doubt and ill-feeling in the Satéré-Mawé tribe.

‖‖‖

At Dona Iraci's, a producer is waiting for Obadias. He has questions about fair trade and wants a full explanation. So as not to miss anything, he brings along his oldest daughter, who speaks both Portuguese and Satéré-Mawé perfectly. Armed with a Guayapi Tropical prospectus listing prices, Obadias patiently explains the costs of transportation, the various taxes and the salary each member earns. "Fair trade is a chain of solidarity in which everyone has a role to play. We don't have clients; we have partners and allies." The talks go on until noon. In the boat, Perpétua, the wise woman, is waiting for us with tucunaré fish, rice, sea-beans and the unavoidable yellow manioc flour. All accompanied by your choice of fruit juice: buriti, açai or cupuaçu.

⊳ Dona Iraci ceremoniously grates a stick of guarana, made from roasted guarana seeds, to prepare *çapó*.

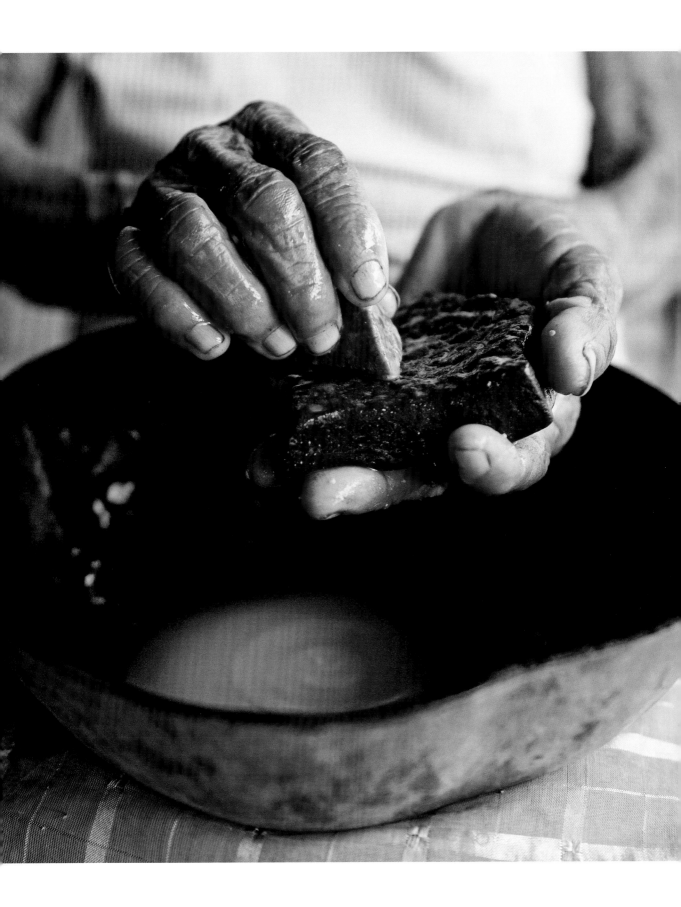

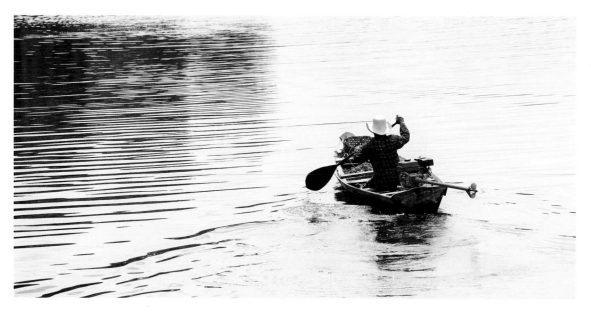

⌃ Returning to Guaranatuba with the guarana harvest. ⌄ Paulo da Costa carrying a heavy basket full of guarana fruit.
⌐ Harvesting clusters of guarana fruit.

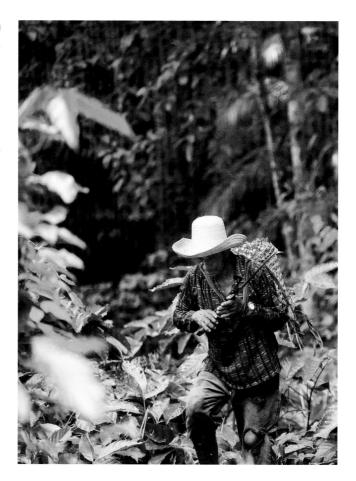

||

Very early the next morning, Paulo da Costa, a local grower, invites us to go harvesting in fields far from the village. It takes us a few minutes by small boat to get to his fields where, beneath the fruit trees, stingerless bees swarm around the entrance to their hives. Increasing the numbers of these hives is an important aspect of the Project, as these bees ensure the pollination not only of guarana, but of 90% of the Amazonian forest!

Paulo da Costa then invites us to take the 'iguana path', at the end of which we find his first guarana plants. Only 135 of the 390 shrubs on this patch are actually producing. "Most of my shrubs are still very young. What's more, I had weeded the field thoroughly, but it rained too much and the weeds have come back full force," he explains. "Last year, I harvested 89 kilos of guarana, but this year, I've just made it to 20 kilos." We are a long way from the small-scale producers of fair trade coffee, whose modest harvests nonetheless reach half a tonne.

Paulo is thinking of starting a new field with 150 plants. "In five years, they'll bear lots of fruit," he says confidently. In accordance with the Satéré-Mawé production protocol, he will have to gather his new plants in virgin forest, where the adult guarana is a creeping vine that produces a carpet of shoots at the foot of the tree it is attached to.

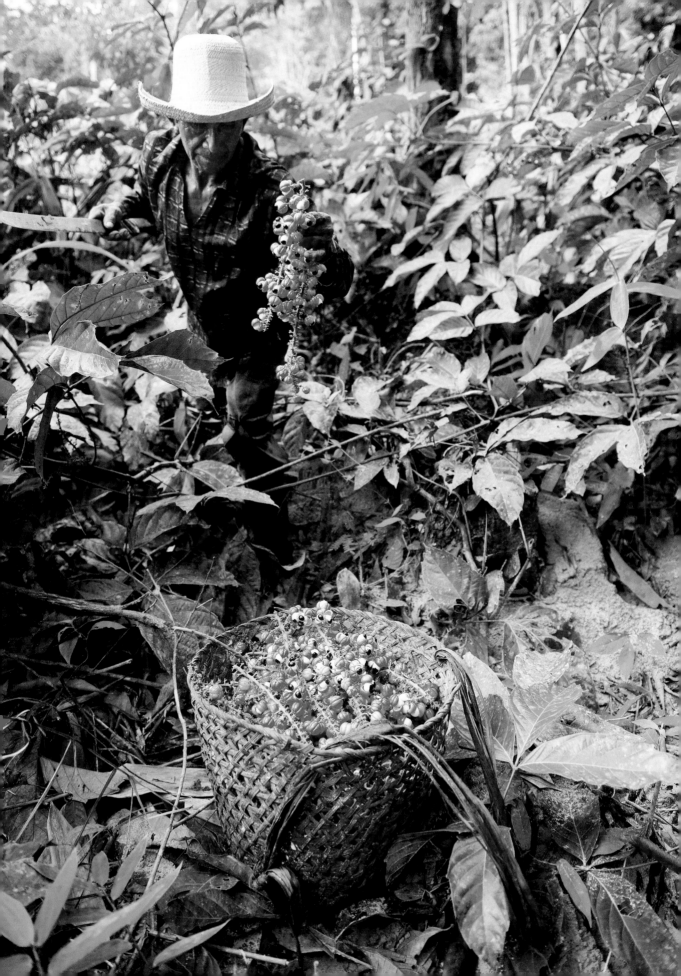

▷ The intriguing guarana fruit, its black seed surrounded by white pulp, looks like a human eye.

In a neighbouring village, we ask Élivaldo, another producer, to show us a mother vine. He agrees to guide us and after a little more than an hour in his small boat we arrive at a hunter's shelter, at the foot of a path. We have several hours of walking to do before we get to the vine and we stop to eat before leaving. Élivaldo begins to gather stalks and plant fibres from which he makes bows and arrows. "When Tocandiras ants die, they turn into fibres that we use as ropes to build our huts," he says, perfectly comfortable with the poetry of his myths. Once we have eaten, we head rapidly into the jungle.

Day and night, the forest sings. According to my companions, the chirping we hear as we walk is triggered by our presence. By transmuting the songs into words in the Satéré-Mawé language, Obadias and Élivaldo are able to understand the birds' eternal question: "Who are you? Who are you?" I am amazed by a biodiversity that surprises me more with each passing second. "Run! Run!" my friends suddenly shout. Without asking why, I take their advice and run until they stop me. "You were right in the middle of Taocas ant territory," Élivaldo informs me. Too late! A few have already made their way under my clothes and are making me pay the price for my intrusion.

After three hours of walking, we come across the first wild guarana plants. Their presence indicates that there is definitely a mother vine in the area. Indeed, a few minutes later, Élivaldo spots a tree to which a prolific vine is attached, which Obadias kisses, as if in religious devotion. He is especially happy to have his picture taken beside a mother vine. "In almost 15 years with Project Guarana, this is the first time this has happened to me!"

On the walk back, Obadias suggests we take another path. He wants to show me a very unusual tree called the *sapopema*. The majestic forest giant rises before our eyes like a being endowed with reason and will. Its aerial roots form plant walls at all four points of the compass to support a long and heavy mass growing in shallow soil. It seems that balance depends on combining forces, on loving and fraternal collaboration. This tree sends a message to the people of the forest. In the world of guarana, there are those who have already begun to understand it.

⌂ Obadias Garcia, next to a guarana mother vine.

Guarana (Paullinia cupana sorbilis) is a plant of the Sapindaceous family, whose birthplace lies between the Tapajós and Madeira rivers, in Brazilian Amazonia, the ancestral homeland of the Satéré-Mawé people. Guarana is rich in various alkaloids, tannins, mineral salts, vitamins and trace elements; it is a powerful stimulant and aphrodisiac also used for medical purposes, because of its anti-diarrheic and anti-neuralgic properties. More recently, its anti-carcinogenic properties have also been discovered.

For thousands of years, the Satéré-Mawé have roasted guarana seeds in clay ovens. The seeds are then ground and turned into sticks. When ritually grated into a calabash of water, this stick is the basis for their sacred drink, *çapó*.

Today, guarana is included in the formulas of many refreshing drinks and energy products. In Brazil alone, guarana-flavoured soft drinks account for 22.6% of the national market, with three billion litres consumed every year. Guarana seems set to conquer the world, especially in the area of energy drinks, an industry that is booming, with growth of 50% since 2002! Five hundred new brands were launched in 2007 alone.

However, even though guarana has the highest caffeine content of any plant, its production in all of Brazil, the only country to grow it commercially, doesn't even reach 4,000 tonnes, a pitifully small quantity if you compare it with the seven million tonnes or more of coffee produced worldwide. According to a Brazilian agronomist specialized in the field, "It's a well-known fact that the annual production of guarana can't provide even the minimum amount of caffeine required by law in 'guarana-flavoured' drinks sold in this country."

Organic fair trade guarana (certified by Ecocert and the WFTO, but not yet recognized by FLO, which is studying the question) is mainly distributed by Guayapi Tropical in France and 20 other countries, and by CTM Altromercato in Italy. In Canada, the fair trade company Nitro Gène has been selling powdered guarana and chocolate bars containing guarana since 2008 and is working on new and promising products.

Guarana is rich in various alkaloids, tannins, mineral salts, vitamins and trace elements; it is a powerful stimulant and aphrodisiac also used for medical purposes, because of its anti-diarrheic and anti-neuralgic properties.

The Sociedade dos Povos para o Ecodesenvolvimento da Amazônia – the Society of People for the Ecodevelopment of Amazonia, or SAPOPEMA – is the result of the union of Satéré-Mawé guarana producers, Caboclos associations and cooperatives and a small family business trading in Amazonian products. So that the economic success of the Satéré-Mawé can spread to include non-Indian producers who can supply high quality organic guarana, SAPOPEMA hopes to create a strong movement to increase the value of agricultural production, while respecting the Amazonian environment.

Later on in our journey, we visit José Francisco Marques, the largest single organic guarana producer in Maués and SAPOPEMA's unofficial spokesman among local guarana growers. According to him, "The Caboclos situation was not just similar to that of the Indians. There was no difference! A monopoly tried to lower guarana prices. The producers were never recognized as representatives." José Francisco is the founder of two local producers' associations.

The next day, Adeilson Gomes de Souza, known as Dedeco, the president of an association, takes us to visit his guarana field. He stresses the importance of the organization. "We have 170 members in the association, 95 of whom are certified organic." According to Dedeco, the organization has given guarana producers new social standing. "We used to be under the control of the middlemen and had to put up with humiliation. Now, we're economic partners. As part of the certification process, the federal government gave us property titles. That changed the nature of the game, especially now that things are looking good for guarana." Obadias adds, "SAPOPEMA is just in its early stages, but our goal is to make it a true economic alternative that will improve the way of life of the inhabitants of the Amazonian rainforest, and thus preserve the rainforest itself."

The Indian leader continued on his guarana buying trip, at each stop calling for a large presence at the founding meeting for the Satéré-Mawé Guarana Growers' Consortium, a decisive

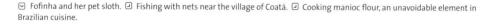

⊡ Fofinha and her pet sloth. ⊡ Fishing with nets near the village of Coatá. ⊡ Cooking manioc flour, an unavoidable element in Brazilian cuisine.

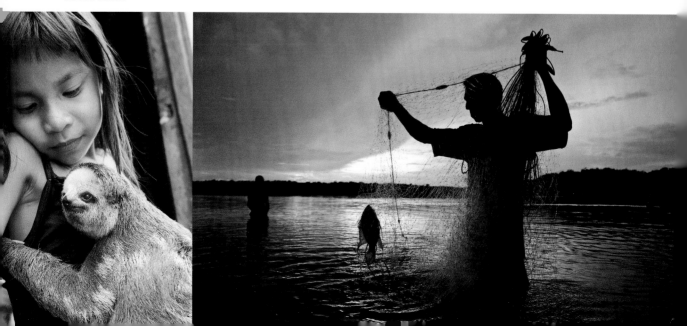

⌃ The wide Andirá River at Guaranatuba.

step in stopping their enemies' attacks. His efforts were crowned with success. On December 19, 2008, at a meeting on Michiles Island, a hundred producers officially established their Consortium.

There will be more battles in the future. "We are engaged in a long process to have the Satéré-Mawé region recognized as the birthplace of guarana", Obadias says. We'll have our own 'appellation d'origine contrôlée' – *Warana*" Like their mythical heros, the Satéré-Mawé will have to face future challenges with courage and emerge from them even stronger and wiser.

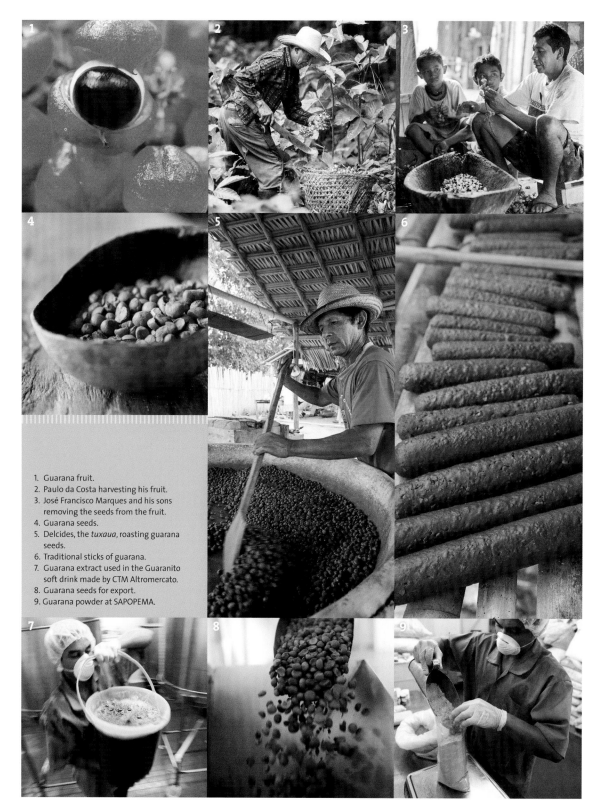

1. Guarana fruit.
2. Paulo da Costa harvesting his fruit.
3. José Francisco Marques and his sons removing the seeds from the fruit.
4. Guarana seeds.
5. Delcides, the *tuxaua*, roasting guarana seeds.
6. Traditional sticks of guarana.
7. Guarana extract used in the Guaranito soft drink made by CTM Altromercato.
8. Guarana seeds for export.
9. Guarana powder at SAPOPEMA.

▷ Paulo da Costa, removing guarana seeds with his grandchildren, takes the opportunity to pass on his ancestral knowledge and values. Young Satéré-Mawé are particularly involved in everyday activities in addition to their normal schooling, which takes place in the Satéré-Mawé language.

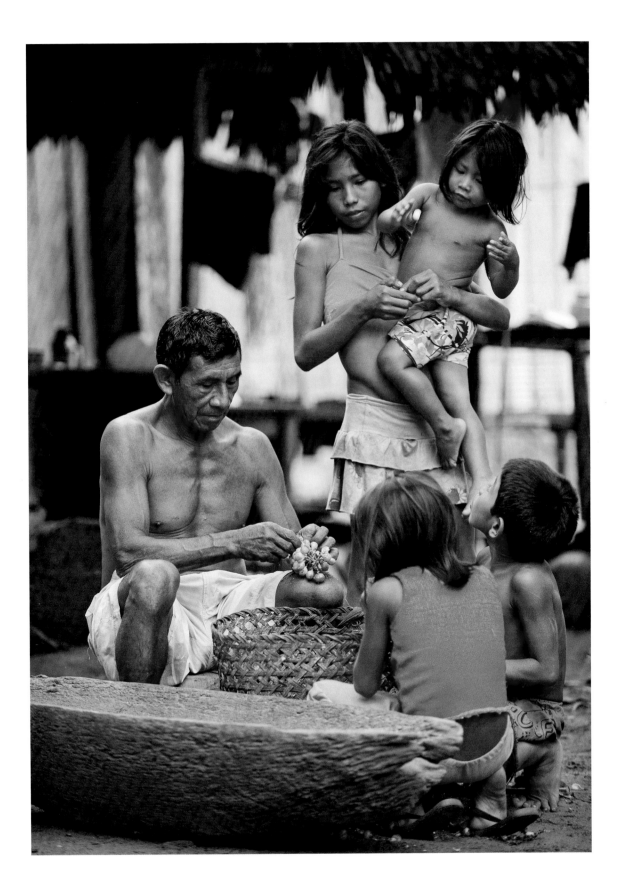

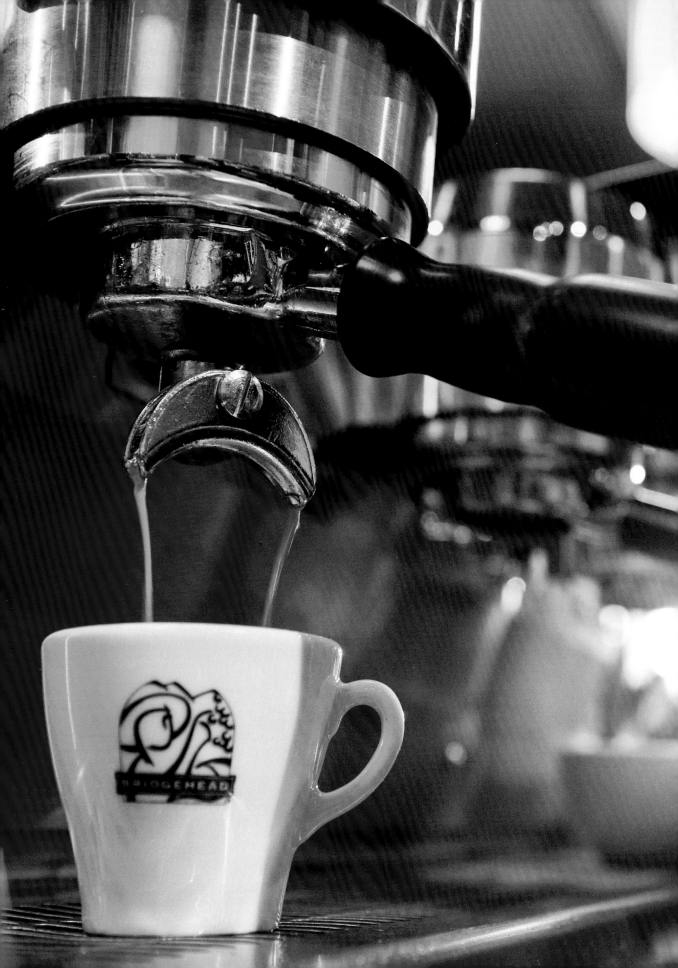

the globalization of
fair trade

"Like democracy, which isn't just about going to vote from time to time, the globalization of social and environmental justice isn't just talk. It means taking ideas and putting them into action on a daily basis," writes Laure Waridel in her book *Acheter, c'est voter* – buying is voting – published in 2005. Ten years earlier, I had met Laure quite by chance at an interview for work with Greenpeace. We were both hired and we became friends. When we headed for the UCIRI cooperative in Mexico in 1996, luck was on our side once again: we were going to visit one of fair trade's flagship cooperatives, home to Francisco Van der Hoff.

When we got back from this trip, several other people joined us to launch the 'Just Coffee'

campaign, still supported by Équiterre today. There were more and more of us who wanted to fight for greater justice through fair trade, but in Quebec we were starting from scratch. Our first list of sales outlets was short, very short; printed on a simple business card, you could count the addresses on the fingers of one hand!

In other parts of Canada, the Ten Thousand Villages shops were already an established network. Today, the initiative started by Edna Ruth Byler in 1946 and supported by the Mennonite Central Committee deals with more than 130 groups of artisans in 35 countries.

Non-governmental international development organizations have always played a predominant role in supporting fair trade. The Oxfam family alone, whose mother house in Oxford began selling handicrafts produced by Chinese refugees in Hong Kong in 1950, now has widespread networks and established import companies handling fair trade products, as does Oxfam-Wereldwinkels in Belgium. In April 2002, Oxfam's 14 branches launched 'Make Trade Fair', a huge lobbying and awareness campaign, with the aim of "calling on governments, institutions and multinational companies to change the rules so that trade can become part of the solution to poverty, not part of the problem." Équita, Oxfam-Quebec's fair trade brand, has the largest range of fair trade products in the country, including rice, spices and dried fruits, alongside coffee, tea and cocoa.

At our early meetings, we had only one fair trade product to offer, coffee, and only one brand, Bridgehead, then the commercial arm of Oxfam Canada. Oxfam Canada is no longer involved in commercial activity, but the Bridgehead brand was bought by former employees and there are now many Bridgehead cafés in the Ottawa area. Fair trade certification had not yet arrived in Canada, but in 1997, Bob Thompson, the first director of Transfair Canada, was working hard to get it.

At that time, several business owners were developing small- and medium-sized 100% fair trade businesses. In 1995, in Nova Scotia, the Just Us! Company became the first roaster of 100% fair trade coffee. "We believe strongly that we have to put people and the planet ahead of profits," explains Jeff Moore, its founder and general manager. Just Us! distributes fair trade and organic products, and it is also a workers' cooperative.

The same is true for La Siembra, in Ottawa, which celebrated its tenth anniversary in 2009

with the slogan '10 Years of Co-operative Fair Trade', and which describes itself in this way: "We have chosen to identify with our producer partners by adopting the same democratic, participatory and transparent model that they follow in their own cooperatives." Caitlin Peeling, a worker-owner, explains La Siembra's views, "We chose fair trade cocoa and sugar so as to offer products other than coffee. By doing this, we hoped to reach young people, who represent the future. Chocolate has a lot more potential where they're concerned!" Cocoa Camino, La Siembra's brand, is now the biggest-selling brand of fair trade chocolate in the country.

La Siembra products are also distributed in the United States by Equal Exchange, another workers' cooperative, founded in 1986. "Our first coffee came from Nicaragua. By having a Dutch organisation do the importing, we avoided an embargo imposed on Nicaragua by the Reagan administration. It was a political gesture," says Rink Dickinson, one of Equal Exchange's three founders; today there are 80 worker-owners. The cooperative is also the main owner of Oké USA, which distributes El Guabo bananas in the United States. Oké USA and El Guabo own shares in Agrofair, based in the Netherlands and made up of a consortium of organizations, businesses and groups of producers in the South who specialize in fresh fruit. With sales totalling 60 million euros, Agrofair is the largest importer of 100% fair trade products in the world.

"The organisations offering 100% fair trade products were pioneers in the movement and, even today, they are the most demanding and the most vigilant," explains Rob Clarke, the current executive director of Transfair Canada. Canada is the country with the highest number of organizations selling 100% fair trade products among its licensed members. However, fair trade certification, begun in the Netherlands in 1988, would coincide with the entry of big food companies into the fold. "At the beginning, our coffees were sold in natural food co-ops," explains Rink Dickinson. Getting into conventional markets was slow going, but at the end of the 1990s, with the arrival of multinationals, things changed. We always wanted this expansion to happen, but we knew it would lead to contradictions in the system."

The advent of multinationals in the importing and distribution of fair trade products often provoked a negative reaction. Some saw it

⌂ Rink Dickinson, one of the founders of Equal Exchange workers' cooperative, a pioneer in the fair trade movement in the United States.

as a deal with the devil, with businesses having poor social and environmental track records and who would sacrifice everything for immediate profits. Other criticized the multinationals' opportunism for boarding the fair trade train just to avoid losing market share.

For producers in the South, the need for markets justified the arrival of the big players. Ten years ago, when fair trade certification was at the halfway point in its history, certified coffee cooperatives exported less than 10% of their products through the fair trade market. Today, they export 50% on average and new groups of producers want to join the movement each year.

FLO fair trade certification, which represents 90% of fair trade product sales, experienced phenomenal growth of 1300% between 2000 and 2008. In 2009, Starbucks committed to doubling its purchases of fair trade coffee, which accounts for just 10% of its imports, but nearly a third of the global supply of fair trade coffee. The British company Cadbury has just launched a fair trade Dairy Milk, made of certified sugar and cocoa. This means the company will quadruple the export of fair trade cocoa from Ghana for a total of 20,000 tonnes annually, or twice the amount of all fair trade cocoa exported in 2008. The advantage

C ANADA IS ONE OF THE COUNTRIES WHERE SALES OF FAIR TRADE PRODUCTS ARE INCREASING MOST RAPIDLY, with a growth of 67% between 2007 and 2008. Even our per capita consumption of nearly six dollars is similar to that of France and compares favourably with that of the Netherlands and Germany, which are bastions of the movement. In the United Kingdom, the largest fair trade market, consumers spend almost 22 dollars on fair trade products, whereas the champions – the Swiss – spend more than 33 dollars.

It is in Europe that the fair trade market is the most solidly established. Europe's vast networks of specialized shops are not just points of sale for fair trade products; they are also nerve centres for education and awareness, with many volunteers. In 1994, 13 national associations of shops founded the Network of European Worldshops (NEWS !), representing more than 2000 worldshops, or half of the market.

These networks of shops are often associated with importing organizations that travel the world looking for new products, or even new groups of producers. CTM Altromercato, in Italy, has a triple identity – it's a business, a movement, and a network of shops. Intermon Oxfam in Spain, Tradecraft in England and Gepa in Germany all started out in handicrafts and then were the first to promote food products. In 1987, 11 importing organizations founded the European Fair Trade Association (EFTA), bringing together some of the oldest and largest organizations specializing in fair trade.

Using the acronym FINE, the four large fair trade networks (FLO, WFTO, NEWS, and EFTA) have been working together since 1996 to develop a joint monitoring system for the entire fair trade movement and to lobby at the international level, among other activities. Based in Washington, the Fair Trade Federation (FTF), which consists of 300 organizations mainly in Canada and the United States, is yet another large fair trade network in the consuming countries.

In the South, fair trade is also getting attention. In addition to the three continental networks connected to FLO (CLAC, AFN and NAP), Brazil is developing its own national fair trade market, Faces do Brazil, which brings together more than 1000 organizations of producers, business people and other official partners. The Alternativa Bolivariana para las Américas(ALBA) – the Bolivarian Alternative for the Americas – also claims to represent fair trade and applies a number of its principles in commercial agreements among nine countries in the Caribbean and South America.

RETAIL SALES OF FLO-CERTIFIED FAIR TRADE PRODUCTS, IN 2008

Country	Total sales	Total expenditures per capita	Growth (2007-2008)
United Kingdom	$1,318,700, 000	$21.71	43%
United States	$1,134,800,000	$3.74	10%
France	$382,800,000	$5.99	22%
Germany	$318,670,000	$3.89	50%
Switzerland	$252,800,000	$33.69	7%
Canada	$192,400,000	$5.84	67%
Sweden	$109,000,000	$11.98	75%
Germany	$97,600,000	$11.83	23%
Netherlands	$91,200,000	$5.54	28%
Finland	$81,600,000	$15.42	57%
Denmark	$76,700,000	$14.23	40%
Belgium	$68,600,000	$6.44	31%
Italy	$61,700,000	$1.05	6%
Norway	$46,400,000	$9.88	73%
Ireland	$45,100,000	$10.48	29%
Australia/New Zealand	$27,900,000	$1.20	72%
Japan	$14,400,000	$0.15	44%
Spain	$8,200,000	$0.15	40%
Luxemburg	$6,300,000	$13.18	33%
FLO	$150,000	unknown	unknown
Total	$4,334,800,000		

of multinationals is that they have the financial resources and distribution networks to move huge volumes.

"We're flattered to see Cadbury participating in fair trade," comments Caitlin Peeling of La Siembra. "We see it as proof of our success; if fair trade were not profitable, the big players wouldn't invest in it. It also shows the importance of continually pushing for even fairer trade. We're motivated by our fair trade mission, not just the certification of our products."

Launched in 2009, the Cuisine Camino line of baking supplies (powdered cocoa, chocolate chips, cooking chocolate and whole brown sugar) are made from fair trade and organic cocoa and sugar; in addition, all processing is carried out in various Latin American countries. "We'll continue to encourage processing in the country of origin by the producers, to ensure they get the maximum added value," insists Caitlin. "Fair trade is part of a bigger concern – that consumption be more responsible, more ethical, and more respectful of communities, the environment and future generations."

In the wider market of 'responsible consumption' and 'social responsibility', many labels, codes of ethics, foundations, charitable works and other initiatives are being launched to highlight various social or environmental commitments. It is impossible not to be aware of the current wealth of 'green', 'ethical', organic' and 'environmentally conscious' products, miracle names that can be stuck on a detergent bottle or an explanatory brochure for an investment fund. This is not just a fad, but a real market trend. Fair trade is certainly part of this dynamic, which is bigger than the North-South framework. A growing desire for justice is inspiring, in both North and South, more and more socially and environmentally responsible initiatives.

Consumers are a key element in this success. 'Consum-actors', 'ecocitizens', 'alter-consumers' – whatever adjective is used, they have the power to take action that leads to changes. "The current revolution and those that will follow begin in our minds, but continue in each of our actions," Laure Waridel insists. There are many people who refuse to accept the injustices and disparities of the conventional market. The strength of fair trade is that it offers a very real alternative, which can be expressed every day through our consumption choices, our purchases and the businesses we patronize.

☑ Equita, Oxfam-Quebec's fair trade brand name, has the largest range of certified fair trade products in the country: coffee, rice, spices, dried fruits and chocolate bars are sold in specialized shops, as well as supermarkets.

soccer balls

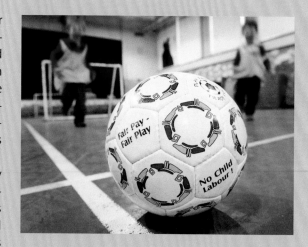

SYMBOLIZING GLOBALIZATION IN SPORTS, soccer (or football) knows no borders. Objects of fascination all the way back to ancient times, inflated leather balls made for ground sports were seen in Greek and Chinese antiquity. The European Middle Ages had its own versions before the era of football; these soon reappeared in conquered territories, renamed the Americas...where native peoples already had their own kinds of ball games.

Perhaps the shining eyes of children as they look at rubber balls reflect the sparks of this primordial impulse. Soccer, which fascinates crowds on every continent, has very strong historical and psychological roots. Its economic groundwork was laid at the end of the nineteenth century, with the birth of 'football' as a business in England – the undisputed cradle of capitalism. To the takings at the wickets were added those from publicity and broadcast rights in various media. The construction of stadiums and all the required infrastructure, related products and professional salaries make this sport a major economic activity. Sometimes the object of shameful political manipulation, soccer is also a place where the underdogs of the world can assert themselves, where the Palestinians can inflict crushing defeats on Israel and the United States trembles with fear when facing Nigeria.

Menander I made the capital of his kingdom, Sagala, famous in the history of Buddhism. For him this was fame enough. History, however, turned this place of wisdom into Siakolt, a Pakistani city known for its production of musical instruments, surgical instruments, textiles and sports equipment, including no less than 70% of the soccer balls sold worldwide. They are made by little hands...in slavery-like conditions even today. Since 1996, the International Confederation of Free Trade Unions (ICFTU) has denounced the exploitation of children and pushed for an agreement involving various international organizations and Pakistani suppliers, but such an initiative, while very laudable, has not managed to stop the practice. According to Tim Noonan, of the ICFTU, "Without the social regulation of international trade, downward competition will continue."

The fair trade movement wanted to find a solution to this intolerable situation by certifying ball-producing companies. One result of certification would be to prohibit work by those under 15. But in spite of its efforts, fair trade soccer balls still represent a minor share of the market, just 3.7% of the production of four Pakistani companies in 2008. We have to hope that expanding this fair trade sector will contribute to a total transformation in the way sports equipment – symbolic of the striking disparities between children at work, in the South, and children at play, in the North – is currently produced.

Jason Nelson, the chef at Bistro Olivieri in Montreal, uses fair trade Thai rice, organic oyster mushrooms, locally grown filet mignon of goat and Zeitouna olive oil, in solidarity with Palestine, to create a dish that is an unequivocal example of 'responsible consumption'.

For consumers, fair trade is also a fertile source of new ideas. In conferences, exhibits, Internet publicity, university studies and school programs, it has become a tool to sensitize both the young and not-so-young about world issues. In provincial schools, and especially in the Établissements verts Brundtland network, the Centrale des syndicats du Québec (CSQ), which represents teachers as well as other groups, has produced various tools for teaching about fair trade. It also supports worldshops in schools, inspired by the Belgian experience with 125 schools and universities. There are fair trade universities and even fair trade cities! Beginning with the 2001 initiative of the 4,000 inhabitants of Garstang, in the United Kingdom, there are now 650 cities, villages and regions all over the world, including London, Brussels, Rome and San Francisco, that respect at least five of the basic principles established by FLO to increase the awareness and availability of fair trade products. Will our provincial capital be the next city to embrace the cause?

"Today's utopia is tomorrow's reality," prophesied Victor Hugo. The pioneers of fair trade identify completely with the words of this apostle of peace and social justice. The poetic dreams of fair trade's early days chose a path paved with solidarity and have now become a tangible reality: 6,000 certified products, 125,000 sales outlets, five billion dollars in retail sales; the results of fair trade are undeniable. Some might see these figures as modest when compared with the sales figures of global trade, but for the millions of producers and their families who are at the heart of the system, this 'modest' difference substantially improves their living conditions. What's more, fair trade must not be measured only in terms of numbers. You have to be very clever indeed to quantify hope, pride and dignity.

The current success of fair trade is first of all proof that trade can lift people out of poverty when conditions are fair. It is also proof, for defenders of the free market, that by respecting a few basic principles, it is possible to combine 'trade' and 'fair'. Ultimately, the goal is not to

reach 20 or 50 billion dollars in sales of certified products. Utopia would instead be to take this success and turn it into political influence to change the conventional trading system, for the concrete benefit of people in the South. Let's hope that what is alternative today will become standard tomorrow.

The products we buy are produced by the labour of men and women. The products they make contribute to our comfort and improve our lives. And yet, these people remain anonymous, hidden behind a veil of figures and statistics, or publicity and packaging. I hope that this world tour has made you more aware of the origins of some of the products we use in our daily lives. I hope this book will have given you the chance to look closely at the faces and actions of the producers and that you will see in them the aspirations for happiness and freedom that are common to us all and that identify us as brothers and sisters in the great human family.

▷ Alice Nignan, a shea butter producer and member of the Union de Léo in Burkina Faso.

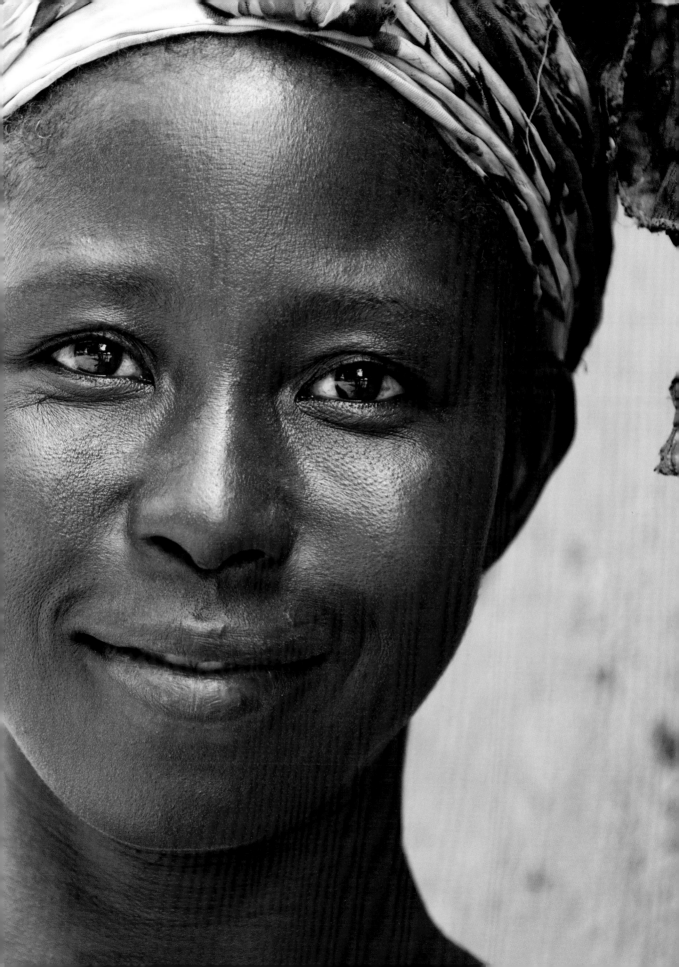

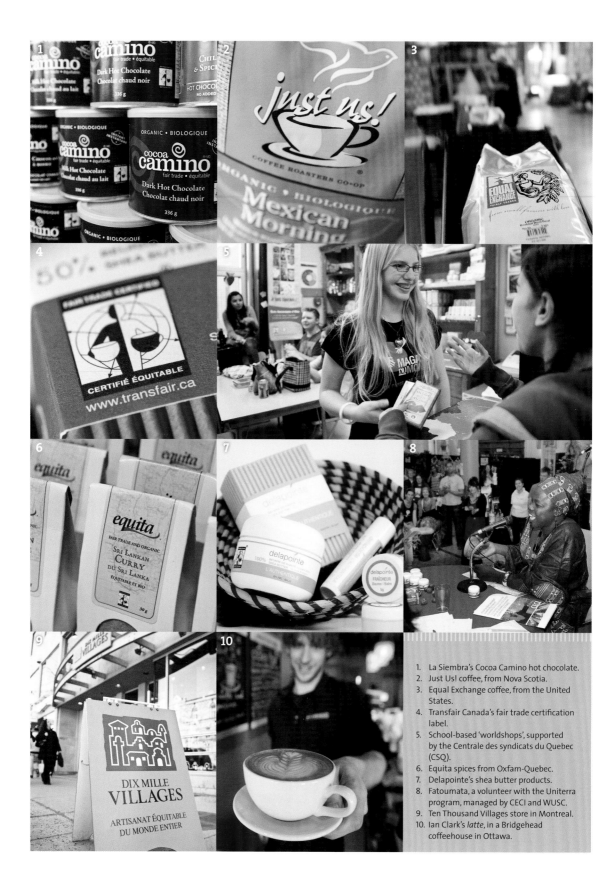

1. La Siembra's Cocoa Camino hot chocolate.
2. Just Us! coffee, from Nova Scotia.
3. Equal Exchange coffee, from the United States.
4. Transfair Canada's fair trade certification label.
5. School-based 'worldshops', supported by the Centrale des syndicats du Quebec (CSQ).
6. Equita spices from Oxfam-Quebec.
7. Delapointe's shea butter products.
8. Fatoumata, a volunteer with the Uniterra program, managed by CECI and WUSC.
9. Ten Thousand Villages store in Montreal.
10. Ian Clark's *latte*, in a Bridgehead coffeehouse in Ottawa.

acknowledgments

First of all, I would like to express my warm thanks to all the men, women and children with whom I've been able to share a moment, a day of work, a few words, a meal and occasionally even a roof. I am indebted to them for their generous hospitality, as well as for the knowledge and experiences they have been kind enough to share with me. A very special thanks to those who granted me the privilege of capturing on camera a few moments out of their lives.

Thanks to the UCIRI members in Mexico, the Prokritee artisans in Bangladesh, the small coffee producers in Oromia, Ethiopia, CONACADO's cocoa growers in the Dominican Republic, the CoopeAgri members in Costa Rica, the Indian tea garden workers and SOFA members in Sri Lanka, the greenhouse workers at Nevado Roses and Agrogana in Ecuador, the Thai rice farmers of GreenNet, the Malian cotton producers in Kita and at MOBIOM, the members of El Guabo in Ecuador and Finca 6 in the Dominican Republic, the Union de Léo shea butter producers in Burkina Faso and those in Siby, Mali, the ANAPQUI members in Bolivia, the wine-growers of Sagrada Familia in Chile and Viñasol in Argentina, and the Satéré-Mawé guarana growers in Amazonia.

Thanks to Transfair Canada, Oxfam-Quebec and its Equita team, the Centre for International Studies and Cooperation (CECI) and its Uniterra program in collaboration with the World University Service of Canada (WUSC), the network of Ten Thousand Villages stores, the Centrale des syndicats du Québec (CSQ), Bridgehead coffeehouses, the La Siembra, Just Us! and Equal Exchange workers' cooperatives, and to the Delapointe company, for offering me financial and technical support in documenting these stories. I also want to thank these organizations for their commitment to fair trade and for their major contribution to the creation of a fairer world.

Thanks to the teams at Équiterre, FLO and Transfair Canada for their statistics.

Thanks to Francisco Van der Hoff for his great wisdom, which he knows how to share so well, to Laure Waridel, with whom this quest began and who has become an exceptional leader in the fair trade movement, to Emerson da Silva and Mathieu Lamarre for their essential contribution to the texts in this book, to Marc-Henri Faure of FibrEthik for his support and to the Nitro Gène team for their support of my trip to the Amazon.

Thanks to friends, colleagues, teachers and the various organizations that have advised and supported me over the past 15 years of work.

Thanks to my parents for passing on their love of travel and for having sown the idea that dreams can become reality. Thanks to my in-laws for always being there, especially for my children during my frequent travels. Thank you, Aline, for your countless revisions.

To Sophie, my better half, and to our three children, Jérémie, Dominic and Justin, thank you for providing stability amidst the ups and downs of living with a globe trotter and for being never-ending sources of inspiration in an exciting life paved with special moments.

useful addresses

Fair Trade Organizations

European Fair Trade Association (EFTA):
 www.eftafairtrade.org
Fairtrade Labelling Organizations International (FLO):
 www.fairtrade.net
Fair Trade Federation (FTF): **www.fairtradefederation.org**
Network of European WorldShops (NEWS):
 www.worldshops.org
World Fair Trade Organization (WFTO): **www.wfto.com**

National Fair Trade Certification Initiatives

GERMANY
Transfair Germany: **www.transfair.org**
AUSTRALIA / NEW ZEALAND
Fairtrade Association Australia and New Zealand:
 www.fta.org.au
AUSTRIA
Fairtrade Austria: **www.fairtrade.at**
BELGIUM
Max Havelaar Belgium: **www.maxhavelaar.be**
CANADA
TransFair Canada: **www.transfair.ca**
DENMARK
Fairtrade Mærket: **www.fairtrade-maerket.dk**
SPAIN
Asociación del Sello de Comercio Justo:
 www.sellocomerciojusto.org
UNITED STATES
TransFair United States: **www.transfairusa.org**
FINLAND
Reilu Kauppa: **www.reilukauppa.fi**
FRANCE
Max Havelaar France: **www.maxhavelaarfrance.org**
UNITED KINGDOM
The Fairtrade Foundation: **www.fairtrade.org.uk**
IRELAND
Fairtrade Mark Ireland: **www.fairtrade.ie**
ITALY:
TransFair Italy: **www.fairtradeitalia.it**
JAPAN
Fairtrade Label: **www.fairtrade-jp.org**
LUXEMBOURG
TransFair Minka Luxembourg: **www.transfair.lu**
NORWAY
Max Havelaar Norway: **www.fairtrade.no**
NETHERLANDS
Stichting Max Havelaar Netherlands: **www.maxhavelaar.nl**
SWEDEN
Rättvisemärkt: **www.rattvisemarkt.se**
SWITZERLAND
Max Havelaar Switzerland: **www.maxhavelaar.ch**

Fair Trade in North America

Bridgehead: **www.bridgehead.ca**
Centrale des syndicats du Québec (CSQ): **www.csq.qc.net**
Centre d'étude et de coopération internationale (CECI)
 (Centre for International Studies and Cooperation):
 www.ceci.ca
Ten Thousand Villages: **www.tenthousandvillages.ca**
Equal Exchange: **www.equalexchange.coop**
Équiterre: **www.equiterre.org**

FibreEthik: **www.fibrethik.org**
Just Us!: **www.justuscoffee.com**
Karité Delapointe: **www.karitedelapointe.com**
La Siembra: **www.cocoacamino.com**
Nitro Gène: **www.nitrogene.ca**
Oxfam-Quebec and its Equita brand: **www.oxfam.qc.ca** and
 www.equita.qc.ca

Producers' Networks

African Fairtrade Network (AFN): **africafairtrade@yahoo.com**
Coordinadora Latinoamericana y del Caribe de Pequeños
 Productores de Comercio Justo (CLAC) (Latin American
 and Caribbean Network of Small Fair Trade Producers):
 www.clac-comerciojusto.org
Network of Asian Producers (NAP): **www.fairtradenap.net**

Producers' Organizations

Agrogana: **alvaro@agrogana.com**
Ambootia Tea Group Exports: **ambootia@vsnl.com**
El Guabo Asociación de Pequenos Produtores Bananero
 (El Guabo Association of Small Banana Producers):
 www.asoguabo.com.ec
Asociación Nacional de Productores de Quinua (ANAPQUI)
 (National Association of Quinoa Producers):
 anapqui@entelnet.bo
Compagnie malienne pour le développement des Textiles
 (CMDT) (Malian company for textile development):
 www.cmdt.ml
CoopeAgri: **www.coopeagri.co.cr**
Coopérative des Productrices de beurre de karité de Siby
 (COOPROKASI) (Siby shea butter producers' cooperative):
 www.maisondukarite.org
GreenNet : **www.greennet.or.th/e0000.htm**
Makaibari tea garden: **www.makaibari.com**
Oromia Coffee Farmers Cooperative Union (OCFCU):
 www.oromiacoffeeunion.org
La Confederación Nacional de Cacaocultores Dominicanos
 (CONACADO) (National Confederation of Dominican
 Cocoa Producers): **www.conacado.com.do**
Mouvement biologique malien (MOBIOM) (Malian organic
 movement): **Siaka.Doumbia@helvetas.org**
Nevado Ecuador: **www.nevadoroses.com**
Prokritee: **www.prokritee.com**
SAPOPEMA – The Satéré-Mawé Guarana Growers' Consortium:
 http ://sites.google.com/site/filhosdowarana/
Small Organic Farmers Association (SOFA) and Biofoods:
 www.biofoodslk.com
Sociedad Vitivinícola Sagrada Familia (Sagrada Familia wine
 producers' association): **www.vinoslautaro.cl**
Union communale des coopératives de producteurs de coton
 de Djidian (Djidian cotton producers' local union of
 cooperatives): **solobamadi@Yahoo.fr**
Unión de Comunidades Indígenas de la Región del
 Istmo (UCIRI) (Union of Indigenous Communities in the
 Isthmus Region): **www.uciri.org**
Union des Groupements de Productrices de Produits de
 Karité des provinces de la Sissili et du Ziro (Union de Léo)
 (union of groups of women shea product producers in
 Sissili and Ziro provinces): **www.afriquekarite.com**
Viña de la Solidaridad (Viñasol) (Viñasol wine-producers'
 association): **www.solunawines.com**

▶ Lukeya Kalaoulé, 32, the mother of four children and a shea butter producer, is a member of the Union de Léo in Burkina Faso. As a child she never went to school, but now she is learning to read in Sissala, her mother tongue, thanks to a program paid for with fair trade premiums from the sale of shea butter.

⌂ Daily chores at the well for Zénabou and Kadio in the village of Tabou in Burkina Faso.

Printed in Spain

Contains 10% post-consumer fibres
EcoLogo Certified, processed without chlorine and FSC Recycled
Made using biogas energy

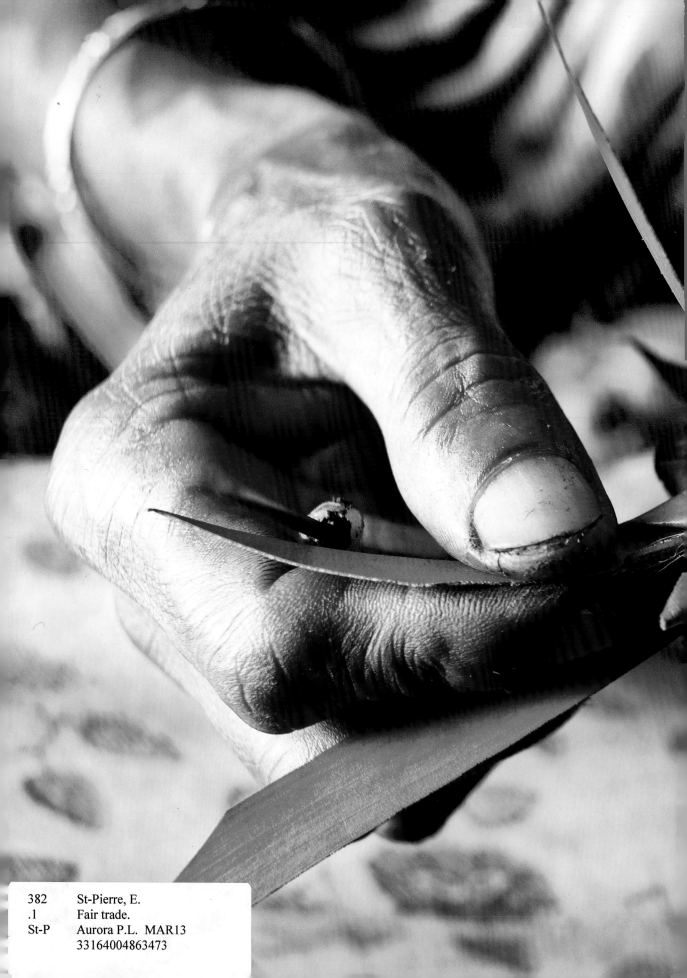